The Painter
EDWARD LEAR

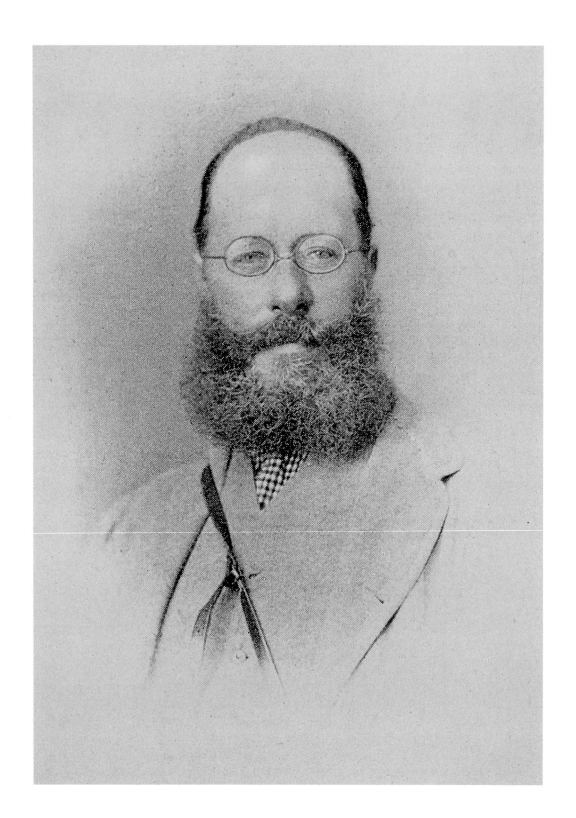

Edward Lear. Photographed in
Egypt, December 1866

The Painter
EDWARD LEAR

Vivien Noakes

With a Foreword by HRH The Prince of Wales

DAVID & CHARLES
Newton Abbot London

Acknowledgements

To Sarah Hollis,
and in memory of Nigel

For their kindness and help in various ways, I would like to thank: John Abbott; Brian Alderson; Michael Appleby; Captain Sir Thomas Barlow, Bt.; the late Dowager Countess Beauchamp; Dr Judith Bronkhurst; Dr Gerald L. Carr; Timothy Clowes; Toby Collyer; Mr and Mrs Matthew Crosby; Sean C. Dawes; the Rt Hon the Earl of Derby; Margaret Divers; Gina Douglas, Librarian of the Linnean Society; Nigell D'Oyly; Harriett Drummond; Owen Edgar; H. P. Ellerman; The Fine Art Society; Nancy Finlay; Donald Gallup; James Gibb; Anne Goodchild; Timothy A. Goodhue; Denise Harvey; Edward King; Hugh Macandrew; Henry Martineau; Colin McFadeyean; David Mawson; D. R. Mitchell; Gabrielle Naughton; Dr Donald M. Nicol; Ben Noakes; Michael Noakes; P. J. S. Olney, Curator of Birds and Reptiles at the Zoological Society of London; Iona Opie; the staff of the Library at the Royal Academy of Arts; Joseph Sharples; Philip Sherrard; Frances K. Smith; Virginia Surtees; Dr Robert Taylor; Fani-Maria Tsigakou; Christina Vardas; M. Walker; Henry Wemyss; Dr J. Selby Whittingham; Derek Wise; Mr and Mrs C. W. Witt.

For permission to reproduce works, I am indebted to: Thomas Agnew & Sons, London; British Council, Athens; the Trustees of the British Museum; Christie's, London; Museum of the City of Athens; the Clonterbrook Trustees; the Clothworkers' Company; The Fine Art Society, London; the Syndics of the Fitzwilliam Museum, Cambridge; Gennadius Library, American School of Classical Studies, Athens; Hazlitt, Gooden & Fox, Ltd., London; the Houghton Library, Harvard University; the Leger Galleries, London; Liverpool City Libraries and Arts Department; D. R. Michell; the Pierpont Morgan Library, New York; the Hon Sir Steven Runciman, C.H.; Somerset Record Office, Taunton; Sotheby's, London; Spink & Son, London; the Trustees, the Tate Gallery, London; the Trustees, the Victoria and Albert Museum, London; Board of Trustees of the National Museums and Galleries on Merseyside (Walker Art Gallery, Liverpool); the Yale Center for British Art; and many private collectors who wish to remain anonymous.

For permission to quote from published work, I am grateful to: Agnes Etherington Art Centre, Kingston, Ontario, from Frances K. Smith, *Daniel Fowler of Amherst Island, 1810–1894;* Thames & Hudson, from Patrick Trevor Roper, *The World Through Blunted Sight;* Ernest Benn, from Sir Ian Malcolm, *The Pursuit of Leisure.*

For permission to quote unpublished material, I am grateful to: the Getty Center for the History of Art and the Humanities, Santa Monica; Glamorgan Record Office; the Houghton Library, Harvard University; D. R. Michell; the John Rylands University Library of Manchester; the Somerset Record Office, Taunton; the Tennyson Research Centre, Lincoln; the Board of Governors, Westminster School.

British Library Cataloguing in Publication Data
Noakes, Vivien *1937–*
 The painter Edward Lear.
 1. English paintings. Lear, Edward, 1812–1888
 I. Title
 759.2

 ISBN 0–7153–9778–8

Book designed by Michael Head

Typeset by ABM Typographics Ltd., Hull
and printed in Singapore by CS Graphics Ltd
for David & Charles plc
Brunel House Newton Abbot Devon

Contents

The Plates

Foreword

HRH THE PRINCE OF WALES

To generations of children, most certainly including myself, Edward Lear has given pleasure as the Father of Nonsense, the creator of limericks, of the Great Grombolian Plain and the Dong with a Luminous Nose. *The Owl and the Pussycat* is one of the best-loved nursery songs. Yet it was as a painter, and not as a writer, that Lear spent his working life.

From the age of fifteen, when he began to sell watercolours to travellers at coaching inns, until a few months before his death just over a hundred years ago, in January 1888, he worked with astonishing industry and commitment, producing several hundred oil paintings and many thousand watercolours.

Lear was also a marvellous teacher. My great great great Grandmother, Queen Victoria, was one of his pupils. He would sketch in front of her, explaining the different stages in the creation of the watercolour. She would then work on her own, and he would see and criticise the work she had done. It is fascinating to see the influence he had upon her because the sketches she produced were remarkably Lear-like.

As with so many painters, Lear failed to achieve proper recognition until even after his death. It was only in 1985 that the Royal Academy of Arts acknowledged his remarkable talents by mounting a major retrospective exhibition, which later moved to the National Academy of Design in New York. I have long been an ardent admirer of Edward Lear's drawings and watercolours, not to mention his stunning oil paintings. As far as I am concerned, he is an inspiration, but his standards are impossible to aspire to!

Vivien Noakes's study of Lear as a painter draws on all his known paintings and watercolours, and builds up a picture of a painter of exciting and unusual talent who is at last receiving the recognition he deserves.

Introduction

Many of those who know Lear as a Nonsense poet do not realise that it was as a painter rather than as a writer that he earned his living. Born in 1812, he worked as an ornithological and natural history illustrator from the age of sixteen until he was twenty-five; in 1837 he became a landscape painter. At his death he left more than three hundred oil paintings; his own estimates of the number of his watercolours vary from ten to thirty thousand, although the first figure is probably more accurate.

The blossoming of English watercolour painting in the late eighteenth and early nineteenth centuries began its growth in the craft of topographical illustration. During the eighteenth century, artists were employed to record the scenery and antiquities of newly discovered lands and rediscovered civilisations. The function of these topographical artists was to produce accurate records of scenes and sites, faithfully rendered without concession to the higher considerations of abstract beauty or the effects of light and shade. Because of this, and its straightforwardly practical purpose, topographical draughtsmanship was one of the least regarded branches of the artist's profession.

Towards the end of the eighteenth century, however, there was a growing awareness of the beauty and fascination of landscape for its own sake, and a group of artists were at work who were less interested in precise topographical accuracy than in recreating the form, light and colour of the natural world. Using watercolour, drawings could be made with relative speed making it possible to capture the transient qualities of light and atmosphere. When used in transparent washes, water-based paint could give to the work a clarity and feeling of light which was more difficult to achieve in oil painting; applied in denser, more opaque layers it gave a sense of depth and richness of colour.

The typical early English landscape watercolour in monochrome grey or brown had given way by the mid-eighteenth century to stained drawings, in which the initial pencil drawing was overlaid with two colours; distant blue moved forward to warmer brown. Later, in what became known as tinted drawings, areas of local colour were added. By the

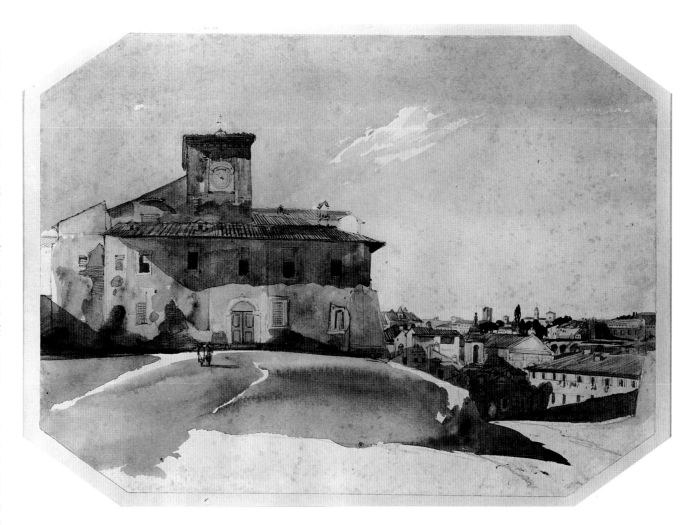

Church of the Ss. Quattro Coronati, Rome. n.d. Watercolour. 9¼in x 12½in. Tate Gallery, London

time that Turner and Girtin were working, the artist might lay in the local colour immediately, without the use of an establishing wash and often without initial pencil drawing.

Although Lear was working half a century after the fashoinable use of stained and tinted drawings, in his early watercolours we can see a progression through the convention of blue and brown washes to the use of areas of local colour. He also experimented, often very successfully, in drawing directly in watercolour, but this was not his usual method; generally he began with a pencil drawing over which he laid watercolour washes. In some of his work the watercolour is laid in almost independently of the pencil line, sweeping across the drawing to form its own abstracted composition, as he enjoys the freedom of the quality of the paint.

At the beginning of his professional career, as an ornithological draughtsman, Lear worked in the convention followed by the early topographical artists; his task was to produce precise and scientifically accurate drawings as a record of birds and animals in both public and private collections. The

7

birds in his early drawings existed only in his imagination and cannot be identified as any known species (see pp.33 and 35), but working as a natural history draughtsman he could have no recourse to fiction in describing bird or animal form. However, from the very beginning, he brought together scientific accuracy and imaginative interpretation, a combination which led to the excellence of his ornithological work. He was the first natural history draughtsman to make his drawings almost exclusively from living birds rather than from stuffed specimens, a way of working which gave him the opportunity to understand not only the bird's outward form but also its less tangible characteristics. Lear saw more than just the physical appearance of the creatures that he drew; to both his ornithological and his later landscape work he brought a response which goes beyond the immediately visible to the shared spirit of nature, something of which he was always aware. 'The Elements – trees, clouds, &c., – silence . . . seem to have far more part with me or I with them, than mankind,' he wrote in 1862, and 'I have been wondering if on the whole the being influenced to an extreme by everything in natural & physical life, – i.e. atmosphere, light, – shadow, & all the varieties of day & night, – is a blessing or the contrary.'

In drawing living birds, Lear was following the Renaissance dictum, *imitare la natura*. The great late fifteenth- and early sixteenth-century exponent of this, a painter whose 'wonderfully beautiful sketches' Lear much admired, was Albrecht Dürer. From classical Greece, however, came the Aristotelian idea that the inherent deficiencies of even the most beautiful of natural forms made them unsuitable subjects for the study of serious art. Nature on her own, without the improving intervention of man, was not good enough. In the seventeenth century Claude Lorrain, Poussin and Salvator Rosa turned to nature as the inspiration for their work, but they and their many successors worked within a convention which viewed nature through the selective filter of the ideals of classical antiquity rather than as it existed before their eyes. In doing so they lost touch with the reality of the world they sought to interpret, setting down instead a vision of idealised nature in a golden age.

By the end of the eighteenth century, therefore, three threads had developed in an artist's way of looking at nature. One, in an age of growing scientific investigation, was a portrayal of natural objects as they were seen, the clear and truthful record of things observed. This was the way in which Lear worked as a natural history illustrator; in landscape, it was the convention of the topographical artist. A second thread was the idea that nature should be studied for its own sake, for the beauty and often wild and untamed grandeur of the Romantic and the Sublime which awoke in man a spiritual involvement with the abstract forces of nature. A third, in which this spiritual involvement played little part, concerned itself less with the realities of nature than with an idealised interpretation of the natural world; it was not the untouched wonders of nature which interested the painters who worked in the highly regarded tradition of High Art in the Grand Manner, but rather a lifeless abstraction constrained within a framework of unreality which disregarded the challenging and often untidy characteristics of nature as it existed. A product of Neo-classicism, the appeal of this convention lay in its apparent intellectual dimension; at a time when respect for classical learning was at its height, painters and sculptors were able to demonstrate a cerebral as well as a visual awareness. It was against this background that Sir Joshua Reynolds founded the Royal Academy of Arts in 1768.

Lear's best work, seen in his travel watercolours, grew from a balanced mingling of the spiritual and the scientific, what he described at Poetical Topography. He had spent too many formative years working within scientific disciplines ever to abandon them, even if he had wished to do so; in fact, the apocalyptic power of his epilepsy was such that he found reassurance in the precise and the predictable, so long as these did not dominate the imagination. The format of his Nonsense poetry offered him the same reliable background against which to let his imagination wander freely. And as, in his limericks, he sets down human nature as he sees it and not as the morally improving literature of the time would like it to be, so in his watercolours he recorded what was before him. He exploited the picturesque, but had no time for Gilpin's idea of being 'so attached to my picturesque rules that if nature gets wrong, I cannot help putting her right', or John Varley's

Athos from near Neochorio. 21 September 1856.
Pencil, sepia ink, watercolour. 9³/₁₆in x 12¹/₁₆in.
The Hon Sir Steven Runciman, CH

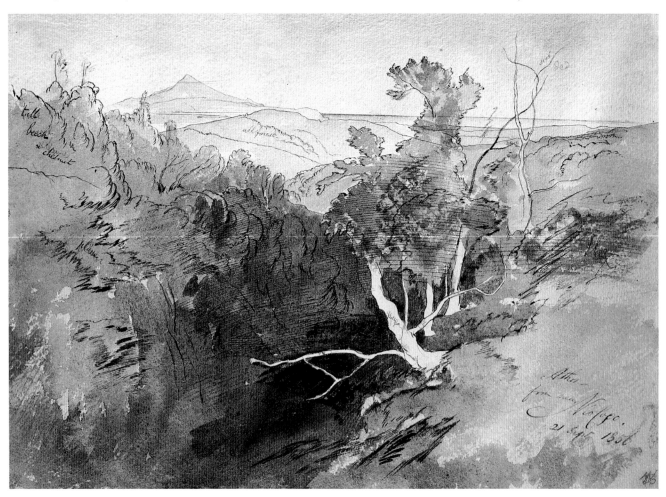

suggestion that on occasion nature needed 'cooking'. From the very beginning of his career, it was not an ideal of nature but nature itself which interested him. Although Lear wrote to Ruskin in 1883 that 'your books caused me to use my own eyes in looking at Landscape', many years before the publication of *Modern Painters* he already knew that he must 'go to nature in all singleness of heart, and work with her laboriously, having no other thought but how best to penetrate her meaning; rejecting nothing, selecting nothing, and scorning nothing'.

His friend Charles Church later wrote of Lear that his 'description of himself as the Topographical Artist marked his purpose of making truth and fidelity the special object in his work, without attempting to give to his landscape effects of his own device or imagination which did not belong to the scenery of that particular region, or, as he said, to make "fiction for the delight of those who prefer prettiness to truth".' Such artifice was something about which he and Holman Hunt shared a common view. In 1861 he wrote to Hunt from Florence, 'I go daily to a villa near here, from which is that wonderful view wh. Turner painted. And I am drawing this, partly because I have no topographical illustration of this beautiful place, – partly because I believe I can do the subject pretty well out of my own brains – placing vines & olives as they really are, – & not calling in to my aid, broken pillars, unset capitals, immense gourds, & 15 Ladies in pink & yellow satin playing on Guitars.'

Many painters at that time had not visited the places they drew, working instead from the drawings of those who had, often with little regard for the true characteristics of the country they were representing. Lear believed that his particular contribution, the result of extensive travels, was the faithful yet poetic portrayal of distant and little-known places. 'I saw the illustrated copy of Tennyson at Farringford', he wrote to Hunt after the appearance of the Moxon edition of 1855, 'greatly to my dismay . . . how beautifully you have done the palms in the floating man & boat scene! – But if you had made them Elm trees, it would have been quite as good for the English public, since Stanfield (RA) gives a tower of the 12th century & a small bit of Alp, as illustrating a scene in Asia minor.'

His earliest training was as a draughtsman, and this remained his real interest. 'I am certain, whatever good I may get by "color from nature" I get more by pencil', he wrote, although as his mastery in the handling of watercolour increased so did his powers as a colourist. The quality of his drawing

had been established in his ornithological work where he developed the habit of working in pencil before transferring the drawing to the lithographic stone (see pp.36–7). Although he prepared the initial watercolour from which the colourist worked, and would have overseen and approved the work, Lear's own responsibility ceased with the drawing. Preparing the lithographic plates in his travel books further increased his expertise as a draughtsman, and endorsed his understanding of the importance of line in recreating a landscape, for in these he could depend on nothing else. It was this same mastery in pencil drawing which gave simple power to his Nonsense illustrations.

By 1861 Lear had come to regard the work of Poussin and Salvator Rosa as 'odious', but he retained an admiration for that of Claude. His first painting to be exhibited in the Academy, in 1850, was *Claude Lorraine's House, on the Tiber*, and throughout his travels, right up to his final journeys in India, he saw and admired Claude-like scenery. An oddity in the Lear canon, the only known example of Lear copying the work of a master, is a watercolour now at Harvard which was done sometime in the late 1840s. It is derived from one of the plates, *Landscape with figures and cattle*, in the second volume of Claude's *Liber Veritatis*, a plate which in its turn was based on a pen drawing in the collection of Lord Egremont and which relates to his oil, *Transformation of the Appulian Shepherd*. It was a work which Turner had copied and exhibited in 1814 as *Appulia in Search of Appulus*; whether Lear copied Claude's work or Turner's later oil is not known. Claude's *Liber Veritatis* and Turner's *Liber Studiorum* were the inspiration behind Lear's final task of preparing for publication his illustrations for Tennyson's poems.

Although he disliked the ideas behind the creations of High Art, yet this was the tradition he had known as a boy and some element of it entered into many of his oil paintings. He did not set out to idealise and thereby destroy the soul of the landscape that he painted, but the spiritual understanding which animated his watercolours slipped beyond his grasp when he was constrained indoors in his studio. This sense of removal from the spirit of nature which gave a powerful dimension to his watercolours, combined with his lack of technical mastery and his belief that a reputation could be made only by the exhibition of large and imposing oil paintings, led to the creation of grandiose pictures, many of which lack the quiet passion which characterises so much of his watercolour work. It was a combination which made the act of painting difficult and dis-

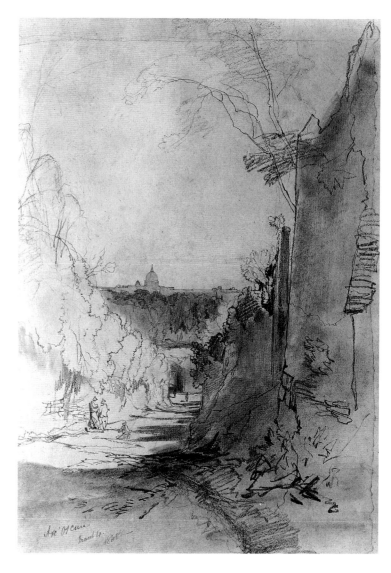

St Peter's from Arco Oscuro. 4 March 1840. Pencil. 13in x 9in. Tate Gallery, London

agreeable, so that in 1861 Fortescue could write: 'You are a curious compound of love of Art – or at all counts power of absorbing yourself in it – with hatred of the actual work', to which Lear replied: 'Yes –: I certainly *do* hate the act of painting: & although day after day I go steadily on, it is like grinding my nose off'. How very different this is from the joy expressed in his travel watercolours, when 'climate & beauty of atmosphere regain their hold on the mind – pen – & pencil'. 'O! the difficulty of dovetailing the charm of early artist life with the formality of later days,' he wrote in his diary in 1881. 'The calm & brightness of the view, & the lovely sweetness of the air, bring back infinite days & years of outdoor delight.'

His oils, like his studio watercolours, were based

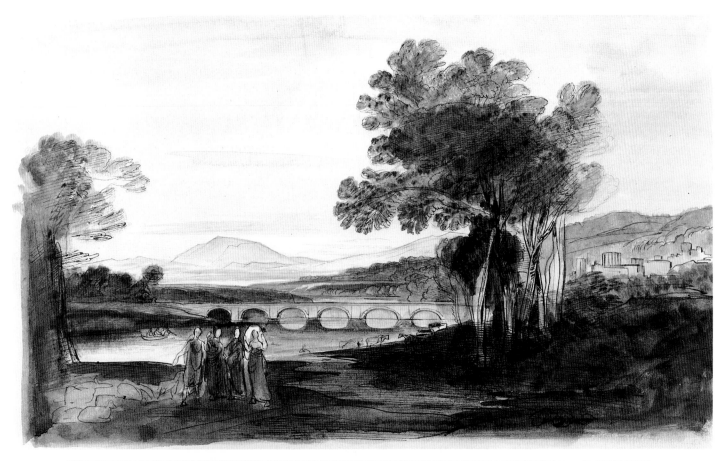

Landscape with Figures After Claude Lorrain and Turner. n.d. Pencil, sepia ink, watercolour. 10in x 14in. Houghton Library, Harvard University

on earlier drawings done direct from nature. These drawings were generally done in pencil on the spot; the watercolour washes were usually, though not always, laid in later when he was back in his studio after his travels.

The third process was one of 'penning out', in which he went over the pencil lines in sepia ink. This was designed to give a greater permanence to the works. Such penning out could, on occasion, affect the accuracy of the drawing, in both its precision of line and its atmosphere. Sometimes the ink line fails to follow the original pencil drawing, and after penning out two of his Indian drawings of 1874, Lear noted that the 'The loose gray pencilling of this sketch, originally gave much idea of the gray monsoon mistiness – this the pen has dispersed, & it can now only be regained by gray colour, & some opaque white', and the 'rock & citadel gray & farther off than they seem now that they are penned out'. He completed this process often months, and – particularly with the drawings he did during his extensive travels in 1848 and 1849 – sometimes years, after the original drawings had been done, so that on occasion he has penned out the wrong date, reading for example 1849 for 1848.

Some of Lear's later penning out was done by an assistant, F. T. Underhill, who on rare occasions also traced and penned out drawings which Lear had given away. Although re-traced drawings are marked as such by Lear, it is impossible for us now to know which were penned out by Underhill.

Despite the beauty of these travel watercolours, the control he acquired over their handling and the pleasure he derived from doing them, Lear did not consider himself to be essentially a watercolour painter. He may have repeated some views endlessly both as 'finished' watercolours (see p.61 and pp.92–3) and as Tyrants (see pp.80–81), hoping for sales of these studio works, but he did not once prepare for sale a copy of any of the drawings which he had done on his travels. However satisfyingly beautiful many of these are, especially to modern taste, he thought of them as his working drawings, the source of reference for his later works.

Hubert Congreve, who knew Lear during the last twenty years of his life, has left an account of a sketching expedition and the way in which Lear set

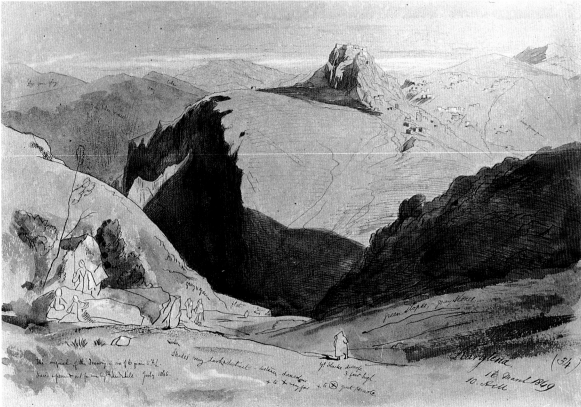

Karytena. 16 March 1849. 10in x 17in. Pencil, sepia ink, watercolour. Gennadius Library, Athens

21 September 1880. Sepia ink. Private collection

about making drawings. 'When we came to a good subject, Lear would sit down [he used a three-legged stool], and taking his block from George, would lift his spectacles, and gaze for several minutes at the scene through a monocular glass he always carried; then, laying down the glass, and adjusting his spectacles, he would put on paper the view before us, mountain range, villages and foreground, with a rapidity and accuracy that inspired me with awe-struck admiration . . . They were always done in pencil on the ground, and then inked in in sepia and brush washed in colour in the winter evenings.'

These drawings were unsigned, but the place, often the time of day when they were done, and a number would be inscribed in the bottom corner. In numbering his drawings, Lear began a series when he arrived in a country; if he crossed from one country to another on the same journey, from Albania into Greece for example, he would begin with a new numbered series.

Lear did not use a camera obscura, but at one time he explored the possibility of taking photographs which he could use for additional reference. In 1856 he wrote to Ann from Corfu that he was setting his spare room 'in order to work at a photographic machine which I have just purchased. I have often wished to possess one, & just now a really good one was for sale. – At just half its original price; so I have bought it, & hope before long to be able to send you & others some real views of Corfu. If I can come to use this mode of working, it will be of great service to me in copying plants, & in many things which distance, limited time, heat etc. would prevent my getting. We shall see.' There is no mention of any success in his subsequent letters to Ann. We know that in 1859 he was still experimenting with the possibility of using photographs taken with his own

camera, but after that we hear no more of the idea. In Crete in 1864 and in India in 1873, he bought photographs for reference, probably for the architectural details of buildings, and at the beginning of his diary for 1875, he notes, 'Johnson's Indian Photographs, 121, Fleet St., London'.

More useful as *aides memoire* were Lear's characteristic and often lengthy notes, written on the face of the drawing and later faithfully penned out. At their simplest, such notes referred to colour and content, a system he had used in his drawings of parrots (see pp.36–7) with the words often spelt in his idiosyncratic, phonetic way. We find 'bloo ski', 'an Argos gote', 'rox,' 'euphorbia', 'youfourbia' and 'U.4.beer'. Sometimes the colour notes were more detailed, and he would number the parts of the picture to which the notes related: '1. all snow – very faint. 2 – snow, & purple pines on red earth & rock. 3. immensely dark violet (all but 1. & 2. very deep tone). 4. red. 5. red, purple. 6. & 7. green. 8. very dark gray green – shrub on grass. 9. plain green. 10. grayer. 11. – redder. 12. near gray. A. russet & red, – green brown shrubs'. Similarly, he would note the relative tones: 'x *very* dark. xx – darkest of all. 2. next in depth – & all above infinitely misty & pale'.

The use of numbers alone on some pictures refers to proportions. 'Add a space between A & B of an inch', or 'The mass of 88 is too large in the propor-

tion to the mass OO'. In the drawing *Between Khan Krea Vrysis, & Argos*, Lear has misjudged the height of the hills and not only drawn in a dotted line marked 'higher', but has also added both a thumb-nail sketch marked '(Totality)', and a second outline marked 'This set of lines is the real proportion'. In the drawing of Phyle the numbers appear to refer to relative distances.

Franklin Lushington speaks of Lear keeping a notebook by him as he drew, but none has survived. In his diary for 16 January, 1872, Lear speaks of 'numbering my note books – from 1831 to 1871 – & oddly enough – 71 in number'. On occasion, colour notes on the drawing itself would be long and descriptive, as in a drawing he did in Malta on 28 May, 1862. 'Just after sunset – all the water is grayer purple – vinous, ocrious, the lights of the wall & houses oker all, still reflected very far down, as are all the boats. The upper 2 churches remain reddest & most prominent, & the wall & the furthest Church at x; the sky behind being gray. At x sky is pink, & the clouds above delicate lilac gray. I think the whole should be without distinct light & shade, the end (at 8;) & the churches above brighter, – all

Between Khan Kria Vrysis and Argos. 26 March 1849. Sepia ink. 10¼in x 16¹⁵⁄₁₆in. Gennadius Library, Athens

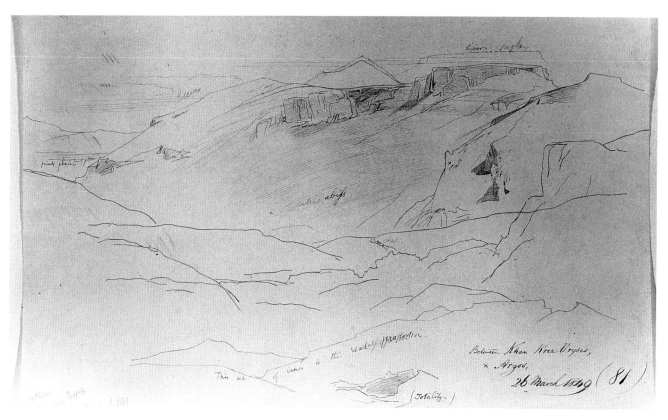

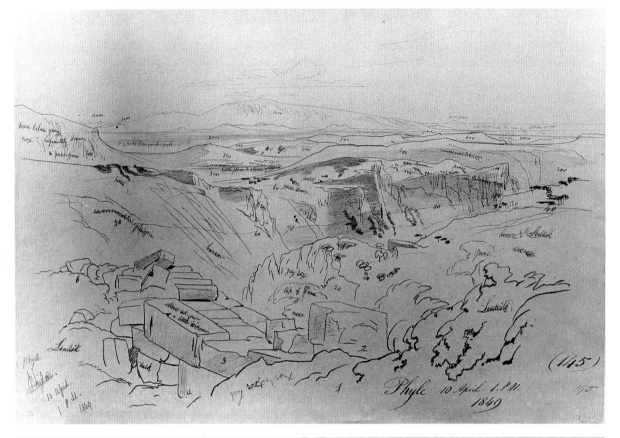

Phyle. 10 April 1849. Sepia ink. 13⁷⁄₈in x 20¹⁄₁₆in.
Gennadius Library, Athens

else pretty monochromatic / Half an hour or more
after sunset, it is more beautiful than ever, – so
choose that time i.e. 7.30 P.M. – May 28th. Then
the whole mass of building becomes one soft red
pearly gray, on a dark ground of sea, the shades of
daylight still remaining. Sky paler grayer.'

He did not always follow his own instructions
when laying in the watercolour washes, so that in a
drawing of Mount Ithome of 21 March 1849, 'green
meadows all in shade' is laid in in blue, hills marked
'deep shade – ochre' have a pale-blue wash, and the
foreground noted 'green' is laid in in pale red. Such
contrariness is not typical. Sometimes he employed
broad washes, which sweep across the drawing
showing little deference to the drawing beneath.

Occasionally Lear noted a resemblance to some
other place that he knew well: thus Baba in Tempe
recalled 'A sort of quiet Arundel old millpond'. Fre-
quently he is reminded of the scenery of English
counties which he knew well. Snatches from Tenny-
son's poetry also occur: at Rettimo in 1864 he wrote
on the sea, 'All hardly differing from the sky – a little
greener. Break, – break, break!'; and in the harvest
fields of Oropo in Greece he wrote, 'Oh, how hot!'
and then 'Mariana in the South' (in which 'the day
increased from heat to heat').

Sometimes it is sounds that he notes, these simply
for his own amusement: 'Nightingales!!!!!' and 'O!
ye crows of Malibar/What a cussed bore you are!'

On the basis of Lear's completed travel drawings,
clients placed commissions for more highly finished
watercolours, and for oils. His first-known studio
watercolour was done in 1837 (see p.43). In this he
uses only watercolour, a method he employed
rarely, even later in life when he had acquired great
skill in its use. In his painting of water and its reflec-
tions, pure, transparent watercolour was the only
effective way of attempting to recreate what he saw.
'Nothing, – short of a moving opera scene, – can
give any idea of the intense and wonderful colour
and detail of these Benares River Banks!!' he wrote
in 1873. 'And nothing is more impossible than to
represent them by the pencil.'

He does not appear to have returned to water-
colour as a medium for finished pictures until 1844.
Instead, during his early years in Rome he produced
highly finished studio drawings. Frequently done on

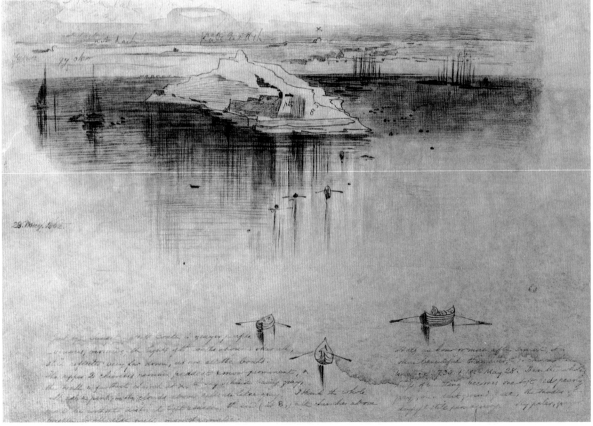

Valetta, Malta. 28 May 1862. Pencil, sepia ink,
watercolour. 7¹⁄₂in x 9⁵⁄₈in. Walker Art Gallery,
Liverpool

half-tone paper, in which he was following a convention established by J.D. Harding, these were drawn in soft pencil and often heightened with white. They were titled, signed and dated. A typical example is his drawing of Amalfi, (see p.45), which is inscribed 'AMALFI. E. LEAR. del 1838'. Sometimes he would sign his Christian name in full. His first sustained group of finished watercolours, dating from 1849 and the early 1850s (see p.61), were signed in a similar way, although by now he was more accustomed to writing his name in lower case. As well as the signature, these studio works are characterised by their degree of finish and their greater use of body colour.

In signing his oils Lear used his name, his initials or, from 1858, the monogram ℒ which he was to use in all his subsequent studio work, apart from some of his Tyrants (see p.81) which are unsigned. Any painting signed with this monogram was either completed or sold after July, 1858. Thus the Bassae (see pp.63–4), completed in 1854, remained unsold until 1859, when he signed it with a monogram. Many of Lear's oils are unsigned.

Some of his oils and studio watercolours are inscribed, either on the frame or on the picture itself, with two dates. The earlier of these is the date of the original drawing, the later is that of the finished picture (see p.61).

Lear has left us very little information about the way in which he worked on his oil paintings. He seems to have used commercially prepared canvases for many of his smaller works; larger canvases were prepared for him by Foord and Dickenson, picture dealers in Wardour Street. No full-size cartoon for any of Lear's paintings has survived; the half-finished painting of Enoch Arden which was in his studio when he died, and which would have told us much about his methods, has not been seen since his studio was cleared after his death. All we know is that it was squared up, and the initial drawing laid in in charcoal.

His correspondence with Lord Derby about his painting of Athens (see pp.60–61) describes the use of a chiaroscuro sketch and also of a tracing. We know that in his ornithological work, he rubbed over the back of the finished pencil drawing which he had done directly from the bird, and traced the outline through onto a clean sheet of paper as the basis for the final drawing (see pp.36–7). Similarly, with his Nonsense he made tracings either directly from an earlier drawing or by means of a transparent sheet. Since he was accustomed to repeating, in other media, methods which he had previously found successful, it is possible that he prepared full-

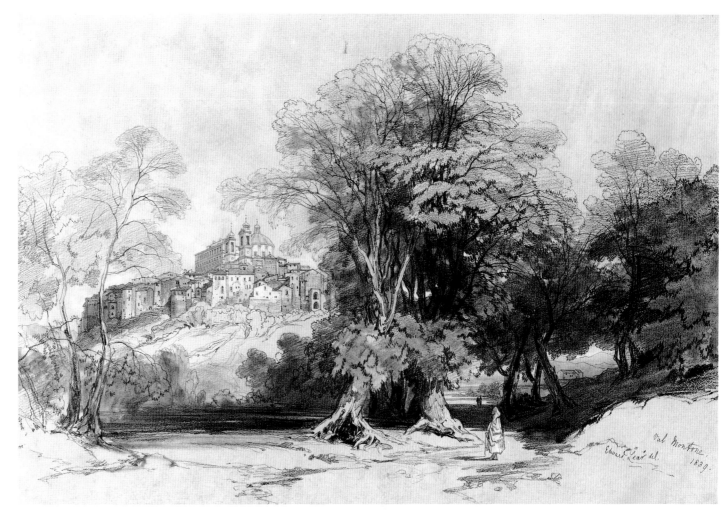

sized tracings from which to lay in the preliminary drawing on the canvas. Such tracings would be unlikely to have survived the very thorough clearing of his studio which followed his death, even if Lear had himself preserved them. A small, early study for the Athens painting has been squared up (see p.60), as has the preliminary drawing for his painting of Nuneham (pp.74–5).

Having established the broad outline of the drawing, he appears to have laid in half-tone washes over what were to be the darker areas of the painting. His palette changed during the 1850s under Holman Hunt's influence. During their time together at Clive Vale Farm, Hunt wrote down notes on his use of colour in what Lear called 'Ye Booke of Hunt'. This too has disappeared, but the evidence of Hunt's advice on colour remains in Lear's work as he moved from a palette dominated by brown and umber towards brighter, more vibrant colours, some of which seem exaggerated and unappealing to modern taste. 'Worked . . . off & on – at Corfu Citadel, Ventimiglia, Lerici, Megaspelion, Palermo: – blue

Val Montone. 1839. Pencil with white bodycolour. 12⅛in x 17⅞in. British Museum

pink & yellow – a la Holman Hunt', he wrote in 1871, and earlier, in 1861, 'did "pink" touches all over the Damascus by fits'.

He would work slowly over the detailed foreground, and in 1872 he wrote, 'if I work with a feeling of hurry I spoil all'. With the sky, however, he attempted to work in one session, for 'to stop in the middle of the sky is to spoil all'. Many of his highly finished oil paintings have a sense of minute, even relentless completion as the eye is drawn without relief across the picture surface. In this they differ from his watercolours, where areas of emptiness rest the eye. Patrick Trevor-Roper has suggested that Lear's paintings are 'typical of myope, with the details and clarity of a miniature'. Lear believed such detail to be a virtue. '. . . his work seemed so unfinished', he wrote in 1882 of another's painting, '"his instructor . . . does not like finish", – which is [as] if one said "so & so teaches French without

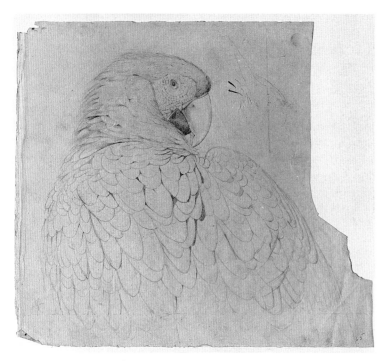

Macrocercus aracanga, Red and Yellow Macaw. 1830. Pencil. 13in x 14⅝in. Houghton Library, Harvard University

verbs or pronouns: – he does not like verbs or pronouns".'

In his Roman oils, when his mentor was Penry Williams, he appears to have worked in his studio from earlier sketches. During the 1850s and 1860s however, he adopted the Pre-Raphaelite method of painting even his very large oils out of doors, direct from nature. Because of the problems this presented (see pp.62–63), he compromised by bringing grass or oak boughs into his studio and working from them there. Later he abandoned it altogether, working from the original drawing and from detailed studies of particular plants or figures that he wished to include. His servant Giorgio would sometimes act as model, wearing peasant costumes which Lear had bought while travelling; in a late painting of the Garden of Gethsemane, he employed an elderly Franciscan from a friary in San Remo as his model.

Although he would concentrate for some days on one painting, he was in the habit of working on a number of pictures at the same time. For example, in the last week of August and the beginning of September, 1859 his timetable was this:

August 25th and 26th; the Roman Campagna;
27th, 29th, 30th and 31st; Petra Theatre;
September 1st and 2nd; small Corfu;
3rd; Athos;
5th; small Corfu;
6th; sky of a large Corfu, and Petra Theatre;
7th and 8th; Petra Theatre.

28 August and 4 September were Sundays, and except when he was travelling he did not paint on that day of the week.

All his life Lear worked very hard. '. . . until his health broke down in old age at San Remo, I do not think he ever wittingly or willingly wasted an hour', wrote Franklin Lushington. '. . . *totally unbroken* application to poetical=topographical painting & drawing is my universal panacea for the ills of life', wrote Lear in 1872.

His working day began early so that he could have the maximum benefit of the light. 'I *never* could work, if I did not do so at once & directly after breakfast', he wrote in 1860. For this reason, although he was by nature 'sociable but not gregarious', he disliked protracted dinner parties and late nights. His ideal routine, which he adopted when he could give unbroken time to his work, was the one which he followed during a stay at St Leonards in the autumn of 1859. 'This is what I do here', he told Fortescue at the end of July, 'rise at 5/2., & after 6 or so, am at work till 8. Bkft – Then work till 5 – occasionally obliged to leave off on account of sight, or from utter weariness – when I do a line or two of Sophocles, or compose some new song music, – & at 5 dinner – to 5 3/4. at most. Thence to 7/2 paint again, & by the time the brushes are washed, it is nearly dark, & I potter out to the post with some notes I may have written, or puddle along the shingly beach till 9/2 – Then, half an hour Sophocles, – & bed.'

Even in his old age, he continued to work with absorbed commitment. 'I *cannot* be idle, even if I could get my living by idleness', he wrote to Church in 1881. It was a pattern of hard work which did not agree with the popular idea of how an artist should live. 'Few seem to realise the constant necessity of work in Artist life', he wrote to Hunt in 1864. 'Even good Miss Carr said to me – "I suppose you have quite passed your life out of doors this lovely summer, Mr. Lear – always delighting in your pleasant profession!"' . . .'How few can realise the labour – simply the manual labour, of an Artist's life – let or be the work of brain, & the vexatious failures of infinitely repeated experiments', he wrote in his diary in 1873.

If he kept a studio book recording the sale of his paintings, none has survived. He made several lists of the oil paintings he had done, from the earliest in 1840, together with the names of the people who had bought or commissioned them, and at least two of these were printed and sent round to his friends. One was subsequently published in 1907 in the *Letters of Edward Lear.* They are incomplete, and a number of pictures are wrongly dated, which suggests that the lists were made up later.

It was not until he designed his own house in San Remo that Lear had a purpose-built studio in which to work. Until then he chose generally the largest and always the best-lit room in his rented lodgings. He could not work with a top light, 'nor can I within four walls, and no outer view'. In Rome he had just two second-floor rooms: a bedroom and a studio. The studio was lofty, but its only window opened onto a covered balcony which must have reduced the light. We do not know which room he used in Stratford Place during his years in London in the 1850s and 1860s, but it would probably have been the large, east-facing, first-floor drawing-room which had windows reaching to the floor with small cast-iron balconies. He found London light 'narrowed & contracted & small', especially in the winter with its '*long* gray cold mornings'.

In his first studio in Corfu, which overlooked the harbour with mountains beyond, the sun came into the room early in the morning making it difficult to work. Within a few weeks he exchanged this for a larger third-floor apartment which had a showroom, which he used also as a dining-room, and a large studio. These rooms, however, were damaged in an earthquake, and he moved to new first-floor rooms where he had both an east-facing studio and a smaller south-facing room which he set aside for drawing. In Villa Emily, and in Villa Tennyson which was built on an identical plan, the studio measured 32ft by 25ft. The main window faced south, but there were large windows looking both east and west, and although once again there was no north light, he was able to control the light at all hours of the day. A room immediately below, and of the same dimensions, was used as a gallery.

A constant problem, particularly in Mediterranean countries, was the reflection of bright sunlight. In Corfu, the sails of the ships in the harbour bounced light into his studio, and after the building of the hotel in San Remo he suffered glare from its white-painted walls.

In rented rooms an unexpected hazard was the decoration of the walls. In one place there was paper decorated with flights of highly coloured birds which he had to hide beneath lengths of white holland; in another, the studio of a portrait painter, he was surrounded by faces, with unfortunate consequences, for 'The Rev. Jabesh Bunting &

Lady Mulgrave sit upon the walls of Masada, Sir Frederick Williams & Mr Spurgeon peer among the branches of my Cedars – Mr & Mrs Cunard of New York abound in the ruins of Philae, & the Bishop of Gloucester is dominant in Interlaken'.

For furniture, we know that in Corfu he had 'A large double table for water colour drawing – & a large one for oils – 12 chairs [in preparation for his Open Days], easels, & frames etc.' Later, he arranged for a carpenter to build five strong wooden cabinets of drawers in which he stored his travel watercolours; two of these still house his watercolours at Harvard.

From the time Lear left England in the summer of 1837 until his last travels in India in 1873–4, he rarely spent more than a few months in one place. The purpose of his travel was two-fold: discovery, 'simply the love of seeing new places', and the collection of landscape drawings from which he could later work in his studio. This collection of drawings justified the expense of his extensive journeys, but more than most artists he delighted in travel for its own sake. The slow wandering through new lands offered him a physical and spiritual freedom which was essential to his well-being.

Since boyhood, the beauty of the countryside had evoked in Lear a strange sense of melancholy. 'What a mingling of sadness & admiration of landscape botheringly will persist in existing', he wrote in 1870. 'A keen sense of every kind of beauty, is . . . if given in the extreme – always more or less a sorrow to its owner, – tho' productive of good to others.'

His ideal landscape was as much one of the mind as of the eye. Speaking of a joyous interlude staying with the Tennysons at Farringford, he wrote to Emily: 'According to the morbid nature of the animal, I even complain sometimes that such rare flashes of light as such visits are to me, make the path darker after they are over: – a bright blue & green landscape with purple hills, & winding rivers, & unexplored forests, and airy downs, & trees & birds, & all sorts of calm repose – exchanged for a dull dark plain horizonless, pathless, & covered with cloud above, while beneath are brambles and weariness.' Lear saw in the spacious beauty of tranquil countryside something of paradise lost; it is no coincidence that his Nonsense characters find a land of lost innocence in the Great Gromboolian Plain and the Hills of the Chankly Bore.

Essential though it was for him to visit Jerusalem or Baalbec, it was not in cities or ancient sites but in the exploration of untouched countryside – the 'whispering woods of bright green pine' in Euboea, or the wild Acroceraunian mountains in Albania –

that he found the greatest happiness. He responded most readily to scenes of calm, classic beauty, and many of his finest drawings and paintings are of wide plains reaching back to delicately delineated hills. 'Doubtless there is something about SPACE by which the mind (leastways *my* mind,) can work & expand', he wrote.

But although this was the scenery in which he felt most at peace, some of his most dramatic and powerful drawings are of wilder, harsher landscape. In Calabria and Albania, in the central mountains of the Abruzzi and among the steep crags of Mount Athos, he found desolate scenes of 'poetic and sullen grandeur', 'beautifully majestic'. He responded with excitement to the 'Stern, awful scenes of Cánalo!' with their 'fearful crags and fragments!' and the deep 'ravine, where torrents falling over perpendicular rocks echoed and foamed around'. This is the sublime scenery of the Romantics. But despite its splendour, such landscape threatened to oppress him. He disliked enclosed valleys, and found 'something constrained and mournful in the never-get-out-again feeling' of gloomy mountain passes. He needed at least the glimpse of a distant view so that

he might feel 'the sensation of freedom of breathing'.

Painting was one side of his topographic exploration; writing was the other. 'By degrees I want to topographize & typographize all the journeyings of my life', he wrote in 1868. He published detailed accounts of several of his journeys; many more remained in manuscript, all but one of which are now lost. The title *Illustrated Excursions*, describing his time in the Abruzzi, became more precisely the *Journals of a Landscape Painter* in his Calabrian and Albanian books, for he wished 'to confine these journals strictly to the consideration of landscape'. In fact the descriptions go far beyond, telling the story also of his strange experiences, but the change of title is significant.

Charles Church, who travelled with him in Greece, tells us that Lear 'made copious journals of his daily work, which he preferred to publish as they were written, in illustration of the drawings they accompany, as "the best method, when read in combination with the illustration annexed, of

Mount Parnassus. 1860. Oil on canvas. 9¼in x 14¾in. The late Philip Hofer.

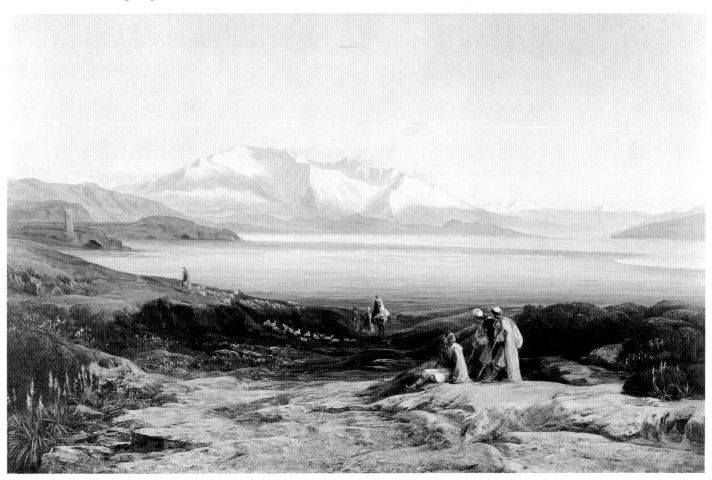

giving a clear idea of the scenes." . . . it was his aim to give as much as possible a topographical reality to the scenery he drew, the combination of journal and drawing form part of his plans as "Topographical Artist".' Together, words and pictures would create a single topographical image, complementing each other as do the verses and drawings of his limericks.

Lear prepared for his journeys with great care.

These were the days before guidebooks, and in devising his route, particularly in the remoter parts of Italy or Albania, he would often make no more than a broad plan, relying on the services of a local guide. Of his travels in Calabria he wrote, 'A man must be guided pretty much by hazard in arranging a tour through a country so little visited as this: the general rule of keeping near the mountains is perhaps the best, and if you hear of a town, or a costume, or

piece of antiquity anywise remarkable, to make dash at it as inclination may devise.' Such travel offered the possibility of sudden rewards: the 'unexpected effects of beauty constitute one of the chief charms of such methodless rambles as ours', he wrote, '. . . the beautiful incidents of pastoral or mountain life, all the romance of a wandering artist's existence, is carefully banished from your high-road tourist's journey.'

He gave careful thought to what equipment he should take, and his advice, published in the Introduction to his *Journals of a Landscape Painter in Albania, &c.* was used in early editions of John Murray's *Handbook for Travellers in Greece.* 'Previously to starting, a certain supply of cooking utensils, tin plates, knives and forks, a basin &c. must absolutely be purchased, the stronger and plainer the better; for you go into lands where pots and pans are unknown, and all culinary processes are to be performed in strange localities, innocent of artificial means. A light mattress, some sheets and blankets, and a good supply of capotes and plaids should not be neglected; two or three books; some rice, curry powder, and cayenne; a world of drawing materials — if you be a hard sketcher; as little dress as possible, though you must have two sets of outer clothing — one for visiting consuls, pashás, and dignitaries, the other for rough, everyday work;

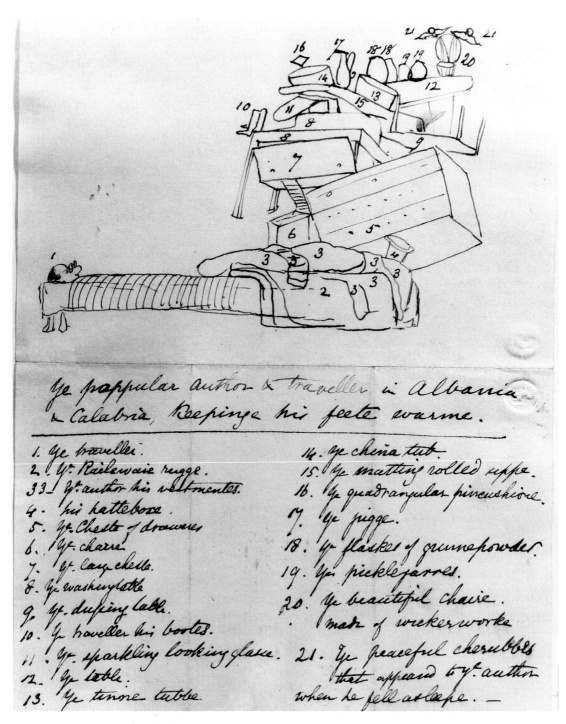

Ye poppular author & traveller in Albania & Calabria, keepinge his feete warme. n.d. Sepia ink. 9in x 7¼in. Pierpont Morgan Library, New York

1. Ye traveller.
2. Ye. Railewaie rugge.
3. Ye. author his vestmentes.
4. his hatteboxe.
5. Ye. Cheste of drawers.
6. Ye. chaire.
7. Ye. large cheste.
8. Ye washingtable.
9. Ye. dressing table.
10. Ye traveller his bootes.
11. Ye. sparkling looking glasse.
12. Ye table.
13. Ye tinne tubbe.
14. Ye china tub.
15. Ye matting rolled uppe.
16. Ye quadrangular pincushione.
17. ye jugge.
18. Ye flaskes of gunnepowder.
19. Ye picklejarres.
20. Ye beautiful chaire. made of wickerworke.
21. Ye peaceful cherubbes that appeared to ye. author when he fell asleepe. —

some quinine made into pills (rather leave all behind than this); a Boyourldí, or general order of introduction to governors or pashás; and your Teskeré, or provincial passport for yourself and guide . . . a long strap with a pair of ordinary stirrups, to throw over the Turkish saddles, may be recommended to save you the cramp caused by the awkward shovel-stirrups of the country. Arms and ammunition, fine raiment, presents for natives, are all nonsense; simplicity should be your aim. When all these things, so generically termed "Roba" by Italians, are in order, stow them into two Brobdignagian saddle-bags, united by a cord . . . and by these hanging on each side of the baggage-horse's saddle, no trouble will ever be given from seceding bits of luggage escaping at unexpected intervals.' He later preferred to carry his artist's materials in an enormous bag which Giorgio called his Coliseum because of 'its extreme antiquity and venerable look', a bag which also somewhat hazardously held his lunch. Hubert Congreve, who accompanied Lear on sketching expeditions towards the end of Lear's life, recalled him 'plodding slowly along, old George following behind, laden with lunch and drawing materials.'

On most of his early journeys he travelled with a companion, someone sturdy enough to survive a relentless timetable in often harsh and primitive conditions. Later in life he travelled on his own or with his servant Giorgio, finding that 'it is better to be alone than in company with a grumbler, or a caviller about farthings, or one who is upset by little difficulties, or – what is worse, perhaps, than all – one who regards all things with total apathy'. Speaking of his two journeys down the Nile, he said, 'In each voyage it has been a rule with me that hard and constant study and work should be the condition of my going abroad at all; and since with myself quiet and study must needs go hand in hand, both of my Nile voyages were made alone. It is sometimes only by such isolation that a painter or poet can work out his own thoughts in his own way, and although a lonely life of travel is not without its drawback, yet the incessant occupation required to work up the portions of a topographic life is in general no bad remedy for the absence of social sympathy.'

In his early Italian travels he went on foot, but in the Abruzzi he travelled on horseback, as he did in Greece and Albania where large distances had to be covered. In the desert he rode on a camel, a method of transport he found most disagreeable. Later in life, in Corsica and India, he used wheeled transport – a carriage in parts of Corsica, and in India almost anything from a train, which on occasion stopped so that he might sketch, to a dhoolie, a jampan, a tonga or a bullock cart. Here he also rode on an elephant, but only as part of a ceremonial procession.

Eight to ten hours of travel was generally the most he could do in any day if he were to allow time to stop and make drawings. Having so little time, he developed the habit of working swiftly and with concentration. Charles Church recalled that on their visit to Thermopylae in 1848 'in great heat and with much fatigue – [Lear] was at work all the time, from 3 o'clock in the morning, only resting during the midheat . . . with infinite patience and unflagging good humour and coolness'.

He could expect to do no more than five large drawings in a day, rarely spending more than an hour on any one and generally far less time than that: '. . . the way one can only devote 10 minutes to subjects requiring 4 or 5 hours' study is too absurd', he wrote in Albania in 1848. 'It is very difficult, on such days of travel as this, to secure anything like a finished drawing. Even let the landscape be ever so tempting, the uncertainty of meeting with any place of repose or shelter obliges the most enthusiastic artist to pass hastily through scenes equal or superior to any it may be again his lot to see . . . Dragoman Giorgio, greatly desirous of reaching Elbassán ere nightfall, strongly besought me not to linger. Nevertheless . . . I could not resist sitting down to draw when I gazed on the extraordinary scene I had passed . . . to appease Giorgio I made but a slight outline of that which I should gladly have employed a day to pourtray.' These swiftly drawn outlines he called 'memoranda sketches'.

The decision about where to stop must be made rapidly; uncertainty simply wasted valuable time, as in Albania, 'a place so wonderfully crowded with

Frascati. V.Taverna. L declares that he considers his horse far from tame. 1842. Pencil and sepia ink. 5⅜in x 7½in. British Museum

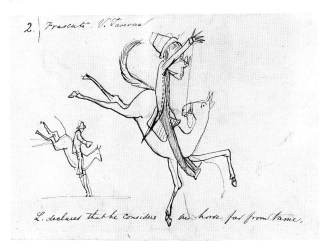

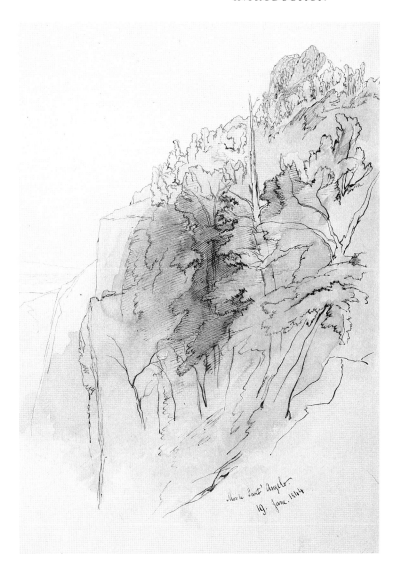

Monte Sant' Angelo. 19 June 1844. Pencil, sepia ink, watercolour. 20⁵/₁₆in x 14⅛in. Houghton Library, Harvard University

beautiful bits of landscape, that knowing how few can be portrayed, even with the utmost energy, an artist is angry with himself for not being able to decide where to settle at once, that no time may be lost'. On the other hand, he might spend half an hour on a view, and then come upon something much finer a short distance further on when he no longer had any time.

Deciding whether or not to stop was especially difficult at the start of a long day's ride. Travelling in Corsica he found 'the landscape looking westward from above the village [Cauro], though very beautiful, is of such magnitude and so full of detail as to be quite out of the pale of an hour or two's sketching. When the day is but just commenced, and the

amount of what may be available for work is as yet unknown, it is not prudent to sit down to make a drawing, the time given to which may be proved later in the day to have been ill bestowed, in comparison with what should have been given to scenes which the painter is then reluctantly compelled to pass by in haste.'

On most journeys he would allow himself several days in what promised to be particularly interesting places, although even this could be too short. 'To make any real use of the most exquisite landscape abounding throughout this marvellous spot, an artist should stay here for a month', he wrote of the dramatic Meteora in central Greece (see p.57). For such longer visits he devised a routine: 'When a landscape painter halts for two or three days in one of the large towns of these regions, never perhaps to be revisited by him', he wrote in Calabria in 1847, 'the first morning at least is generally consumed in exploring it: four or five hours is very well spent, if they lead to the knowledge of the general forms of the surrounding scenes, and to the securing fixed choice of subject and quiet study to the artist during the rest of his stay.'

He was generally up before it was light. In countries where the midday heat was overpowering and the bright sunlight flattened the countryside, robbing it of colour and shadows, he enjoyed working in the softer, more interesting early light with its 'beautiful broad morning effect', even though in the Himalayas, for example, these early hours were so cold that it was difficult to hold a pencil. He had no difficulty in rising early, for it was a time of day he loved. 'How exquisite was the sweet morning light and air', he wrote in Calabria. 'As the sun rose, the perfect calm of broad blue shades, and olive-coloured lawns, – streaked with fine gold, and dotted with silver lines of sheep, – brought back to me the early morning hours of Olevano and other places.'

After a light breakfast, and with his possessions packed into leather saddle-bags, he and his guide would set out. As well as the stops for drawing, there would be a halt for a midday meal. As the day progressed, they would often have to hurry on so as to arrive at their night's lodgings before dark. Having reached their stopping place, the guide would prepare a meal while Lear sorted his day's work and wrote his journal.

The quality of his accommodation varied enormously. Sometimes he would stay with the local bey, but such visits, though fascinating, offered hospitality which was more lavish than he wished. 'My dormitory was a real Turkish chamber', he wrote in Króia in Albania, 'and the raised cushions on three

sides of it – the high, square, carved wooden ceiling – the partition screen of lofty woodwork, with long striped Brusa napkins thrown over it – the guns, horse-gear, etc., which covered the walls – the fireplace – closets – innumerable pigeon-holes – green, orange, and blue stained-glass windows – all appeared so much the more in the light of luxuries and splendours when found in so remote a place as Króia. It was not easy to shake off the attentions of ten full-dressed Albanian servants, who stood in much expectation, till, finding I was about to take off my shoes, they made a rush at me . . . I was obliged to tell Giorgio to explain that we Franks were not used to assistance every moment of our lives and that I should think it obliging of them if they would leave me in peace.' Lengthy dinners might fill the evening, when he was tired and anxious to go to bed so that he could start early the next morning. In the morning he might be expected to join in sociable breakfasts, where he would sit lamenting the 'loss of shade and all landscape effect, which, beside all the rural-passing incidents, cease after 8 or 9 A.M.!'

The alternative in many countries was often primitive. In Italy he would generally find an inn for the night, but there were not such refinements everywhere he went. 'Horrors I had made up my mind to bear in Albania,' he wrote, and horrors he soon found. 'Midnight, – O khans of Albania! Alas! the night is not yet worn through! I lie, barricaded by boxes and bundles from the vicinity of the stable and enduring with patience the fierce attacks of numberless fleas. All the khan sleeps, save two cats, which indulge in festive bouncings, and save a sleepless donkey, which rolls too contiguously to my head. The wood-fire, blazing up, throws red gleams on discoloured arches within whose far gloom the eye catches the form of sleeping Albanian groups. Bulky spiders, allured by the warmth, fall thick and frequent from the raftered ceiling.' Such arrivals were no more than minor inconveniences. More alarming were the human companions, like the whirling dervish who occupied the next room. Sometimes, though, his fellow sleepers stirred his appreciation of the picturesque.

'The raised part of [the khan] was already occupied by five very unclean-looking Albanians, but one side of the fire was at liberty and soon swept and arranged for me; and Giorgio ere long prepared tea on the little squat stool-table, after which sleep quickly followed; not however, before I had leisure to meditate on the fact that I was now actually in the very wildest phase of Albanian life.

'Those five creatures, blowing the fire, are a scene for a tale of the days of past centuries. When they

had sipped their coffee they roll themselves up in capotes, and stretching out their feet to the embers, lie motionless till an hour before daybreak. The large khan is now silent (for even the vile little fussy chickens cease to scrabble about in the dead of night), and only the champing of the horses in the farther part of this great stable-chamber is heard; the flickering light falls on these outstretched sleepers, and makes a series of wonderful pictures never to be forgotten, though I fear, also, never to be well imitated by the pencil. That I do not speak the language, and that I had not previously studied figure-drawing, are my two great regrets in Albania.'

In the Acroceraunian hills in remote western Albania he settled down after a night of Khimariot hospitality . . . 'About ten or eleven, all but the family gradually withdrew; the old gentleman . . . and the rest of the Albanians rolled themselves up in capotes and slept, Anastásio placed himself across my feet, with his pistols by his side; and as for me, with my head on my knapsack I managed to get an hour or two of early sleep, though the army of fleas, which assailed me as a new-comer, not to speak of the excursion cats, who played at bo-peep behind my head, made the rest of the night a time of real suffering, the more so that the great fire nearly roasted me, and was odious to the eyes, as a wood fire must needs be. Such are the penalties paid for the picturesque. But one does not come to Acroceraunia for food, sleep, or cleanliness.'

'Is it necessary, says the reader, so to suffer? And when you had a Sultan's bouyourldí could you not have commanded Beys' houses? True; but had I done so, numberless arrangements become part of that mode of life, which, desirous as I was of sketching as much as possible, would have rendered the whole motive of my journey of no avail. If you lodge with Beys or Pashas, you must eat with them at hours incompatible with artistic pursuits, and you must lose much time in ceremony. Were you so magnificent as to claim a home in the name of the Sultan, they must needs prevent your stirring without a suitable retinue ...thus, travelling in Albania has, to a landscape painter, two alternatives; luxury and inconvenience on the one hand, liberty, hard living, and filth on the other; and of these two I chose the latter, as the most professionally useful, though not the most agreeable.'

An additional problem could be the unpredictable response of local inhabitants. Sometimes these attentions were charming, as when the villagers brought him 'bunches of narcissus and cowslips and endeavour to converse'. At others, however, he was treated less kindly, especially in Muslim countries

where the drawing of images was considered to be profane. 'No sooner had I settled to draw – forgetful of Bekír the guard – than forth came the populace of Elbassán; one by one, and two by two, to a mighty host they grew, and there were soon from eighty to a hundred spectators collected, with earnest curiosity in every look; and when I had sketched such of the principal buildings as they could recognise a universal shout of "*Shaitán!*" [the Devil!] burst from the crowd; and, strange to relate, the greater part of the mob put their fingers into their mouths and whistled furiously, after the manner of butcher-boys in England. Whether this was a sort of spell against my magic I do not know; but the absurdity of sitting still on a rampart to make a drawing, while a great crowd of people whistled at me with all their might, struck me so forcibly, that ... I could not resist going off into convulsions of laughter, an impulse the Gheghes seemed to sympathise with, as one and all shrieked with delight, and the ramparts resounded with hilarious merriment. Alas! this was of no long duration, for one of those tiresome Dervíshes – in whom, with their green turbans, Elbassán is rich – soon came up, and yelled, "*Schaitán scroo! – Shaitán!*" [The Devil draws! – the devil.] in my ears with all his force; seizing my book also, with an awful frown, shutting it, and pointing to the sky, as intimating that heaven would not allow such impiety. It was in vain after this to attempt more; the "*Shaitán!*" cry was raised in one wild chorus – and I took the consequences of having laid by my fez for comfort's sake – in the shape of a horrible shower of stones which pursued me to the covered streets, where, finding Bekír with his whip, I went to work again more successfully about the walls of the old city.'

He never forgot that he was a visitor in their country and must observe their conventions; '... however a wandering artist may fret at the impossibility of comfortably exercising his vocation,' he wrote, 'he ought not to complain of the effects of a curiosity which is but natural, or even of some irritation at the open display of arts which, to their untutored apprehension, must seem at the very least diabolical'. He was less philosophical about the treatment he received at Petra (see pp.70–71), where he was fortunate to escape unharmed.

Travelling as he did during the years of European revolution, he was sometimes thought to be a spy. 'Why are you drawing our mountains? ... what is the meaning of it?? ... do you go about mapping all our country?' they wanted to know, while others asked, '"If I had an order from the Sultan to write down this town?" so constantly, and not very un-

naturally, is the idea of political espionage ever associated with the act of topographical drawing.'

A problem which any traveller must face, but which for a landscape painter presented particular difficulties, was the weather. Rain was the most trying, especially mountain tempests which 'continued hour after hour; thunderstorms bursting at intervals, with thick cloud driving down the ravine, or effacing the dark earth and acqueduct into so many dissolving views'. In Albania, rain ran down his fez into his glasses, which were 'soon dimmed and little does one see of all above, below and around'. And after the rain came the mist, hiding the countryside he had come to draw. Only occasionally, as in Corsica, did Lear exploit atmospheric affects for their beauty (see p.89); generally such mist simply obscured the countryside.

High winds could be 'so violent that when enough stones were piled on the paper to keep it down, the folio was too heavy to lift, – so G[iorgio] had to hold it hard with both hands while I drew, or tried to draw'. Cold and falling snow were a problem in Greece and Albania as much as in the Himalayas.

Lear, however, was not easily discouraged; he knew that discomfort was the unavoidable price to be paid for travelling through wild and little-known scenery. '... the wayfarer soon forgets the inconvenience of travel while recording with pen or pencil its excitements and interests', he wrote as the 'sublime scenery obliterated from the memory all annoyances of travel'.

When Lear arrived back from his travels, he would sort his drawings and then arrange to show them to friends and chance callers on Open Days at his studio. This way of exhibiting his work dated back to his first visit to Rome, from where he had written to Ann, 'every Wed. you may think of me as being very busy with explorers'. Later in life, and especially after a journey which had produced a quantity of new work, he would open his studio two or three times a week, from 11 or 12 o'clock until 5pm.

On his return to Rome in 1859, he wrote that at noon 'rings at the door bell come – & ... from 20 to 30 people rush up the stairs. Giorgio lets them into my show-room, where a fire is lit, & there are chairs set before my folio stand, – & he comes & says with a grave grin "the Arabs are come!"' Lear would then go to join his guests. On occasion there were as many as fifty in his studio at a time. He would talk to the assembled gathering, describing his adventures as he showed them the drawings from his most recent travels. The performance would take about an hour and a half, 'after which, they all thank me & shake hands, & go; & I go back to work'.

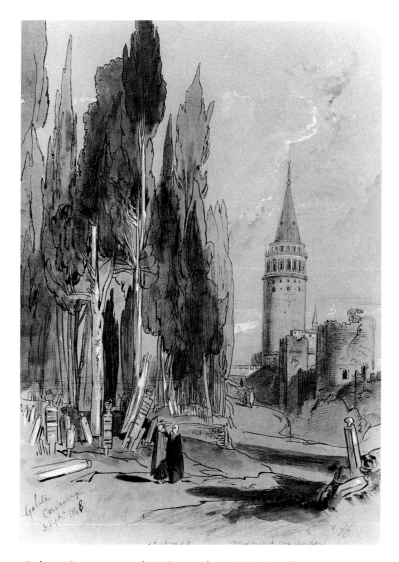

Galata, Constantinople. 3 September 1848. Pencil, sepia ink, watercolour. 11¼in x 8in. Private collection

It was a necessary and generally enjoyable task, although on occasion it could be provoking. 'You may suppose it is not unpleasant to communicate knowledge, where it is appreciated, but I am sometimes annoyed at inattention or gossip,' he wrote to Charles Church from Rome in 1859. 'Very funny things are said now and then. One man gravely interrupted me to assure me I had never passed through Petra, because Dr. Keith said Ezekiel's prophecy "No man shall pass through Eden for ever" is literally fulfilled, to which I only said, shortly "I did pass through Petra, Sir, therefore either Dr. Keith, or Ezekiel, or both, were wrong," on which the unhappy man's mouth remained open with horror for many minutes. A lady (I don't know one-tenth of those who come) stood before Lady W.'s picture and said "Ah, the *New* Jerusalem!",

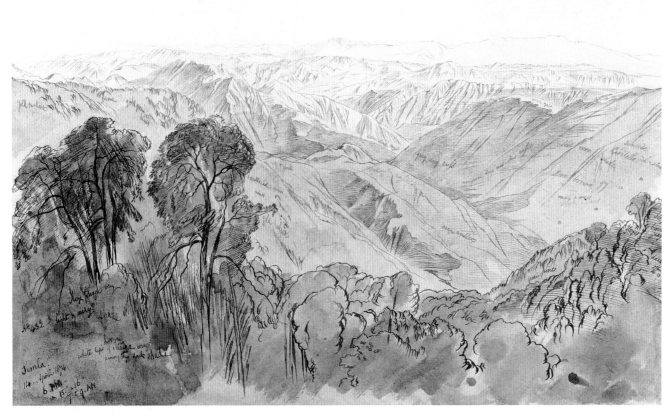

Simla. 14, 15 and 16 April 1874. Pencil, sepia ink, watercolour. 14⁷⁄₈in x 21¹⁵⁄₁₆in. Houghton Library, Harvard University

Advertisement for Studio Open Days. c1858. 7³⁄₁₆in x 4⁹⁄₁₆in. Houghton Library, Harvard University

DRAWINGS OF PALESTINE. SYRIA.

EGYPT. GREECE. SICILY. ITALY. &c.

BY

MR. LEAR.

TO BE SEEN AT HIS STUDIO,

15, STRATFORD PLACE, (W.)

FROM 11 TO 5,

ON

TUESDAYS,

WEDNESDAYS,

AND

THURSDAYS.

and, turning to me, "Symbolical, Mr. Lear? *Bunyan*? Ah! doubtless – Bunyan!" A third, having been in the room two hours, said "Pray, Sir, did you do any of these drawings or paintings?"' Such luminaries did not always escape the wickedness of Lear's replies, as with the man who came to visit his new showroom at Villa Emily in San Remo, 'a maggriffient gallery, with 99 water color drawings – not to speak of 5 larger oils . . . (In one is a big beech tree, at which all intelligent huming beans say – "Beech!" – when they see it. For all that one forlorn ijiot said – "Is that a *Palm* = tree Sir" – "No," replied I quietly, "it is a Peruvian Brocoli".)'

Sometimes, however, these Open Days took a great deal of his time and produced nothing. 'No one wanted anything', he wrote in his diary in 1866, 'except they were this or that – more finished – more coloured – the windmills bigger &c &c &c'. Many, particularly those who passed the winter in Mediterranean watering places such as Nice and Cannes, regarded his Open Days as a pleasant social

event, an agreeable way of passing an otherwise idle morning.

'Some good scenes might be drawn out of Studio life', he wrote to Holman Hunt from Nice in 1864, 'as for instance

(4 ladies – having staid 2 hours – rise to go.)

1st Lady What a treat my dear Mr. Lear! but how wrong it is of you to stay so much in doors! You should take more care of your health – work is all very well but if your health fails you know you will not be able to work at all, & what could you do then! Now pray go out, & only see your friends before 12 or 1. in the morning.

2d Lady. But how dreadful these interruptions must be! I cannot think how you ever do anything! – *Why* do you allow people to break in on you so! It quite shocks me to think we have taken up so much time.

3d Lady. Yes, indeed: these are the best hours of the day. You should never see any one after 2 o'clock.

4th Lady. You should walk early, & then you could see your friends all the rest of the

day. Interruptions must be so dreadful! (Enter 4 more ladies. The first 4 rush to them.)

All 8 Ladies. – How charming! how fortunate! dear Mary! Dear Jane! dear Emily! dear Sophia! &c.

5th Lady How wrong of you dear Mr. Lear to be in doors this fine day!

6th Lady How you *can ever* work I *cannot* think! You really should not admit visitors at all hours!

7th Lady But do let us only sit & look at these beautiful sketches!

8th Lady. O how charming! & we will not go to Lady O's.

The other O then we also will all sit down
4 Ladies. again – it is *so* delightful.

Chorus of
8 Ladies. What a charming life an artists is! –
Artist. ------D--------n!'

However, as he grew older and more irascible, Lear regarded with increasing irritation those 'beastly aristocratic idiots who come here, & think

they are doing me a service by taking up my time! One day one of them condescendingly said "you may sit down – we do not wish you to stand"'. '"What books did you copy all these drawings from?"' asked one visitor. '"O don't look at the drawings – only come and see the view from the window!"' exclaimed another.

Some asked if they might come and watch him work, a suggestion which appalled him. '... because I cannot have some 3 or 4 hundred visitors lounging in my rooms – I am dubbed a mystery & a savage', he wrote during a winter which he spent in Malta in 1865–6, 'tho' the very same people can understand that they could not go to a Lawyer's or Physician's rooms to take up his hours gratis ... No creature has as yet asked for even a 5£ drawing, though 28 amateurs have volunteered to shew me their sketches.'

'I am resolved to never again lay myself open to the Belgrave Brighton rabble of "visitors" – who, having nothing to do themselves, choose to believe that idleness is the condition of all other people', he wrote in 1871. In fact, he continued to open his studio one day a week, for he could not afford to lose the possible sales which might result, but by now he had devised a way of controlling who visited him. 'On this day he sometimes sent his servant out and opened the door himself', recalled Lady Strachey after a visit to San Remo in 1884. 'If he did not like the appearance of a visitor, with a long face and woe in his voice he would explain that he never showed his pictures now, being much too ill. He would then shut the door, and his cheerfulness would return.'

He would take his drawings with him when he went back to England in the summer, and was often invited to show them as an after-dinner diversion when visiting the houses of his friends. This was not always a success. 'Upstairs, after fuss, arranged drawings', he recalled after such a visit in 1856, 'but the whole thing was a failure, & but for the attention of R. P. and Lady L. I don't think I should have carried it through. Tittering & laughing & bore. – And Sir R. talking Cicero, & D[avid]. Roberts – but no lifelike care for Palestine itself, though they asked to see views of it ... At 11 I came away – I confess – very angry.'

After he settled in San Remo, Lear relied increasingly on the exhibition of his work at the galleries of Foord and Dickenson in Wardour Street. He had earlier shown his pictures in the galleries of Thomas McClean at 26, Haymarket, the firm which had published his early Italian travel books and the first two editions of *A Book of Nonsense*. Foord's had for

many years been making his canvases and frames, and arranging for the transportation of his pictures to and from his wintering places abroad, and they now began to exhibit his work on a regular basis. Lear would arrange for advertisements to be placed in *The Times*, the *Daily News* and the *Daily Telegraph*, and he had circulars printed. 'Regarding Wardour Street', he wrote to Fortescue in 1884, 'you, & all my friends ought to be made aware that my annual Circulars are as much, tho' of a different sort, – "advertisements" – as are the sending of pictures to the RA – the Grosvenor Gallery &c &c &c. But I, as you well know, was long ago unable, from climate &c, to bear the rub of competition in England, & thus am compelled to a wholly different mode of trying to live.'

'I have no other means of reminding people of my existence now that I no longer go to London', he told Lord Derby, 'nor can I afford a shining-splendid gallery in Bond St. or elsewhere.' All dealers were 'edjoggs', he grunted. In 1884 he approached Christie's with the suggestion that they might like to sell his work, an offer which they declined.

Lear had exhibited in mixed exhibitions from 1836, when his picture *Dead Birds* was hung in the Royal Society of British Artists. His first painting to be hung in the Academy, *Claude Lorraine's House, on the Tiber*, was exhibited in 1850. As with many artists, his response to the Academy was ambivalent. Its influence could not be ignored, and any artist seeking a reputation must exhibit there. Extensive reviews of the Summer Exhibition appeared in the leading national newspapers, and sales were good. Its monopoly of influence in the wider field of contemporary art, however, was something that Lear came increasingly to deplore. 'I see you are going to have a R. Academy Commission,' he wrote to Fortescue in 1863. 'It will do nothing at all I fear. I wish the whole thing were abolished – for as it now is it is disgraceful. 30 men self declared as the 30 greatest painters of England – yet having in their body – Witheringtons – Frosts – Coopers C. Landseers – & other unheard of nonentities, while Watts – Linnell – Hunt – Maddox Brown – Antony – & many more are condemned to official extinction'. Members were involved in the selection and hanging of works in other exhibitions, such as the Great International Exhibition of 1862 where two Academicians, Creswick and Redgrave, hung Lear's painting *The Cedars of Lebanon* so high that it could not easily be seen (see pp.76–7).

He sent in regularly to the Academy during the 1850s, but in 1863 he wrote to Fortescue, 'While 4 landscape painters such as Lee, Creswick, With-

erington & Redgrave substantially shut out those they don't like from all Academic exhibition I never intend to send work to their shop – so that loophole is closed.' It was not until 1870, after he had decided to settle abroad, that he began to send in again.

Indeed, his decision to live in San Remo was a plan which 'may ultimately succeed, if I can only work hard enough to send to every kind of exhibition in England ... The R.A. hung 2 of my pictures very well this year', he told Holman Hunt, 'the small one extremely so – & it was sold the first week. And now I am going to make 3 Watercolor drawings to try (as you did – tho' I have not the same chance of success,) to get into the Old W[ater]. Color. I'm sure 8 or 10 of my various subjects would attract more

Edward Lear's sister. 1832. Pencil, white chalk. 12½in x 8½in. D.R. Michell, Esq

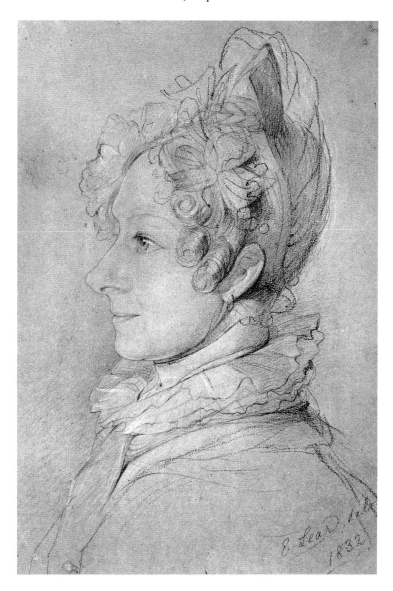

than everlasting Hampstead Heaths – but perhaps they won't think so.' Apparently they did not, for he failed to be elected to the Society. Since he had shown no interest in them before, this is perhaps not surprising.

It is strange that Lear had not earlier been attracted by either the Old or New Watercolour Societies. In 1863 he had written in his diary, 'sometimes I would gladly get even into an academic groove, or be a watercolour member – to save the vîva vôce contact with people I can't care about, & whose conversation destroys my capacity for any continuous work', but he had not done so. He exhibited watercolours in his own studio, and later at Foord & Dickenson whose exhibitions he regarded as an extension of his Open Days, but although his first exhibited picture, *Dead Birds*, was a watercolour, he did not again submit watercolours to any public exhibition until 1871, and then only once. His decision not to send his work to either of the two prestigious societies, of which many leading painters were members, is an indication that he regarded his watercolours either as working studies or as slight pictures for which he could find a ready market, rather than as significant works of art.

Except for a few years in the 1850s and early 1860s, it was in the end almost exclusively on private patronage that Lear depended. His early introduction to Lord Derby and his years at Knowsley gave him a circle of acquaintance which was to be invaluable. Of Lord Derby's generosity in sending Lear to Rome, the Canadian artist Daniel Fowler wrote, 'There are not many to whom such a happy opportunity would fall, and perhaps there are *some* to whom its taking such a shape would not be *quite* acceptable, but Lear was perfectly free from all such scruples. His career was founded on patronage, and under that he was content to enter upon it. It was, too, more or less patronage all his days, but he proved himself worthy of it, if any man ever did.'

In both Rome and Corfu he was well known in a small circle, something which could have unexpected disadvantages: '. . . just now I looked out of the window at the time the 2d were marching by – I having a full palate & brushes in my hand', he wrote in Corfu in 1862, 'whereat Col. Bruce saw me & saluted – & not liking to make a formillier nod in presence of the hole harmy, I put up my hand to salute, – & thereby transferred all my colours into my hair and whiskers – which I must now wash in turpentine or shave off.'

Lear was aware of his dependence on patronage, and in 1877 he wrote to Lord Aberdare, 'one of the most curious points in my Artist Career, is the stead-iness with which my friends have relied on my doing them good work, contrasted with the steadiness with which all besides my friends have utterly ignored my power of doing so. Said a foolish Artist to me – "you can hardly be ranked as a Painter – because all you have done, or nearly all, – is merely the result of personal consideration, & you are comparatively if not wholly unknown to the public." Says I to he, – "that don't at all alter the qualities of my pictures – whether they are done to the commissions of Ld N[orthbrook]. or Ld. A[bedare] – or Lord C[arlingford] – or Lady W[aldegrave] – or Sir F[rancis]. G[oldsmid]. – or F. Lushington, or R. Bright, or F.W. Gibbs – or any other friend, – or whether they are bought in a gallery by Mr. Timothy Timkins or the Duke of Popmuffin: – For the Public, says I, I have no sort of respect not none whatever – for providing pictures are cried up & well hung up – they are safe to be bought – be they by Whistler or anybody else. But the voice of Fashion whether it hissues hout of a Hart Cricket in a Paper, or hout of the mouth of a Duke or a Duchess – ain't by no means the voice of Truth. So you see o beloved growler – your ozbervations don't affect me a bit, who haven't got no ambition, nor any sort of Hiss Spree de Kor at all at all at all.'

He was increasingly aware of the power of fashion in dictating which artist's work would be bought and which ignored. 'Fashion my dear child is all in all', he wrote to Holman Hunt in 1885, and to Chichester Fortescue, '. . . how plainly is it visible that the wise public only give commissions for pictures through the Press that tell the sheep to leap where others leap'.

It was fashion too which decided the price which artists could command. 'I am thankful that I have never known what it is to envy anyone,' he wrote to Aberdare in 1884 about a group of his modestly priced paintings which remained unsold, 'but it cannot be otherwise than strange to me that with all my labour I find a difficulty in getting rid of such works, while Johnny Millais get 1,000, 2,000, or 3000£ for what costs him hardly any labour at all . . . Fashion explains all things odd, & besides Johnny M's works have great talent'. The connection between endeavour and worth, originally proposed by Sir Joshua Reynolds, was a common assumption in his day.

Although Lear's work never became fashionable, there had been a time during the 1850s when this had seemed possible. As hope of this faded, he came to rely increasingly on selling pictures to his friends, on occasion acting quite ruthlessly towards them. Any sign of interest might be followed up by a letter saying that the picture would be reserved for them while they decided whether or not to buy. If they pleaded hardship, he suggested that they might care to pay in instalments. He would remark that a particular wall in their house was a perfect position for one of his pictures. Often such unsubtle strategy worked and the picture was bought. The 15th Earl of Derby, grandson of Lear's original patron, summed up the effect of such approaches. '. . . in a world where nothing succeeds like success, he has done himself much harm by his perpetual neediness. An artist who is always asking his friends to buy a picture, & often to pay for it in advance, makes outsiders believe that he cannot know his business: which in Lear's case is certainly far from the truth. But he has been out at elbows all his life, & so will remain to the last.' Lear himself knew the folly of these approaches. In 1884 he told Fortescue, 'Being an ass I wrote some time since to the Duke of Westminster, – about my Argos, Gwalior, Ravenna, & Pentadatelo, & how I wished he would buy one. I agree that this is an asinine proceeding – yet it seems hard to work so constantly & conscientiously for several years on Classic topography & get nothing by it. "He never was overwise" – says ATennysons "Grandmother".'

Perhaps one reason why Lear was prepared to approach possible patrons in this way is that from 1830 he had been accustomed to selling works by subscription. The habit of asking a number of people to pay a small amount of money in advance in order to finance future work, remained with him. On occasions these were just loans, as in 1866 when he wrote from Cairo to eight friends asking if they would each advance him £100 so that he might go down the Nile to the second cataract. 'Verily I am an odd bird', he wrote then in his diary. Sometimes, however, they were more considered ideas, such as his plan to finance a two-year stay in Jerusalem (see p.73).

Two of Lear's large oil paintings, *The Temple of Apollo at Bassae* (p.63) and *Argos from the Citadel of Mycenae*, were bought by subscriptions raised among his friends, the Bassae being presented to the Fitzwilliam and the Argos to Trinity College, Cambridge. On both occasions there were those, including the 14th Earl of Derby and Arthur Penrhyn Stanley, who declined the opportunity to donate, an indication that some had grown weary of his repeated approaches.

There were other occasions too when such a plan misfired. In 1871 Victoria's daughter Princess Louise was married, and F. W. Gibbs, who had been tutor to the Prince of Wales, gave her as a wedding

present a painting by Lear of the Roman Campagna. The marriage of Tennyson's son Hallam in 1885 offered a splendid opportunity for another such present, and Lear let it be known that thirty admirers of the Poet Laureate could each subscribe ten guineas 'upon a three=pronged principle . . . 1st Gratitude to or admiration of the Poet. 2dly. Expression of goodwill to his son. & 3dly. Ditto of helpfulness to & sympathy with the aged dirty Landskippainter as performed the painting.' However, only two or three people sent in contributions. In order to encourage the flagging idea, Lear halved the price from 300 to 150 guineas, but still there were not enough subscribers. In the end he had to abandon the scheme, and he gave the painting to Hallam himself.

The Cedars of Lebanon was the first of his paintings for which he reduced the price, from 700 to 200 guineas. It was bought by Louisa, Lady Ashburton in 1867. He must have felt great satisfaction when in 1875 she paid £700, the highest price he ever received, for a large and very fine oil of Kinchinjunga, a picture which sold after her death in 1903 for twelve guineas. For a rather smaller painting of Kinchinjunga done for Lord Aberdare he had asked £400, paid in two equal instalments, one of which had helped to finance his travels in India. 'Do not, please, say to the generally vulgar & vicious world, the price I did the painting for,' he asked Aberdare, 'for that refers only to my own feeling towards yourself for having so constantly been so kind a friend. I should now charge 600 Gs. for a painting of that size − if done for any casual translucent or poberabious commission.'

Bringing down the price of pictures was something he did with increasing frequency in the last years of his life. In 1883 he devised a plan for the exhibition and sale of a series of large studio watercolours of Corsica. 'I have arranged the Drawings into 10 Lots of Five each, the subjects of such lots not to be changed, − since to do so would perhaps involve the best being selected & the least interesting left. Any 5 persons however can purchase one Lot & divide it among their 5 selves as they please.' He was advised against this idea, and those which did sell were bought individually. A year later the price of the remaining pictures was reduced by half.

For most of his life, Lear had little income beyond what he earned as a painter. Financial transactions were, as he said 'an nabbomination to this child', but they could not be ignored, and chronic shortage of money dictated the decisions he made in his career.

At the beginning, when he was selling pictures to chance buyers and then working with Prideaux

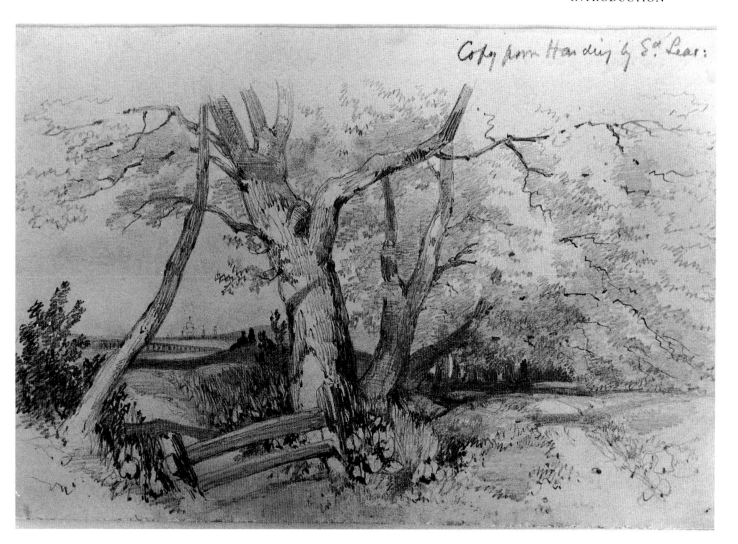

Trees drawn by Lear after J. D. Harding. n.d. Pencil. 6⅞in x 10³/₁₆in. Private collection

Selby (see p.33), he lived at home with his sister Ann who had a modest private income. This basic background of accommodation and board enabled him to take the bold step of publishing his work of *Parrots* on his own, and established a habit of precarious independence. He was not prepared to follow the accepted convention of copying the work of others, even though this would have given him a sound basic income. Nor did he illustrate the work of others, although there is mention in 1844 of his doing drawings for the seventh book of Virgil, and a few years later he played with the idea of illustrating the Grecian travels of William Martin Leake. In 1858 he turned down an offer to become Principal in the Art School in Corfu, a post which would have given him a regular salary, a free house and four months' annual holiday.

The expenses incurred in preparing the book of *Parrots* were met by subscribers, who paid 10s for each of the projected fourteen parts. Some, however, were slow to pay, and he was forced to abandon the work without finishing it. From the end of 1831 until he left for Rome in the summer of 1837, he was employed by others as a natural history draughtsman. His charges, for which he left a record, varied from £1 for the small drawings of parrots which he prepared for the *Naturalists' Library*, to £3 for drawings done at the Zoological Society in London for Lord Derby. As well as this, he was giving drawing lessons to private families in London, and to relatives of Lord Derby. Throughout this time he continued to live either with Ann in London, or at Lord Derby's home at Knowsley.

In July 1837 he left for Italy. We do not know what arrangements were made for funding his journey and setting up his studio in Rome, but we do know that Lord Derby and his cousin, Robert Hornby, made possible this move into a new career. In his early years in Rome, he earned his living by

teaching and by selling studio pencil drawings. From 1840, he came to rely increasingly on commissions for oil paintings. By this time he seems to have had very few students, and to be living only on his painting and drawing. In 1841 he published his first book of landscape illustrations. As with the *Parrots*, this was published by subscription and he paid the production costs himself. The income from *Views in Rome and its Environs*, as from all his subsequent publications, was used to buy Bank of England bonds or Government consols. These savings were a security for his old age, or for such time as his sight might fail and he could no longer paint. From the publications of 1846, the two volumes of *Illustrated Excursions in Italy* and the first edition of *A Book of Nonsense*, he was able to save £100, and from *Views in the Seven Ionian Islands*, published in 1863, he saved £300.

In the mid-1840s he painted his first large uncommissioned oil, a picture of Civitella di Subiaco (see p.49), which was bought in 1861 for 150 guineas. Most of the earlier Italian oils were small commis-

Wastwater. 1836 or 1837. Lithograph. 6¾in x 9¾in. British Museum

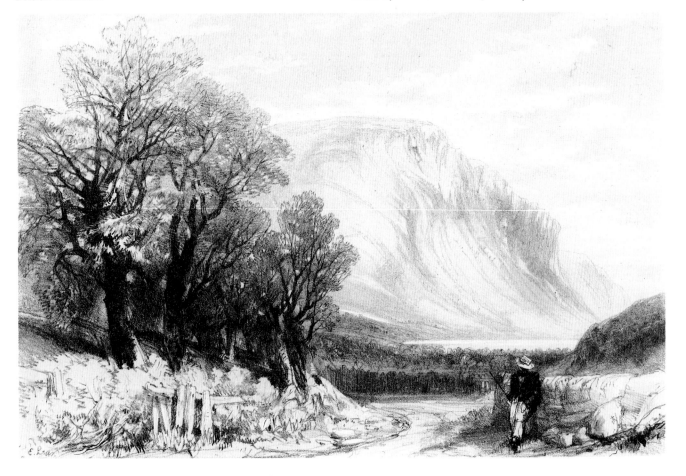

sioned paintings for which he seems to have been paid £20. In 1842 he told Ann that his income would be £100–120, explaining that he could only expect to earn until the end of May, after which the city of Rome emptied for the summer months. This pattern of working hard over a short period to produce studio works, and then setting off on his travels, was one he followed for many years after leaving Rome.

In 1847, he began on a fifteen-month tour of the Mediterranean. He speaks of receiving money from friends such as Chichester Fortescue, although whether these were loans or sums paid in advance for pictures is not known. Such travels, where the daily price of a guide who provided all his meals was £1. 5s, were extremely costly, and indeed it is in his travels that we find the cause of his lifelong financial insecurity.

On his return to England in 1849 he worked on a series of studio watercolour drawings, the first he had done since 1837. It is possible that at least some of these were given to the friends who had advanced money for his travels. Then, shortly after his return, he received a bequest of £500 from an old family friend, a Mrs Warner, money which enabled him to

go as a student to the Royal Academy Schools (see pp.58–9).

By the autumn of 1850 he was once again working on oil paintings, and it was with these that he expected to earn his living from now on. During the early 1850s, as well as commissioned pictures, he worked on a series of important uncommissioned works which he exhibited in large mixed exhibitions such as the British Institution and the Royal Academy. These sold quickly and well. For a painting of the Quarries of Syracuse, exhibited in the Royal Academy in 1853, he was paid £250. In the next few years his prices rose steadily, until the sale in 1857 of an oil of Corfu for which he received 500 guineas. He was earning well but was also spending generously, visiting Egypt and the Holy Land where travel was particularly expensive. During these journeys of several months, he earned no income. In 1855 he set up a winter home in Corfu and then, in 1858 and 1859, he wintered in Rome. Although he was away for months at a time, he needed to keep on a studio in London to which he would return to exhibit his work during the summer, so that in addition to the cost of his travels of exploration he had the expense of two sets of lodgings and an annual double journey to and from the Continent. Since people visited him in his studio on his Open Days, he had always to find rooms in the more expensive part of town. There was also the cost of shipping back and forth the large paintings on which he was working, or completed works which he hoped to sell, so that, for example, the painting of Bassae was shipped out and exhibited in Rome during his two winters there, and then brought back still unsold to London.

In 1860, he decided to spend the winter in England, concentrating on three large uncommissioned oil paintings. One of these, a 9ft long painting, *The Cedars of Lebanon*, was the most ambitious of his works so far. When it was completed he decided that he would price it at 700 guineas. Its too high price, its bad position in the Great International Exhibition of 1862, and its dismissal by the critic of *The Times* marked the turning point in Lear's career (see pp.76–7).

Friends, old and new, continued to buy and commission work, but from the early 1860s he made few sales to people he did not know. His diaries and letters at this time are filled with the problems of shortage of money. 'If I had a clear 4 or 500 a year I would produce some good work yet – : but, fighting against disquiet, drudgery, & conventionality, – I must needs do what I can, not what I will', he wrote to Fortescue in 1862, and a few months later, 'tho' I

have 400£ worth of commissions, yet people don't pay their money till the pictures are done usually – not always then. So I have been obliged to write for an advance on two paintings. I much wish I could get so far beforehand as to be out of the constant worry of "daily bread" wh. is a bore – but there is no remedy.'

He depended increasingly on the exhibition and sale of studio watercolours which he could price at £15, £10 or 'slight small 5 pound pot-boilers', and from the winter of 1862–3 on the sale of his mass-produced Tyrants (see pp.80–81). These works – and he could produce one hundred and twenty of them in three months – were priced at ten and twelve guineas. Of course, he could not expect to sell more than a part of those that he exhibited, but nevertheless from a single batch of Tyrants he might earn as much as he would have received from the sale of several small oil paintings, which in the 1860s he priced at between £30 and £100. It is not surprising that between 1862 and 1884 he produced nearly a thousand Tyrants.

His annual tax returns in England in the 1860s declared a profit from his painting of £250, although he would expect to earn as much again from his sales in whichever place he chose to winter. He continued to save the money which he earned from his publications, and also the small inheritance of £300 which he received on Ann's death in 1861, so that by the end of 1869 he had £3,000 invested.

At this point he made the decision to buy land and build himself a house. He chose San Remo because it was neither 'too much *in*, nor altogether *out of* the world', and with an annual summer visit to England, which was essential for sales and commissions, he could maintain contact with his friends and patrons.

With the building of Villa Emily, he no longer had the income from his £3,000, and an invitation from Lord Northbrook in 1872 to visit India was perfectly timed. Lear spent that summer in London, where he was given Indian commissions worth several thousand pounds. By March 1878 his savings had been restored, and he had £3,600 invested. 'I have a house, and a Ninkum of just 100£ a year', he told Fortescue in 1878. With the sale of drawings and the occasional painting commission, he was now able to lead an agreeable, if lonely, life; after so many years during which his only luxury had been the money he spent on travel, he could look forward to an old age free from financial worry.

But then, in the spring of 1879, he discovered that a large four-storey hotel was being built on the olive grove which separated his house from the sea. As the

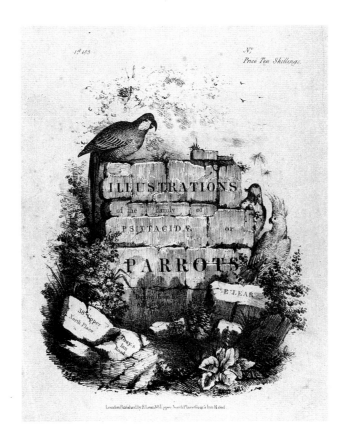

Folio wrapper for Part I of *Illustrations of The Family of Psittacidae, Or Parrots.* 1830. Lithograph. 22¼in x 15in. Private collection

building grew it not only blocked the open view which was so essential to him, but also destroyed his studio light, and it became impossible for him to work; '. . . it is a dreadful thing to be obliged to stop all one's poetical life=work', he wrote in despair. He struggled on for a while, but soon realised that the only solution was for him to sell Villa Emily and begin again in another house.

To cover the cost of rebuilding, some of his friends lent him money and others commissioned works. The most generous loan was from Lord Northbrook who advanced £2,000, enough to buy the land and begin the building. However, although he moved into his new house in November 1881, it was not until 1884 that he was able to sell Villa Emily. Meanwhile, anxious about the outstanding loan from Lord Northbrook, he arranged for fourteen boxes containing nearly a thousand of his travel watercolours to be sent to England in repayment of the debt. The rest of these watercolours were left in his will to Franklin Lushington. These two sets of watercolours began to come onto the market in 1929 (see p.28).

He proposed that his final oil painting, that of

Enoch Arden, would be sold after his death to pay his legatees whose bequests had disappeared with the building of Villa Tennyson, but the painting was never finished.

Lear's reputation as a painter is now established and continues to grow. Yet why has this taken so long? About the quality of his natural history work there has been no question. Compared in his own time to Audubon and responsible for much of the work attributed to John Gould, he has been described as the finest English ornithological draughtsman.

Yet, at the age of twenty-five, he turned his back on this success and became instead a landscape painter. In doing this, he chose to work within a convention which was no longer fashionable. By the mid-nineteenth century, public taste favoured paintings with medieval, exotic or narrative themes, or edifying works with a high moral tone. Even where his subject-matter coincided with fashionable taste, as it did in his interest in the Middle East, his

Title-page of *Views in Rome and its Environs.* 21in x 14½in. Private collection

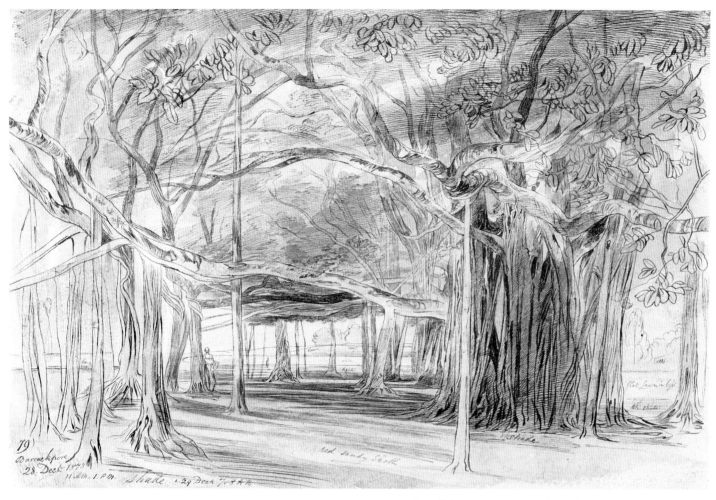

Barrackpore. 28 and 29 December 1873. Pencil, sepia ink, watercolour. 12in x 17¹⁵⁄₁₆in. Houghton Library, Harvard University

unwillingness to employ the material he gathered there in the creation of exotica denied him the popularity such interpretation would have offered. Few nineteenth-century English painters can have been conducted, as he was, round the inside of a harem, albeit without its customary inhabitants, yet he did not use what he had seen in order to paint colourful seraglio interiors as others, less privileged than he, were content to do. His most important painting of Lebanon was not of an evocative classical site or colourful market scene, but of its cedars. He knew what interested him, and he did not stray beyond his self-imposed limits. However, having turned his back on fashionable subject-matter, he suffered the consequences. Had his technical powers been greater, he might have risen above public taste or even modified it. As it was, his decision not to paint popular subjects contributed to his failure to establish a reputation in his own lifetime.

Until the late 1920s, when the travel watercolours began to come onto the market, the work by which Lear was publicly judged was that in which he was least successful. Those people who came to his studio had an opportunity to see the limpid, lively watercolours he had made on his travels, but for others it was by his oils, his studio drawings and watercolours, and his Tyrants that his reputation was assessed. The publication in 1889 of the volume of Tennyson illustrations, reproducing heavy, monochrome drawings made when his eyesight had deteriorated, did little to help.

Some mention must be made of the problems of Lear's eyesight. He was congenitally short-sighted. As a boy he wore no glasses, and his 'imperfect sight . . . formed everything into a horror'. By the time of the first-known image of him, a silhouette drawn in the early 1830s, he was wearing glasses, and he did so for the rest of his life. By 1861, when he was forty-nine, the strength of his glasses was -12; at that time the strongest available glasses for short sight were -14. This means that, without glasses, objects more than 3½ inches away would have

been out of focus. When drawing landscape he removed his glasses and used a monocular glass, or telescope. This would have brought distant landscape into sharp focus. Before beginning to draw, he replaced his glasses. His visual memory must have been well trained to retain precise images for far longer than is normal. Such short sight made him vulnerable to further eye problems as he grew older. After a fall in 1872 he gradually lost the sight in his right eye. That in his left eye continued to deteriorate, but he did not, as he had always feared, go completely blind.

As we have seen, he regarded himself as an oil painter rather than a watercolourist, and it was in this medium that he had, therefore, to establish his reputation. His oil painting falls into two distinct groups: the early, untutored Roman work which he did from 1840 until he left Italy in 1848; and the mature work which developed after his introduction to Holman Hunt in 1852. A handful of paintings, such as the Martinesque picture of Mount Tomohrit (p.58) which was begun in 1849 but not completed until 1871, and Athens (p.61) painted in 1852, mark a transitional period of a growing confidence which came from months of increasingly powerful drawing done during his travels around the Mediterranean. Paintings of the earlier, immature period are generally more sombre in colour and more conventional in composition than the later work. It was in order to move on from this, to give himself an opportunity to develop as yet unproven powers, that he made the decision to return to England at the end of 1849 and to commit himself, as he explained to Fortescue, to '*hard study* beginning at the root of the matter – the human figure – which to master alone would enable me to carry out the views & feelings of Landscape I know to exist within me. Alas! if real art is a *student*, I know no more than a child – an infant – a foetus: – how could I – I have had myself to thank for all education – & a vortex of society hath eaten my time. – So you see I must choose one or other – & with my many friends it will go hard at 36 to retire – please God I live – for 8 or 10 years – *but* if I did – *wouldn't* the "Lear's" sell in your grandchildren's time!'

What he needed was not only instruction in figure drawing – and incidentally also in perspective, for he never succeeded in mastering either – but more fundamentally, tuition in the technical aspects of handling oil paint. His courageous step in deciding to go to the Royal Academy Schools at the age of thirty-seven produced little result. He had placed himself in an institution which followed an academic tradition with which he had little sympathy, and the time

he spent there was passed entirely in working from the antique. He did not stay long enough to move into the painting school or to receive instruction in life drawing. Had he done so, and especially had this opportunity come when he was a young man, the increase in his powers could have been remarkable. To have produced the work he did, and yet to have been almost entirely self-taught, demonstrates the extent of his talent and poses the question of what he could have done if he had acquired not only the technical mastery for which he so longed, but also the assurance, the confidence in his own ability and the opportunity to transcend the anxiety of his inadequacies that such mastery would have given. The other side of his being self-taught, however, was an artistic independence which gave a special quality to his travel watercolours.

As it was, the persistent realisation of his shortcomings created an inhibition which too often prevented him from approaching his work with any degree of confident abandon. He could not afford to take risks. '. . . you have now entirely conquered (it seems to me,) all the technical difficulties of painting, & have to work on the highest qualities only', he wrote to Hunt in 1861. He himself never reached this point, and uncertainty about what he should be doing prevented the powers which he did possess from breaking through and taking charge. The criticism that his less successful paintings lacked poetry, that they did no more than hold up a mirror to nature, was justified to the extent that his anxious handling prevented him from daring to transcend the literal. On those occasions when he did, as for example in the oils of Bassae (see p.63), Beachy Head (p.79) or Kasr-es-Saad (p.94), he produced pictures which were both powerful and exciting.

His introduction to Holman Hunt, and the few weeks they spent together at Clive Vale Farm in the summer of 1853, were of great importance to Lear (see pp.62–3). They marked a move forward in his approach to oil painting, one which was already under way after his return to England but which now received a more powerful momentum. Although we may, on occasion, question the advantage which Lear gained from learning about Hunt's use of colour in a palette more suited to symbolic realism than to pure landscape, nevertheless the years immediately after their meeting saw a rapid development of his powers, and the first possibility of real success. But he and Hunt were together for too short a time for Lear to assimilate all that he needed to know, so that for some years afterwards he depended on Hunt's help in getting him out of the problems which developed as he worked. By the late

1850s he was learning to stand on his own, and to solve his problems without Hunt's help. He attempted always to improve, to progress as a painter, but the style which he developed in the 1850s and built on in the 1860s remained little changed for the rest of his life.

Just as his lack of confidence sometimes denied him the freedom to override the mechanical aspect of painting, so it dictated his reponse to studio work. 'No life is more *shocking* to me than the sitting motionless like a petrified gorilla as to my body & limbs hour after hour – my hand meanwhile, peck peck pecking at billions of damnable little dots and lines, while my mind is fretting and fuming through every moment of the weary days work', he told Fortescue in the summer of 1861. It is perhaps not surprising that some of his commissioned oils, especially those in which he was repeating a subject for the third or fourth time, lack bravado. From the early 1860s, he professed a lack of interest in practical aspects of painting which he now realised he would never master. '. . . technical study and manipulation will always be a bore to me', he wrote to Lady Waldegrave in 1862, having stated a newly articulated belief to which he would often return 'that

in converting memories into tangible facts – recollections & past time as it were into pictures, – lies the chief use & charm of a painter's life'.

The problem he confronted in working on some of his studio watercolours is rather different. There was no lack of technical competence, and many of these works are very fine. On the occasions where they fail it is either because they are soulless repetitions of earlier pictures, for some scenes were repeated many times, or because, in complying with the convention of 'finished' watercolours and the expectation of his purchasers, he overworked them. In addition, many of his later studio watercolours were conceived and created as pot-boilers. 'None of these are what they should be', he confessed to Holman Hunt in 1857 of a group he had just finished, 'yet for 10£ how can one try at perfection.' The destructive element of painting for no other purpose than to earn money can be readily seen in the Tyrants (see pp.80–1) and in the groups of pictures linked to a single theme, such as Corsica or the Nile, on which he worked in the last decade of his life.

Cannes. 8 April 1865. Pencil, sepia ink, watercolour. 13⅝in x 21¼in. Private collection

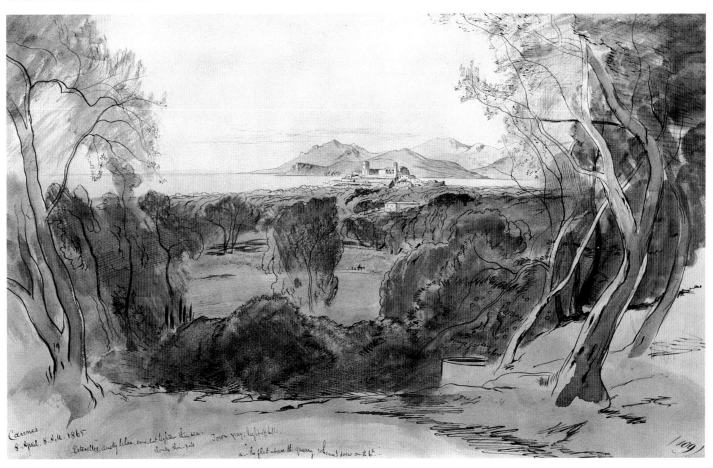

In his Tyrants, the most deadening effects came from boredom and the mechanical method of their execution; 'the constant change of subject, & inability – according to this system, – to work out any improvement or feeling, worries & drives me wild', he wrote in January 1865 when he was working on a group of 240 Tyrants. The contrast between these and the magnificent drawings which he had done on the Corniche only a month before (see p.86) – drawings which show him at the height of his powers as a draughtsman – points more clearly than anything else can do to the squandering, the destruction of talent which can result from chronic shortage of money and his response to it.

In looking at his travel watercolours, we turn to what is now considered to be the best of Lear's work. It is important to realise that he regarded these drawings as working tools, and that he never threw any of them away; they were done, often hastily and under difficult conditions, for his own reference. Some of them, sketchy and unresolved, represent no more than a few minutes' work, but although uncompleted they served to revive in his memory some feature of the landscape through which he had passed on his travels, and to which he would later return in his studio.

Many others show the joyful mastery which Lear achieved in the medium of flowing watercolour laid over splendidly controlled drawing. Powerfully drawn, delicate but decisive, they display all the bravura which is so often lacking in his oil paintings. In doing them he worked without self-consciousness, with no need to please or to conform to any pictorial convention, delighting in the beauty of the

landscape before him to which he responded with empathetic interplay and delight, setting down not only its physical characteristics but also, in a way which he could not achieve in his oils, its essence. The best of these works, demonstrating the virtue of his artistic independence, have a rare and very special quality of timelessness, and it is in this more than anything that Lear's contribution lies.

But it was not by these drawings that he was judged in his own time; '. . . there is no denying', wrote Sir Ian Malcolm in his book *The Pursuit of Leisure* published in 1929, 'that Lear's best watercolours are very good indeed, nor that if he had exercised a judicious selection of his exhibition pieces, instead of hanging good, bad and indifferent pictures together in Stratford Place and elsewhere, his value at the time would have been considerably enhanced. As it was, he was very seldom dissatisfied with his work . . . His enormous output of sketches must, one cannot help thinking, have cheapened him in the public eye; it may also have lessened the quality of his labour at the same time.' The suggestion of Lear's lack of self-criticism is certainly unfounded, for he knew his shortcomings only too well. Nor can he have been unaware of the effect that showing such inferior work would have on his reputation. The truth, perhaps, is that by the mid-1860s he had grown too disillusioned to care. As he entered his fifties, he was beginning to suffer from the weariness of constant struggle, a weariness in which the burden of his epilepsy played no small part. He had given the Victorian public what he believed to be his best work, and they had scorned it. His mass-produced watercolours, which he sold at only a few guineas each, gave him some degree of financial independence, and if the price he paid in terms of reputation was a heavy one, he would leave it to posterity to judge the quality of his better work.

Whatever misgivings he felt about his lack of technical skill, he had no doubt that his best work would, in time, find its proper level. It was in this belief that he justified the unwise demands he made upon his friends to buy his paintings.

Immediately after Lear's death, his reputation as a painter declined still further. The 1907 and 1911 publication of the correspondence between Lear and Chichester Fortescue was prompted more by his established reputation as a Nonsense writer than his standing as a painter. In the first decade of this century his large oil paintings were changing hands for a few pounds; at Christie's in 1909, two early oil paintings, *Olevano* and *Civitella de Subiaco*, each measuring $10\frac{1}{2}$in by $14\frac{1}{2}$in, were sold on behalf of Lord Derby. They fetched £1. 2s.

In 1912 there was the first posthumous exhibition of Lear's work. It was a low-key affair, brought together for the benefit of a girls' club in Lambeth and held at the home of Sir Richard Sutton at 112 Piccadilly. The pictures were lent from private collections owned by the families of Lear's friends, including Lushington, Fortescue, Northbrook, Aberdare and Holman Hunt. It comprised 106 pictures and several cases of letters and sketches. A small catalogue was printed. For most people – although the audience for such an exhibition cannot have been large – this was the first opportunity to see Lear's travel watercolours in all their freshness. The critic of the *Morning Post* believed the exhibition to reveal 'a talent of unusual distinction, particularly in the sketches made in the late Fifties and early Sixties. They express an emotional fervour based on instinctive structural knowledge rare in these days of Post-Impressionist unrest . . . this exhibition brings to the ken of the present generation an artist of real, if undeveloped, genius.'

However, it was not until February and March 1929, when the first of Lear's travel watercolours came onto the market, that there was opportunity for a comprehensive assessment of his landscape work. Later that year, Craddock and Barnard, who had purchased from Franklin Lushington's daughter the watercolours which Lear had bequeathed to her father, arranged an exhibition of fifty-two of these works at their galleries in Museum Street. Prices ranged from three to ten guineas, but although the exhibition was a critical success, sales were slow. In the same month, November 1929, many of the watercolours which Lear had given to Lord Northbrook were auctioned at Sotheby's.

It was at this time, when the market was glutted with work which few people seemed interested in buying, that two discerning American collectors,

Scutari. 4 October 1848. Pencil, sepia ink, watercolour. $7\frac{1}{8}$in x $20^{15}/_{16}$in. Houghton Library, Harvard University

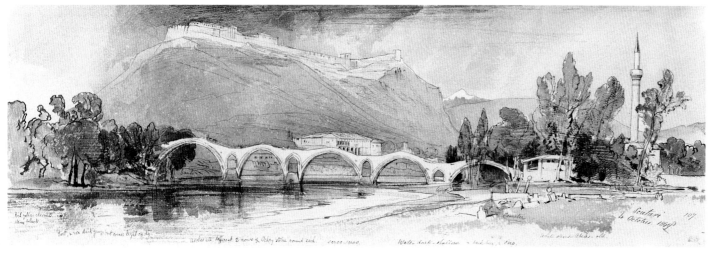

Philip Hofer and William B. Osgood Field, began to buy more than three thousand of Lear's water-colours, for many of which they paid no more than five shillings. In 1942 these two collections were deposited in the Houghton Library, Harvard University, where they form the basis of unrivalled Lear holdings.

At a second, larger exhibition in Museum Street, the starting price for individual watercolours was one guinea, rising to fifteen guineas for a particularly fine example, a view of S. Giorgio Maggiore in Venice at sunset, dated 20 November 1865. The beautiful watercolour of Finale (p.86) was priced at seven guineas; *The Cedars of Lebanon* (p.76) was purchased before the exhibition opened. For bargain-hunters, a folio album, bound in half russia with straps and buckles and containing forty-seven large views of Switzerland and more than fifty sketches of Corfu, Greece and Italy, was on offer for £20.

The appearance of so much hitherto unknown work prompted an article by Martin Hardie in the Summer 1930 edition of *Artwork*, the first considered appraisal of Lear's painting by an authority on nineteenth-century English landscape. In it he said: 'Lear, we think, is far greater as draughtsman and painter than has hitherto been admitted. This is to some extent because his work has remained largely in the homes of those who, in a past generation, were his personal friends . . . "It is on the Himalaya of nonsense that Edward Lear sits enthroned", [here he is quoting from a review in *The Times Literary Supplement*], but though he takes this high and undisputed place in what is a specifically English contribution to the world's literature, he has a secure one, higher than has been recognised, in water-colour, again a specifically national heritage in the world's art.' A review in *Country Life* said: 'In a small area, and with the simplest materials, he can draw the sublimest mass of mountains . . . and pack the scene with detail, but still keep it vast, full of air and mystery: but not the vague mystery of Turner. The mystery of things clearly seen, but too remote to be known . . . the mystery, surely, of the Land where the Bong Tree grows.' Such reviews would have delighted Lear, as would the statement in *The Times* that the drawings 'immediately remind us of Turner in his more expansive mood'.

But although his posthumous reputation was now beginning to be firmly laid, his fame as a Nonsense writer was in part responsible for its slow development, as indeed it may have been in his own lifetime. On the corner of a letter written to him by

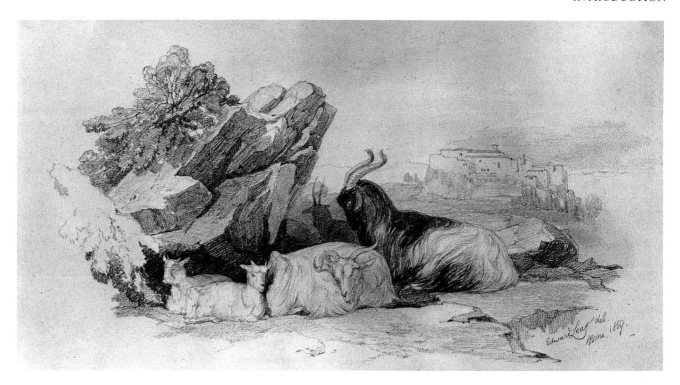

Goats on the Roman Campagna. 1839. Pencil. 8½in x 14¼in. Private collection

Lear in 1883, Ruskin has scribbled, 'Is this the nonsense man?' The Introduction to the catalogue of the second exhibition of Lear's watercolours at Craddock and Barnard speaks of 'Edward Lear, "the landscape painter" as he was wont to call himself', and it goes on to say that as 'the author of the *Book of Nonsense, Nonsense Songs and Stories*, etc., Lear is deservedly famous, but his landscape sketches, to which he attached far greater importance, are little known'. In 1957, he is still described in one art gallery list as 'Edward Lear, the nonsense writer'.

1939 saw the publication of Angus Davidson's biography of Lear, a book which gives consideration to his contribution as a painter, and in the 1940s and 1950s there were further small exhibitions of his work. The value of his oil paintings had risen – no difficult task from the nadir of £1. 5s – but they were still very underpriced. When, in October 1954, the Earl of Derby disposed of the rest of his collection of Lear oils, he received fifteen guineas for the powerful 6ft painting of the Acropolis (see pp.60–1), thirty guineas for a 7ft painting of Windsor Castle (present whereabouts unknown), forty guineas for a 4ft 6in painting of Parga (now in a private collection in Greece), and forty-five guineas each for two 4ft paintings of Albania (now in a private collection in Britain) and Corfu (present whereabouts unknown).

In 1958, an exhibition reflecting all aspects of Lear's work was mounted by the Arts Council, but his reputation remained largely that of the Nonsense writer. 1968 saw the publication of the first study of Lear as a landscape painter, written by Philip Hofer and based largely on his collection in the Houghton Library. This, and the publication of a new biography, prompted exhibitions of his work at the Worcester Art Gallery in Massachusetts, and at Gooden and Fox in London. In the years immediately after this, he began to benefit from the general reassessment of Victorian paintings, but the most important event in establishing his permanent reputation was the 1985 major exhibition of his work at the Royal Academy of Arts in London and the National Academy of Design in New York. The overwhelming public response to this was one of delight and surprise. Few had realised either the breadth or the value of his achievement. Some who knew his landscape were unaware of the brilliance of his ornithological work. His music, which does not concern us here, was known to even fewer, although many of his settings of Tennyson's poems have now been recorded by Robert Tear. Since then, and particularly on the centenary of his death in 1988, there has been a steady flow of books, articles and exhibitions, and at the time of writing a good Lear oil can fetch a quarter of a million pounds.

Bibliography

(Place of publication is London unless otherwise stated)

Lear, Edward,
 Illustrations of the Family of Psittacidae, Or Parrots
 pub. Edward Lear, 1832. Facsimile reprint,
 Johnson Reprint Co. Ltd, 1978
 Views in Rome and its Environs, Thomas
 McLean, 1841
 *Gleanings From The Menagerie And Aviary At
 Knowsley Hall*, ed. John Edward Gray, Knowsley,
 privately printed, 1846
 Illustrated Excursions in Italy, Thomas McLean,
 1846. Italian translation, *Viaggio Attraverso
 L'Abruzzo Pittoresco*, a curo de Ilio de Iorio,
 Sulmona, 1987
 Journals of a Landscape Painter in Albania, &c.,
 Richard Bentley, 1852. Reprinted as *Edward Lear
 in Greece: Journals of a Landscape Painter in
 Greece and Albania*, William Kimber, 1965. Also
 reprinted as *Journals of a Landscape Painter in
 Greece & Albania*, Century, 1988
 *Journals of a Landscape Painter in Southern Calabria,
 &c.*, Richard Bentley, 1852. Reprinted as *Edward
 Lear in Southern Calabria and the Kingdom of
 Naples*, William Kimber, 1964
 Views in the Seven Ionian Islands, pub. Edward
 Lear, 1863. Facsimile reprint, Hugh Broadbent,
 Oldham, 1979
 Journal of a Landscape Painter in Corsica, Robert
 Bush, 1870. Reprinted as *Edward Lear in Corsica:
 The Journal of a Landscape Painter*, William
 Kimber, 1966
 Poems of Alfred, Lord Tennyson, illustrated by
 Edward Lear, Boussod, Valadon and Co., 1889
 'A Leaf from the Journals of a Landscape Painter
 (Journey to Petra, with an introduction by
 F[ranklin]. L[ushington].)', *Macmillans Magazine*
 LXXV, April 1897, pp. 410-30
Campbell, Thomasina M.A.E., *Notes on the Island of
 Corsica in 1868. Dedicated to those in search of
 Health and Enjoyment*, Hatchard & Co., 1868
 (frontispiece by Lear)
Davidson, Angus, *Edward Lear: Landscape Painter and
 Nonsense Poet (1812–1888)*, John Murray, 1938;
 second edn 1968
Dehejia, Vidya, *Impossible Picturesqueness; Edward
 Lear's Indian Watercolours, 1873–1875*, Columbia
 University Press, New York, 1989
Durrell, Lawrence, *Lear's Corfu: An Anthology drawn
 from the Painter's Letters*, Corfu Travel, Corfu, 1965
Fowler, Rowena, *Edward Lear: the Cretan Journal*,
 Denise Harvey & Company, Athens & Dedham, 1984

Hofer, Philip,
 Edward Lear, Oxford University Press, New York,
 1962
 Edward Lear as a Landscape Draughtsman, Belknap
 Press, Cambridge, Mass., 1967; Oxford University
 Press, 1968
Hunt, William Holman, *Pre-Raphaelitism and the Pre-
 Raphaelite Brotherhood*, Macmillan, 1905
Hyman, Susan, *Edward Lear's Birds*, Weidenfeld and
 Nicolson, 1980; 2nd edn Trefoil Publications, 1989.
 William Morrow & Co. Inc, New York, 1980
 *Edward Lear in the Levant; Travels in Albania,
 Greece and Turkey in Europe, 1848–1849*, John
 Murray, 1988
Jackson, C.E., *Bird Illustrators; Some Artists in Early
 Lithography*, H.F. & G. Witherby Ltd, 1975
Lehmann, John, *John Lear and his World*, Thames and
 Hudson, 1977
Malcolm, Sir Ian, *The Pursuit of Leisure, & other
 essays*, Ernest Benn, 1929
Murphy, Ray, *Edward Lear's Indian Journal:
 Watercolours and extracts from the diary of Edward
 Lear (1873–5)*, Jarrolds, 1953
Noakes, Vivien,
 Edward Lear: the Life of a Wanderer, Collins, 1968;
 Houghton Mifflin, Boston, 1969; revised edn
 Fontana, 1979; revised edn, BBC Publications, 1985
 *Edward Lear, 1812–1888; the catalogue of the Royal
 Academy exhibition*, The Royal Academy of Arts
 and Weidenfeld and Nicolson, 1985; Harold
 Abrams, New York, 1986 (containing a detailed
 bibliography of all aspects of Lear's work)
 Selected Letters of Edward Lear, Oxford
 University Press, 1988. Italian translation, *Edward
 Lear: Paesaggi mediterranei, Lettere, 1833–1858*,
 a cura di Griziella Cappello, Rosellina Archinto,
 Milano, 1990
Pitman, Ruth, *Edward Lear's Tennyson*, Carcanet, 1988
Reade, Brian, *Edward Lear's Parrots*, Duckworth, 1949
Sherrard, Philip. *Edward Lear; The Corfu Years; A
 chronicle presented through his letters and journals*,
 Denise Harvey & Company, Athens and Dedham,
 1988 (containing an excellent appendix: 'Lear as
 Landscape Painter')
Slade, Bertha C., *Edward Lear on My Shelves* (for
 William B. Osgood Field), privately printed, New
 York, 1933
Smith, Frances K., *Daniel Fowler of Amherst Island,
 1810–1894*, Agnes Etherington Art Centre, Kingston,
 Ontario, 1979

Strachey, Lady,
 *Letters of Edward Lear, Author of 'The Book of
 Nonsense' to Chichester Fortescue, Lord
 Carlingford and Frances, Countess Waldegrave
 and others*, T. Fisher Unwin, 1907
 *Later Letters of Edward Lear, Author of 'The Book
 of Nonsense' to Chichester Fortescue (Lord
 Carlingford) and Frances, Countess Waldegrave
 and others*, T. Fisher Unwin, 1911
Thorpe, Adrian, *The Birds of Edward Lear*, Ariel
 Press, 1975
Tsigakou, Fani-Maria,
 *The Rediscovery of Greece; Travellers and Painters
 of the Romantic Era*, Thames and Hudson, 1981
 'Edward Lear in Greece', M.Phil. Thesis, University
 College, London, 1977

Barnes, Janet, 'Lear's Unknown Birds', *Country Life*,
 7 July 1988
Bruce, M.R., 'A Portfolio of Monasteries: Edward
 Lear's Sketches of Mount Athos', *Country Life*,
 8 October 1964
Bury, A.,
 'Lear at Parnassus', *Connoisseur*, September 1962
 'The Other Side of Edward Lear', *Antique Collector*,
 August 1963
Butler, J.T., 'Edward Lear, painter, poet and
 draughtsman (the American way with art)',
 Connoisseur, August 1968
Causley, A., 'Landscapes to paint a poet's vision',
 Illustrated London News, 11 February 1967
Clark, A., 'There was a Young Man named Lear',
 Aramco World Magazine, July-August 1986
Fiorentino, E., 'Edward Lear in Malta', Proceedings of
 History Week 1984, *The Historical Society*, 1986
Hardie, M., 'Edward Lear', *Artwork*, no. 22, Summer
 1930
Hill, R., '"The Travels of Edward Lear" at The Fine Art
 Society', *Country Life*, 3 November 1983
Hofer, P., 'Edward Lear, one of the ablest topographical
 draughtsmen of his day', *Connoisseur*, January 1967
Kastner, J., 'The runcible life and works of the
 remarkable Edward Lear', *Smithsonian*, Washington,
 September 1981
'Lear's Indian View', *The Connoisseur's Diary*,
 Connoisseur, April 1962
Lambourne, M.,
 'Birds of a Feather. Edward Lear and Elizabeth
 Gould', *Country Life*, June 1964
 'Edward Lear and John Gould', *The Antique*

Exhibitions

Collector, December 1984

Magazine of Art, p. xxiv, March 1888

Murray, A., 'Corfu by Edward Lear', Rhode Island
Bulletin xliii, no. 2, December 1956

Neve, C.,
'There was a Young Person of . . . Edward Lear's
Parrots', Country Life, April 1972
'The Loneliness of Edward Lear', Country Life,
17 October 1978

Noakes, V.,
'No Nonsense Natural History of Edward Lear', New
Scientist, 25 April 1985
'The Sense and Nonsense of Edward Lear', Natural
History, New York, December 1985
'Laughter out of pain', The Times, 6 June 1988

Reade, B., 'The Birds of Edward Lear', Signature,
no. 4, 1947

Pictures by Lear Exhibited at the Royal Academy, the British Institution and the Royal Society of British Artists

1836	RBA	Dead Birds (760) (watercolour)
1850	RA	Claude Lorraine's House, on the Tiber (30)
1851	RA	Street Scene in Lekhredha, a town in Northern Albania (170)
		The castle of Harytena, in Arcadia (679)
1852	BI	The Akropolis of Athens, sunrise; Peasants assembling on the road to Piraeus (238)
	RA	Mount Parnassus, Lake Cephissus, and the plains of Boetia, Northern Greece (569)
1853	BI	The Mountains of Thermopylae (428)
	RA	Prato-lungo, near Rome (475)
		The city of Syracuse, from the ancient quarries where the Athenians were imprisoned, BC 413 (1062)
1854	BI	Marathon (105)
		Sparta (561)
1855	BI	Windsor Castle from St Leonard's Hill (317)
	RA	The Temple of Bassæ or Phigaleia, in Arcadia: from the oakwoods of Mount Cotylium. The hills of Sparta, Athome and Navarino in the distance (319)
	RBA	A Calabrian Ravine, Pentedatylo (214)
		A Devonshire Glen, Lydford (216)
1856	RA	The island of Philæ, above the first cataract on the Nile, from the south, afternoon (625)
		The Island of Philæ, above the first cataract on the Nile – from the Noch Mount (993)
1861	BI	The Fortress of Masada, on the Dead Sea (349)

1863	BI	The Monastery of Zagori near Yannina, Epirus (493)
1870	RA	Kasr es Saad (271)
		Valdoniello (508)
1871	RA	Cáttaro, in Dalmatia (638)
		On the Nile: near Assioot (759)
		On the Nile: Nagádeh (1056)
		On the Nile, near Ballàs (1059)
1872	RA	Petra (942)
1873	RA	Monastery of Megaspelion in the Morea (744)

'How Pleasant to Know Mr. Lear!': paintings and
drawings by Edward Lear, London, 112 Piccadilly,
March 1912

Edward Lear: fifty-two watercolours, London,
Craddock & Barnard, The Howard Gallery,
October-November 1929

Drawings by Edward Lear (156 watercolours),
London, Craddock & Barnard, The Howard Gallery

One Hundred Landscape Drawings (In pen and water-
colours) by Edward Lear, Tunbridge Wells,
Craddock & Barnard, 1937

Edward Lear, 1812–1888: Landscapes in Watercolours,
London, The Fine Art Society, June-July 1938

Edward Lear, 1812–1888, London, Redfern Gallery,
March-April 1942

Watercolour drawings of the Ionian Islands by Edward
Lear, London, Adams Gallery, November-December
1946

Mediterranean Views by Edward Lear, London, Leger
Gallery, February-March 1950

Edward Lear. An Exhibition of Paintings and
Drawings, London, Walker's Galleries, 1950

Edward Lear: Water-colours of Greece: A Loan
Exhibition arranged by the Help to Greece
Consultative Committee, London, Walker's Galleries,
November-December 1951

Edward Lear, New Haven, Conn., Jonathan Edward
College, Yale University, 1951

Edward Lear 1812–1888: An Exhibition of Oil
Paintings, Water-colours and Drawings, Books and
Prints, Manuscripts, Photographs and Records, Arts
Council of Great Britain, July 1958

Drawings by Edward Lear, San Marino, Calif., Henry
E. Huntington Library and Art Gallery, November-
December 1962

Corfu (Ionian Islands): Greece, London, The British
Council, May-June 1964

Edward Lear: Drawings from a Greek Tour, Sheffield,
Graves Art Gallery, 1964

ΕΝΤΟΥΑΡΝΤ ΛΗΑΡ. Exhibition of Paintings. Athens,
British Council, October-November, 1964

Edward Lear. An Exhibition of Watercolours, London,
Davis Galleries, October-November 1966

Edward Lear: Painter, Poet and Draughtsman: An
Exhibition of Drawings, Watercolours, Oils,
Nonsense and Travel Books, Worcester, Mass.,
Worcester Art Museum, April-June 1968

Edward Lear, London, Gooden and Fox Ltd, October-
November 1968

Edward Lear in Greece: A Loan Exhibition from the
Gennadius Library, Athens, Washington, DC,
International Exhibitions Foundation, 1971–2

Edward Lear and Knowsley, Liverpool, Walker
Art Gallery, March 1975

Travellers Beyond the Grand Tour, London, The Fine
Art Society, June-July 1980

How Pleasant to Know Mr. Lear: Watercolors by
Edward Lear From Rhode Island Collections,
Providence, RI, Museum of Art, Rhode Island School
of Design, October-November 1982

The Travels of Edward Lear, London, The Fine Art
Society, October-November 1983

Edward Lear, 1812–1888, London, The Royal
Academy of Arts, April-July 1985; New York, The
National Academy of Design, September-November
1985

Edward Lear as a Book Illustrator, Cambridge, Mass.,
The Houghton Library, Harvard University, April-
June 1988

Edward Lear: the Centenary Exhibition, The Fine Art
Society, London, June-July 1988

Travels with Edward Lear, Sheffield, Graves Art
Gallery, July-August 1988

Edward Lear's Birds: centenary exhibition, Sheffield,
Ruskin Gallery, July-September 1988

Impossible Picturesqueness: Edward Lear's Indian
Watercolours, 1873–1875, New York, The Miriam
and Ira D. Wallach Art Gallery, Columbia University,
October-December, 1988

How Pleasant to Know Mr Lear: an exhibition to
commemorate the centenary of Edward Lear's
death, Brighton Museum, November 1988–January
1989

Edward Lear, 1812–1888, Athens, Gennadius Library,
March-July 1989

Drawings by Edward Lear from the Collection of the
Hon. Sir Steven Runciman, National Galleries of
Scotland, February-April 1991

Early work

Painting was considered to be an important activity in the Lear household, and in their house in Holloway a separate room was set aside as a painting room. As a child, Edward suffered from asthma, bronchitis, epilepsy and short sight, and he was not sent away to school. Instead he was taught at home by his sisters, Ann and Sarah, the two oldest of twenty-one children; Edward was the twentieth.

Working within the convention of young ladies of the time, Ann and Sarah taught Lear to draw and paint birds, butterflies, bees, shells, flowers, fruit and miniature landscapes. His early work is small, precise and controlled, often gemlike in its brilliant colour, indeed work typical of a myope. Some of the drawings were copied from books, but much was taken direct from nature. This was something they obviously believed to be important; from the beginning, Lear was trained in accurate observation. Six brightly coloured birds' feathers have been stuck into an early sketch-book, and beneath one of Ann's drawings she has written 'drawn from nature, Holloway – A.L.'. *Eleanor's Geranium*, done when Lear was sixteen, is drawn from life.

Peppering House. 1829. Pencil. 5in x 7½in. Private collection

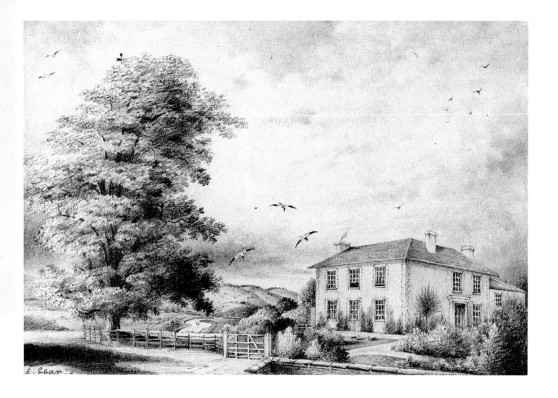

Eleanor's Geranium. 18 June 1828. Watercolour 13¹³/₁₆in x 9⅞in. Private collection

When Edward was ten years old, Sarah married and went to live at Arundel in Sussex. He went frequently to stay with her and, whilst there, he came to know a family called Drewitt who lived at Peppering in the nearby downland village of Burpham. The drawing of their house, done when Lear was seventeen, is his earliest known landscape. Although by far the largest part of his early surviving work is of birds, his fascination with both landscape and travel went back to his childhood reading of Stothard's edition of *Robinson Crusoe*, 'those exquisite creations of landscape which first made me, when a child, long to see similar realities'.

In 1827, when he was fifteen, the family split up, and Ann and Edward set up house together in Gray's Inn Road in London. He had now to earn his own living and he decided to do this by his painting. He later recalled that he 'began to draw, for bread and cheese, about 1827, but only did uncommon queer shop-sketches – selling them for prices varying from ninepence to four shillings: colouring prints, screens, fans; awhile making morbid disease drawings, for hospitals and certain doctors of physic'. Daniel Fowler, a young artist whom Lear met shortly after this, tells us that 'Lear's first attempts at earning money were made in offering his little drawings for anything he could get to stage-coach passengers in inn yards'. These were possibly the 'uncommon queer shop sketches'.

Some time after this, he was introduced to a Mrs Wentworth, who was the sister of Turner's patron, Walter Ramsden Fawkes. He later said that it was her introductions which launched him on his artist's life, and although he does not elaborate on this we know that Mrs Wentworth introduced him to the natural history illustrator, Prideaux Selby, who was at that time preparing his nineteen-part publication, *Illustrations of British Ornithology: or figures of British Birds*. In April 1830 he sent her a collection of seventeen drawings, mostly of imagined, unidentifiable birds, with an inscription acknowledging her kindness to him.

So little has survived from this time of Lear's life that it is impossible to know precisely what happened, but it seems likely that he served an unofficial apprenticeship with Selby. As a child, he had been trained in the careful and accurate observation of natural objects; working with Selby, he saw ornithological illustrations which were large, bold and lively. By bringing these two factors together, within the space of a few months he was to develop rapidly and powerfully as a natural history draughtsman.

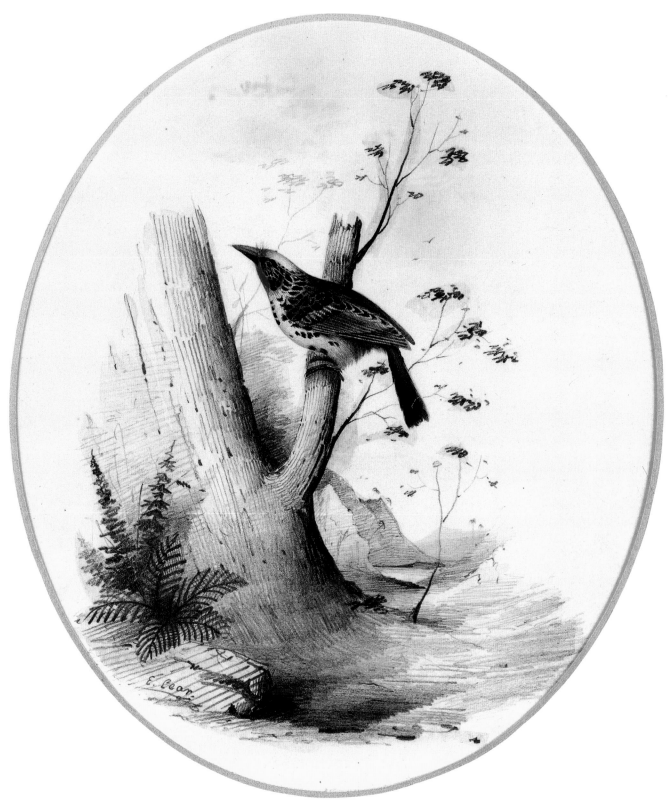

Mrs Wentworth's bird. 1830. Pencil and watercolour. 6½in x 5½in. Private collection

33

Miss Fraser's Album

Lear supplemented his income by giving drawing lessons, and in about 1830 he presented a leather-bound volume to a Miss Fraser as '1st Drawing Prize'. Lear tells us that he visited houses in Cavendish Square and St James's to teach drawing, but Miss Fraser lived near his childhood home in Holloway.

The album was intended as a common-place book, and on the opening pages he has written a poem which begins:

My album's open; come and see; –
What; won't you waste a thought on me;
Write but a word, a word or two,
And make me love to think on you . . .

It is accompanied by a pencil drawing of the volume, open to show a page of hummingbirds drawn by Lear, and festooned with a garland of flowers.

Peasant woman. n.d. Pencil. 4⁵/₁₆ x 3⁵/₈in. Private collection

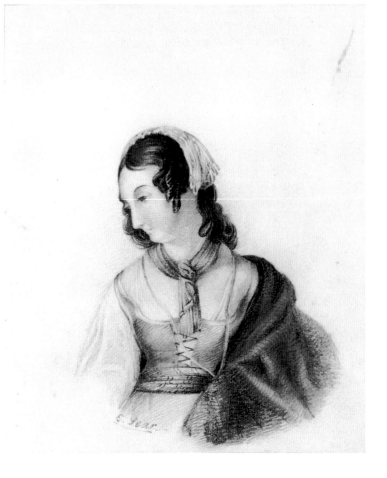

As well as this initial contribution, Lear wrote and illustrated a poem, 'Ruins of the Temple of Jupiter, Aegina, Greece'. He also seems to have given a number of drawings and watercolours to Miss Fraser, who glued them into the volume.

The small, derivative drawings and watercolours are typical of his immature, teenage work. Some are apparently copied from books. The exotic, imaginary birds in a tropical landscape are similar to surviving work done by his sister Ann. One watercolour is painted on rice-paper: in imitation of oriental work, such watercolours were known as Poonah paintings. Lear is known to have worked in this way in 1830–31.

Panther. n.d. Pencil and watercolour. 3¹⁵/₁₆in x 5⁷/₈in. Private collection

The highly finished watercolour of flowers is the only known example of its kind, and could represent the work which he was selling in inn-yards or with which he decorated fans and screens.

Lear's own tuition came not only from his sisters, but also from drawing manuals. These were fashionable at that time, particularly the volumes by Samuel Prout and his pupil, James Duffield Harding. Lear's copy of John Burnet's *A Practical Treatise on Painting*, which he bought in 1836, has survived.

Flowers. n.d. Watercolour. 6⁵/₁₆in x 8¹/₈in max.
Private collection

Lyre, book and palette. n.d. Pencil and watercolour.
7⁹/₁₆in x 6¹/₄in. Private collection

Temple of Jupiter, Aegina. n.d. Pencil. 1¹/₈in x 1⁹/₁₆in.
Private collection

Flower and butterflies. n.d. Pencil and watercolour on
ricepaper, collage, 9³/₁₆in x 7³/₈in. Private collection

Birds in Scenery. n.d. Pencil and watercolour.
6³/₁₆in x 8⁷/₈in. Private collection

35

Illustrations of The Family of Psittacidae, Or Parrots

In 1830 Lear decided to work on a book of his own, and in the summer of that year he applied to the Zoological Society to make drawings of the parrots in their collection. Permission was given by the Council of the Society at a meeting held on 16 June, chaired by the President, Lord Stanley.

Until now, volumes of bird illustrations had shown the birds of particular countries, such as Selby's *Illustrations of British Ornithology* and Audubon's *The Birds of North America*. Lear's book was the first to be devoted to a single family.

Unusually for his time he decided to draw living birds rather than stuffed specimens, a decision which enabled him to produce drawings where the birds posed as living creatures with often pronounced personalities. He worked in the parrot house at the zoo, and his ebullient youthfulness can be seen in many of the drawings he did there. Some have messages in code scribbled beside the drawing, such as 'Sarah will stay a week, that is if you ask her', others are decorated with caricatures of the visitors who watched him as he worked.

While the parrots were held by a keeper, Lear took measurements of beaks and legs and wing-spans. His first drawing, establishing the bird's pose, was smaller than life-size. As he worked he made jottings on the picture, notes which gave details of both form and colour, such as 'soft undulating feathers' and 'rather too pink'. In doing this he followed the advice of Audubon, the master of ornithological drawing, who wrote, 'Leave nothing to memory, but note all your observations in ink, and keep in mind that the more particulars you write at the time, the more you will afterwards recollect'.

The next stage was to do a detailed, life-size study of the bird, producing an accurate master drawing (see p.14). He then rubbed soft pencil over the back of the paper, and from this he traced through a

(Above)
Visitors to the Parrot House. n.d. Pencil. 11in x 8¾in. The Houghton Library, Harvard University

second outline which he laid in with watercolour; this would act as a guide for the colourist. A second image was traced onto the lithographic stone, on which it was drawn with a fine greasy chalk. During this stage there was no opportunity to correct errors; if he made any mistakes, he had to begin again with the process of transferring the drawing.

Lithography, a method of reproduction which allows great fluency of line, had been discovered at the end of the eighteenth century and was just beginning to be widely used. It was both cheaper and easier to execute than engraving; early critics believed that it would bring the work of artists into contempt by making them more readily available. Early lithographic reproductions are woolly and crude, but by the time Lear was preparing his *Parrots*, delicate lines could be accurately and sensitively reproduced.

The book was printed by Charles Hullmandel, who was the leading lithographer in England in the 1830s. His book, *The Art of Drawing on Stone* published in 1824, was the standard reference work. Daniel Fowler described him as 'a singular character, a man of very acute intelligence, an accomplished linguist, decidedly caustic'. His warren of workrooms at 49, Great Marlborough Street, was a gathering place for many artists of the day.

Lear had an opportunity to see proofs before the

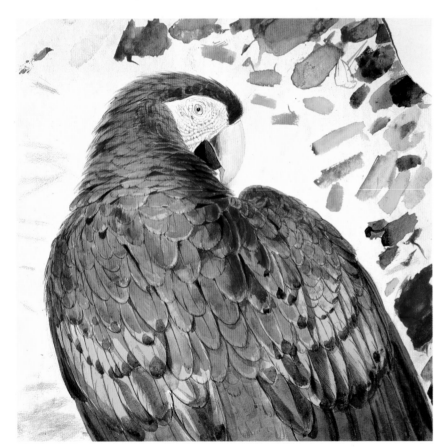

Study for Macrocercus aracanga, Red and Yellow Macaw. 1830. Pencil and watercolour. 14½in x 14⅞in. The Houghton Library, Harvard University

final printing began, and could reject those that were too dark or indistinct. The black-and-white lithographs, which were reversed images of the original drawings, were then coloured by hand. The colourists, guided by Lear's original watercolour, laid a number of the prints round the room and moved from one to the next, painting in all the reds, and then all the yellows, and so on until the work was complete. Finally, egg-white was added to certain areas in order to give a glossy sheen to the feathers. This method of hand-colouring was expensive, but the finished result was clear and brilliant.

Lear financed the project himself. To do this he followed a convention popular at the time, of publishing the work by subscription. In order to attract subscribers, he limited the number of reproductions of each plate to 175, after which the lithographic stones were destroyed.

Individual prints became available as they were produced, gathered into folios of three or four and sent to all those who had subscribed. Lear was responsible for distributing the folios as they appeared, and for collecting the subscriptions for each part. Inevitably there were those who tired of the project before it was completed, and others who paid only slowly. Lear, meanwhile, had to meet all the costs of printing and hand-colouring. This became an increasing problem, and in October 1831 he wrote, 'I have pretty great difficulty in paying my monthly charges, – for to pay colourer & printer monthly I am obstinately prepossessed – since I had rather be at the bottom of the River Thames – than be one week in debt – be it *never* so small'. In the end, shortage of money forced him to abandon the project unfinished. Twelve of the projected fourteen folios of *Illustrations of The Family of Psittacidae, Or Parrots*, appeared in a single volume in the spring of 1832. The book contained forty-two scientifically precise, compositionally bold and rhythmically satisfying lithographs.

From the appearance of the first folios in the autumn of 1830, when Lear was still eighteen, the work was highly acclaimed, for both its accuracy and its beauty. The day after the appearance of the first folio, he was elected an Associate Member of the Linnean Society. The *Red and Yellow Macaw*, drawn with astonishing confidence for someone so young, was one of the first plates he prepared, and the natural history illustrator, William Swainson who had studied with Audubon, thought it 'equal to any figure ever painted by Barraband or Audubon, for grace of design, perspective, or anatomical accuracy'. The development of Lear's work in just a few months had been remarkable.

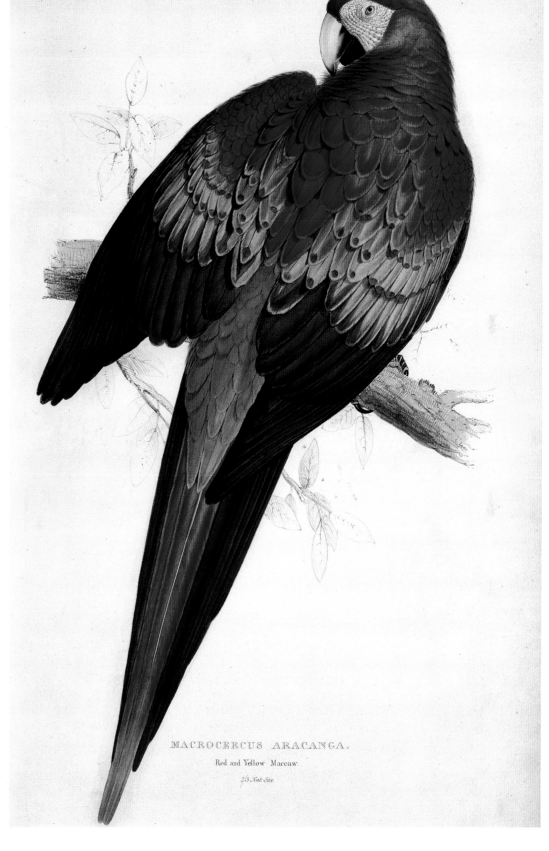

Macrocercus aracanga, Red and Yellow Macaw. 1830. Hand-coloured lithograph. Plate 7 from *Illustrations of the Family of Psittacidae, Or Parrots*, 1831. 21¼in x 14¼in.

MACROCERCUS ARACANGA.
Red and Yellow Macaw.
⅖ Nat. Size.

Francolinus perlatus (Gmel). 1835. Pencil and watercolour. 14⁷/₁₆in x 20¹⁵/₁₆in. Private collection

to the Stanley Crane was done in watercolour without preliminary pencil drawing.

Although he worked for Lord Stanley between 1831 and 1837, Lear was not exclusively at Knowsley. This was a time when many zoologists were preparing volumes describing newly discovered animals, and in London he had more offers of work than he could manage. He continued to do drawings for Prideaux Selby, making plates for his *Illustrations of Ornithology*. He prepared the illustrations for two volumes, *Pigeons* and *Parrots*, in Jardine's popular series, *The Naturalist's Library*, and worked on Thomas Eyton's *A Monograph of the Anatidae, or Duck Tribe*, on Thomas Bell's *A Monograph of the Testudinata*, and *A History of British Quadrupeds*, and on the *Transactions of the Zoological Society* and *The Zoology of Captain Beechey's Voyage*. His accuracy, draughtsmanship and sympathetic understanding of the bird or animal he was drawing, made him one of the most sought-after natural history illustrators of his day.

Work for Lord Derby

Lord Stanley, the President of the Zoological Society and heir to the Earl of Derby, was one of a number of amateur zoologists who owned private menageries. The fashion for private zoos in England went back to the time of Henry I whose collection at Woodstock included lions, leopards, lynxes and camels. Some centuries later, Louis XIV established a collection of animals at Versailles, and it was here that the word 'menagerie' was first used to describe a collection of wild animals.

Originally, the purpose of such menageries was ornamental; a handful of curious and picturesque animals might agreeably adorn any country estate. However, in the new scientific age it was no longer enough simply to admire the creatures; they had now become objects of study.

Lord Stanley, who in 1834 became the 13th Earl of Derby, owned one of the finest private menageries in the country. Nearly a hundred acres of land and large expanses of water at Knowsley,

near Liverpool, were set aside to accommodate a collection which was continually being added to by more than twenty agents around the world. From his collection of living specimens and skins, previously unknown species were described and classified. A number, including a crane and an Abyssinian lovebird, were called after Lord Stanley.

In 1831, he decided to employ a natural history illustrator to make an accurate record of some of the birds and animals. He had seen Lear at work on the parrots in the Zoological Society Gardens, and invited him to stay at Knowsley. More than a hundred watercolours done by Lear still survive as a record of a remarkable collection. In 1846, seventeen of these were published in *Gleanings From The Menagerie And Aviary At Knowsley Hall*.

As with the parrots he worked from life, combining careful observation and truth to nature with satisfying, vital compositions. The pictures were drawn in pencil and painted in watercolour, sometimes with the addition of gum arabic to give sheen to the fur and feathers, just as egg-white had been used on the parrots. With the Whiskered Yarke, Lear also employed the technique of scratching out to give a sense of depth to the animal's thick coat.

Lear's earliest landscape watercolours are found in his work for Lord Derby. The exotic background

(Opposite)
Scops paradisea, Stanley Crane. 1835. Hand-coloured
lithograph. Plate XIV from *Gleanings From The
Menagerie And Aviary At Knowsley Hall*, 1846.
21½in x 14½in. Private collection

Pithecia rufigastar, Whiskered Yarke. July 1835. Pencil,
watercolour, gum arabic. Drawing for Plate II of
*Gleanings From The Menagerie And Aviary At
Knowsley Hall*, 1846. 14⁵/₁₆in x 20¹⁵/₁₆in. Private
collection

Strix tengmalmi, Tengmalm's Owl. 1837. Hand-coloured lithograph. Plate 49, Vol 1, *The Birds of Europe*, 1832. 22in x 16in

John Gould and Early Landscape

Although employed by many leading zoologists, most of Lear's work during these years was for a man whose name was to become synonymous with nineteenth-century English ornithological illustration, John Gould.

Gould, whose wife Elizabeth was an accomplished artist, had been appointed in 1827 as taxidermist to the Zoological Society. In 1830 he was given a collection of Indian bird skins, and having prepared and stuffed the skins, he decided to publish illustrations of the birds. Lear was at this time issuing the first folios of his parrots, and Gould chose to use the format of large lithographic plates which Lear was employing so successfully. In 1832 he bought from Lear all rights to the *Psittacidae*, including the unsold copies. He planned to finish the work himself, but did not do so.

His first book, *A Century of Birds from the Himalayan Mountains*, was published in 1831. Its success enabled him to move on to a second volume, *A Monograph of the Ramphastidae, or Family of Toucans*, and then to a more ambitious project, a five-volume work illustrating the birds of Europe. In this, as in the previous works, he sought Lear's collaboration.

We know that at some point they went together to visit zoos in Amsterdam, Rotterdam, Berne and Berlin to see specimens which would be included in *The Birds of Europe*. Nothing has survived from this time to tell us how long they were away or Lear's response to what he saw, but it is apparent that during this journey he committed himself to working with Gould until the publication was complete.

Lear's responsibility was to illustrate many of the bigger, bolder birds such as cranes, cormorants, owls and eagles; Elizabeth Gould's finer touch was better suited to the smaller, more delicate birds. As with all his natural history work, where living specimens existed the drawings were taken from life. Although Gould acknowledged Lear's help in the Preface, many of the plates, even where Lear's signature appears on the drawing, are inscribed 'Drawn from nature & on stone by J. & E. Gould'.

By 1834, although he was to continue as an ornithological draughtsman for another three years, we have the first indications that Lear did not want to spend the rest of his life drawing birds and

Rustic Scene. 1834. Lithograph. 16in x 13in. Trustees of the British Library

animals. Indeed it is possible that had he been financially independent he might never have become a natural history illustrator in the first place. As an illustrator, however successful, he could not be considered as a serious painter, and this is what he wanted to be.

In that year he enrolled as a student at Sass's School of Art in Charlotte Street, Bloomsbury. Sass's, which had been established in 1818, prepared students for entry into the Royal Academy Schools. Among the pupils there at the same time as Lear were William Frith, who later painted *Ramsgate Sands* and *Derby Day*, and Augustus Egg. It was a rigorous course, during which students worked exclusively from the antique.

We do not know how long Lear stayed at Sass's, nor how much time he was able to give to his work there, but since he was not in a position to support himself without working it can only have been a brief stay. His interest, however, was turning increasingly from natural history illustration towards landscape. He had access to the printing facilities of Hullmandel's workshop, and in 1834 he prepared

his earliest landscape lithographs. This rustic scene, which is much chunkier in its handling than any of Lear's later lithographic work, is within the convention of drawings reproduced in art manuals at this time, and it is unlikely that it was drawn from nature.

Hullmandel was in the habit of giving splendid parties in his studio, and at these Lear met other painters of the day including Turner – whose work he admired more than any other – Clarkson Stanfield, and J. D. Harding. Harding, who was involved with Hullmandel in the development of lithography, was one of the most influential teachers of his time, publishing a number of important drawing manuals. His work was to have a powerful influence on Lear's early landscape drawing (see p.23).

One of Lear's close friends in the 1830s was the young painter, Daniel Fowler, who had been one of Harding's students. In 1834 Fowler left England to spend a year in Switzerland and Italy. Many years later Lear recalled sitting under a mulberry tree in the garden of Fowler's home in Queen's Square with Fowler's sisters, Lucy and Elizabeth, reading excited letters sent from Italy, and a year later looking through the sketches which Fowler had brought home from his travels. Lear's longing to travel and

to draw the places that he saw, an ambition which dated back to his boyhood reading of Stothard's edition of *Robinson Crusoe*, must have grown even stronger.

Meanwhile, he was using every opportunity he could find to do landscape. In 1835 he travelled to Ireland with Arthur Penrhyn Stanley, later to be Dean of Westminster and who was at this time up at Oxford. Stanley's father was an amateur zoologist who in 1836 published a *Familiar History of Birds*, and he was visiting Dublin to attend a meeting of the British Association. No account of the trip by Lear has survived, but we know that they explored the Wicklow mountains, visiting Glendalough and the Seven Churches. At Glendalough they listened as their guide shouted out Thomas Moore's poem of the legend of St Kiven's Cave before persuading the two young men to attempt to entwine their legs around a large stone cross, an act which would guarantee them a beautiful wife and a large fortune. When time allowed, Lear worked to fill a sketchbook of drawings, his first collection from a single tour.

Sugar Loaf Mountain. 1835. Pencil 3³/₁₆in x 5¹/₈in. Private collection

time until now. In all the work which Lear did in the Lake District in 1836, he has picked up the strong rhythmic lines of the landscape, as he had done in the composition of his parrot drawings.

On this tour Lear used both soft pencil with chalk, and pencil with watercolour, although it is possible that he laid on the watercolour later, in his studio. In the drawings which he did with pencil and chalk, he rubbed the graphite with either his finger or a soft leather stump in order to create both tonal differences and the effects of atmosphere. Stumping, a method encouraged at the end of the eighteenth century, was based on the idea that natural objects have no outline and that their form should therefore be described by the use of tonal differences rather than line.

In the drawing of Windermere, we can see that from the very beginning of his landscape work he used a method which had served him well when he was drawing the parrots direct from nature, for he has inscribed notes on the picture surface; he has

The Lake District

In the late summer of 1836, Lear again had an opportunity to spend several weeks sketching, this time in the Lake District. From the end of the eighteenth century, with the popularity of the Lakeland poets and the fashion for pantheistic images, the Lake District had been a mecca for English landscape painters who were attracted to what some saw as the English Alps.

Lear left Knowsley in the middle of August to stay with the Revd J. J. Hornby, a cousin of Lord Derby, and his son Robert whom Lear later described as 'my oldest and dearest friend in the world'. From their home in Windermere, he set out to walk through Cumberland and Westmorland.

The sense of release which Lear experienced during his two months' tour can be seen from the freedom with which he handled the drawing of Crummock. The bold, sweeping abstraction of form is very different from the minutely accurate drawings of birds and animals which had occupied his

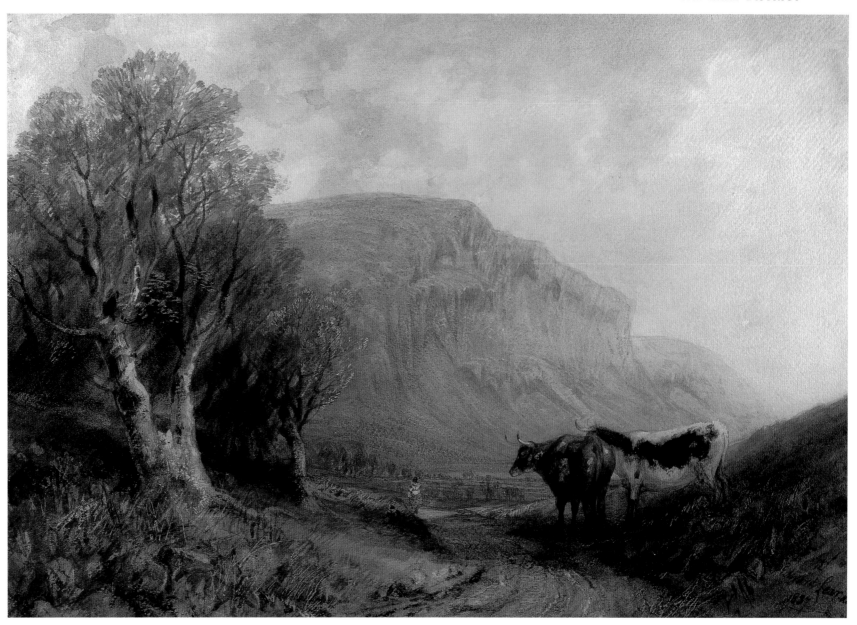

Wastwater. 1837. Watercolour.
13³⁄4in x 22⁷⁄8in.
Private collection

written 'all heathy green', 'misty', 'yellowish grey'. The pleasure which he derived from the delicately sculptured form and flowing rhythms of distant hills is something that he was to carry forward into his finest work, although here the pencil line is much more tentative, less direct and assured than it was later to become.

The watercolour of Wastwater, painted in the following year and given as a present to his Windermere hosts, is the earliest known example of a studio landscape based on earlier drawings done on the spot. In its colour it is reminiscent of the work of William Havell, who had spent a year in the Lake District in 1811–12, and it is unlike anything that he did subsequently. It is drawn directly in water-

colour, and as with some of his natural history work Lear has used gum arabic and scratching-out to give additional texture to the picture surface.

This view is the subject of an early lithograph (see p.24). *Wastwater and the Screes from Wastdale*, now in the British Museum, is smaller and more delicate in touch than his first landscape lithographs of 1834 and is more closely related in handling to his later Italian lithographs.

By mid-October Lear was back at Knowsley with a folio of more than a hundred drawings. In the damp Liverpool climate, the asthma and bronchitis from which he had suffered since childhood was getting worse, and his eyesight had deteriorated further – he believed as the result of the small, close work in-

volved in his natural history drawings – so that in October he wrote to Gould, 'no bird under an Ostrich shall I soon be able to see to do'.

On his own, it is difficult to see what Lear could have done to change the way of life to which he had been committed since his mid-teens, for he was no more secure financially now than he had been previously. The question must have been discussed at Knowsley, and may indeed have been raised during his tour of the Lakes, for in the summer of 1837 Robert Hornby and Lord Derby together offered to send him out to Rome. Suddenly he was free to travel, and to become a landscape painter.

Early Italian years

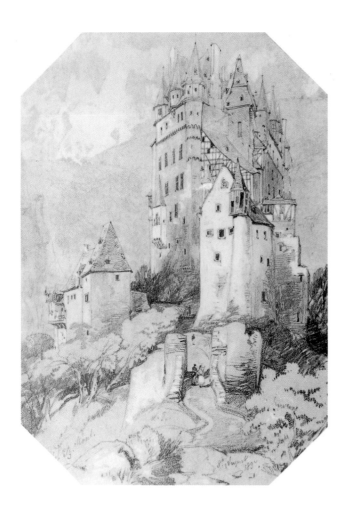

Castle of Elz, Mosel. 8 August 1837. Pencil and white bodycolour. 10^{15}/$_{16}$in x 7^7/$_8$in. The Houghton Library, Harvard University

Lear did not leave England alone. He travelled with Ann, who came with him as far as Brussels, and with Daniel Fowler, the friend whose letters from Italy he had listened to under the mulberry tree in Queen's Square a few years before. On 18 July they sat together making drawings of the Gran' Place in Brussels, and two days later they were in Luxembourg. By 8 August, he was on his own, making drawings of the fairytale Castle of Elz on the Moselle; at this time he enjoyed drawing every kind of building, an enjoyment which would later fade. At the beginning of September he crossed over into Switzerland, and later that month he was in Italy.

From the beginning he was overwhelmed by everything he saw. 'If you look at Claude's pictures you can exactly understand the scenery – for it is just like it', he wrote to Ann. Ann would have been familiar with Claude's work from his *Liber Veritatis*, which was published in three volumes between 1778 and 1819. In these early years Lear admired also the work of Salvator Rosa and Poussin whose ornate, classical landscapes were constantly in his mind as he travelled.

On his arrival in Florence he immediately found English friends, one of whom was William Knighton whom he had known at Sass's three years earlier. Together they toured the artistic sites of the city, and he wrote to Ann, '. . . I cannot tell you about the galleries – the pictures – the statues – the churches – the tombs of Michael Angelo – Dante – etc. etc. because all this would take so much time, and after all conveys little idea of the place. It is all a hurly-burly of beauty and wonder.'

At the end of November he left Florence for the last part of his journey to Rome, travelling now with the sculptor William Theed, who had lived in Rome for many years and who was able to help Lear find rooms and to introduce him to other artists.

From the beginning, he entered with enthusiasm into his new life. 'At 8 I go to the Cafe, where all the artists breakfast', he told Ann, 'and have 2 cups of coffee and 2 toasted rolls – for 6½d. and then – I either see sights – make calls – draw out of doors – or, if wet, – have models indoors till 4. Then most of the artists walk on the Pincian Mount, (a beautiful garden overlooking all Rome, and from which such

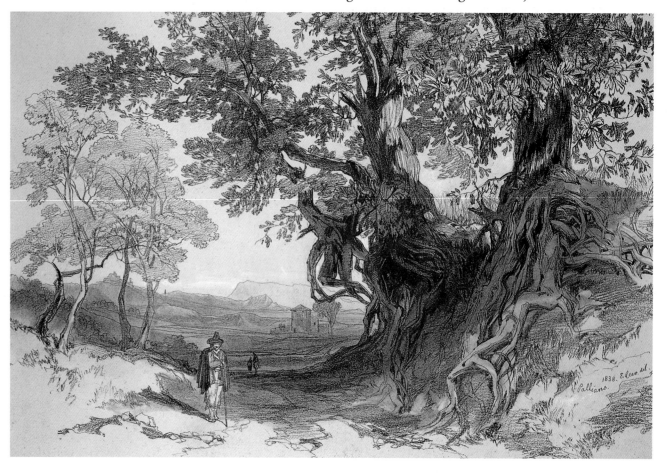

Paliano. 1838. Pencil and white bodycolour. 9^9/$_{16}$in x 13^5/$_8$in. The Victoria & Albert Museum

sunsets are seen!) – and at 5 we dine very capitally at a Trattoria or eating house, immediately after which Sir W. Knighton and I walk to the Academy.' We do not know how long Lear attended the Academy, nor what he studied there.

During Lear's Roman years, from 1837 to 1848, we can watch a maturing of his style. At the beginning he worked almost exclusively in pencil and soft chalks on tinted paper, with the addition of often quite extensive areas of white bodycolour. His way of drawing foliage, a subject in which he became increasingly interested, owed much to Harding's style, as one can see from his dramatic drawing of Paliano, a village on the Roman Campagna; he now understood a great deal more about tree form than he had done in his early drawing of Peppering House. The composition of many of these drawings uses the Claudian convention of bundles of interest in the foreground, working rhythmically back through receding, overlapping layers towards a distant outline. This was a compositional device which served Lear well, and which he used throughout his life.

During the summer months the city emptied, and in July 1838 Lear set out with other young artists for Naples. In the group was James Uwins, the nephew of the Academician Thomas Uwins. They walked much of the way south, drawing as they went. In Naples, Uwins and Lear shared a *pensione* with Samuel and Hannah Palmer.

The drawing of Amalfi, with its dramatically low vanishing point, is based on a drawing which Lear made on the spot on 18 July 1838. It is an early example of a studio drawing, and in it he has used grey and brown wash as well as white bodycolour. His earliest studio drawings, of the Lake District, date from 1836. It was from a combination of teaching, and the sale of such studio drawings based on earlier studies and priced at £10 each, that he made his living during his early Roman years.

At the beginning of August, they were in the village of Corpo di Cava, where Salvator Rosa had worked and where Thomas Uwins had lived twenty years before. James Uwins's artistic training had been closely overseen by his uncle who had been apprenticed to an engraver, and Lear's friendship with him may have played a part in the gradual evolution of his style. He was beginning to move away from soft pencil and chalks, and was instead drawing finer lines with a harder pencil and without the use of rubbed graphite to create tonal differences.

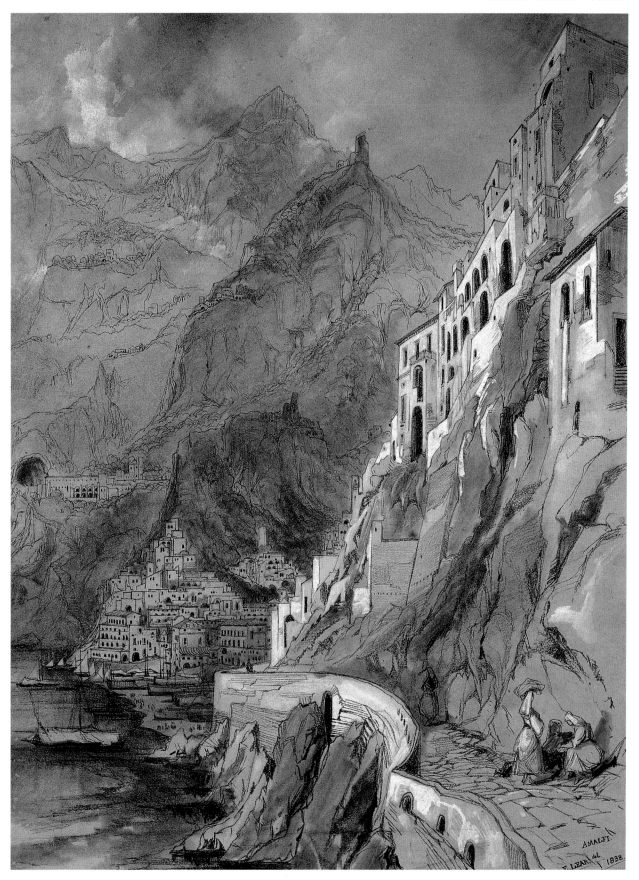

Amalfi. 1838. Pencil, wash and white bodycolour. 13½in x 9⅞in. The Victoria & Albert Museum

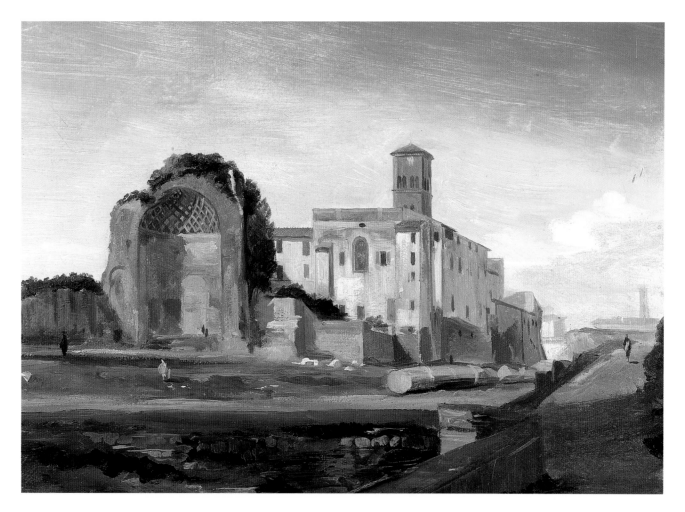

Temple of Venus and Rome. 1840. Oil on paper. 9⅝in x 13⅜in. Yale Center for British Art, Paul Mellon Fund

Villa d'Este, Tivoli. 1840. Oil on canvas. 17¾in x 12½in. Private collection

Middle Italian years

Lear's earliest surviving oil sketches date from the summer of 1838 when he was staying at Corpo di Cava. One, a study of trees and rocks done on paper direct from nature, shows him handling oil as freely as if it were watercolour. During the next two years he continued to do *plein air* oil sketches on paper; the *Temple of Venus and Rome* was painted in 1840. These early studies do not relate to later oil paintings, but were done as independent works.

In the same year, he began work on his first painting commissions. *Villa d'Este, Tivoli* is one of the most competent and assured of Lear's early oil paintings; in most of these there is an uncertainty and diffidence in his handling of paint which contrasts with the growing confidence of his drawings. Many have uninspired and unsatisfactory compositions; here the vertical composition induces its own drama.

There had been no more talk of attending the Academy in Rome. Instead he was developing his skills by watching other artists at work, in particular Penry Williams. Williams, the pre-eminent English painter in Rome at that time, was twelve years older than Lear and had lived in Italy for ten years. He was primarily a painter of Italian genre scenes. Although Williams did not achieve the success which he deserved, Lear never ceased to admire his work, nor to acknowledge the help and advice which he had given.

Lear's earliest Italian watercolours date from the spring of 1838. The next few years were a time of experimentation, as he sought for the way of working which best suited him. He used watercolour, bodycolour and on occasion even oil paint. He sometimes painted directly in watercolour without any preliminary drawing, but he remained happier when using a pencil to describe form. In the work of this period we can see his drawing becoming more economical and controlled. Increasingly he laid watercolour washes over the initial drawing, some-

times in grey or sepia monochrome. Occasionally he built up form by cross-hatching; with this, the use of colour, and the greater control of his line he no longer relied on stumping.

In the spring of 1841 he decided to return to England for a few months. While there he published his first book of Italian drawings, *Views in Rome and its Environs*. This volume, containing twenty-five lithographs, was printed by Hullmandel and published by subscription.

He was back in Italy before the end of the year, and the following summer he travelled through the Abruzzi, the first journey in which he broke away from scenes popular with artists to explore wilder countryside. He went with a companion, but there was little time to make detailed sketches. In the late summer of 1843 he retraced his footsteps, wandering slowly and stopping to make drawings of a part of Italy which was close to Rome yet scarcely known to outsiders. With its broad washes laid over the larger, receding areas, its dry dragging of watercolour in the foreground, and its penning out, the drawing of the 'narrow and formidable pass' of the Bocca di Castelluccio, which is typical of the work he was doing at this time, shows a significant move towards his mature style.

These were the first travels in which Lear kept a journal for later publication, and in it he described this romantically sublime scene. 'The entrance to this lonely ravine, ever unvisited by the sun, is between terrific rocks, which in parts of the pass are so close together as barely to admit the passage of a loaded mule. Throughout the winter, torrents, or snow, prevent any communication by this untoward road; but during summer it is visited by a few poor people, who gather the wood left in it by the winter's ravages ... the scream, or rushing flight of a hawk, or the fall of a stone from the lofty sides of this mountain *foce*, as these chasms are called, were the only sounds that broke its deadly stillness.' We can see here the extra dimension given by the journal description, an example of the complete topographical image he sought to create from a combination of words and pictures.

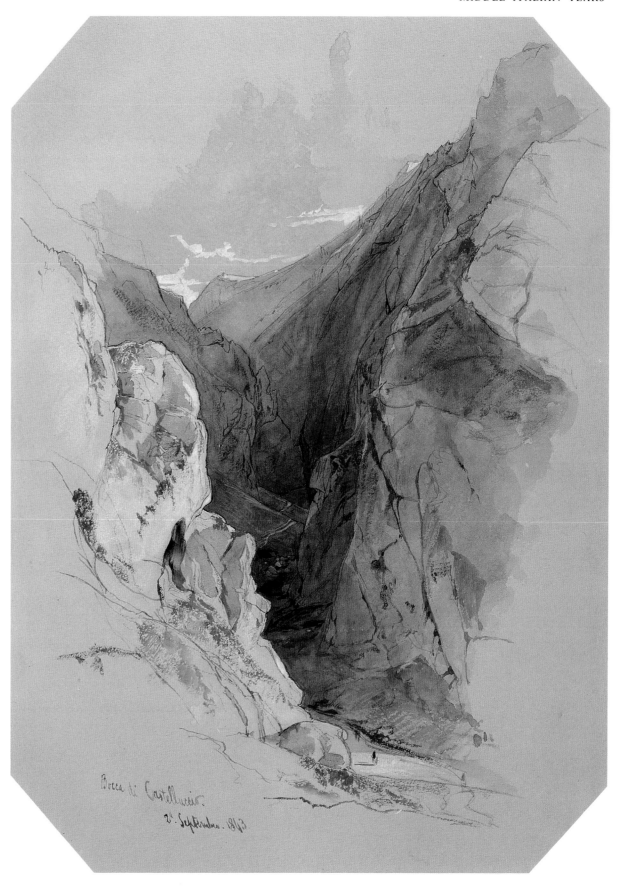

Bocca di Castelluccio. 2 September 1843. Pencil, watercolour and bodycolour. 15in x 10⅞in max. Liverpool Public Library

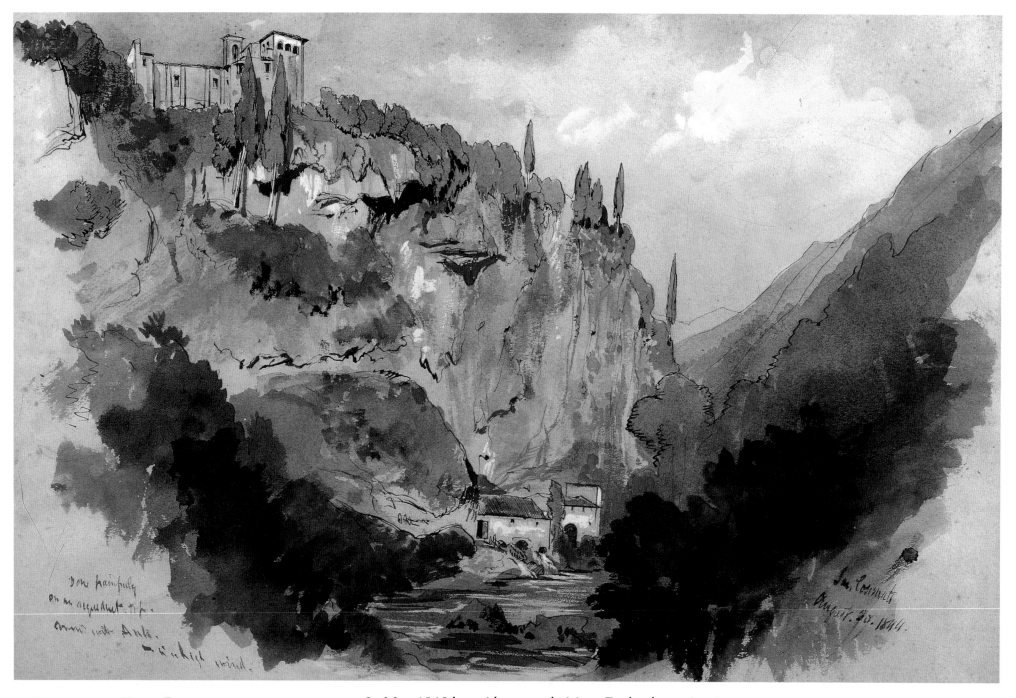

Later Italian years

The dramatic composition of the Amalfi and Bocca di Castelluccio drawings is echoed in the superbly confident watercolour of San Cosimato, a village close to Rome. The picture was done in watercolour on the spot, and Lear has written on it, 'Done painfully on an acqueduct top. covered with Ants – in a high wind'.

In May 1845 he paid a second visit to England, this time staying for eighteen months. In 1846 he published two volumes describing his *Illustrated Excursions in Italy*. The first, published in April 1846, contains the journal of his travels in the Abruzzi and is illustrated by full-page lithographs and smaller vignettes drawn on wood; in the second, which came out four months later, there are lithographs and vignettes with a short letterpress describing the places illustrated. Up to this time Lear had received no instruction in figure drawing, and

San Cosimato. 30 August 1844. Pencil and watercolour. 12¾in x 18in. Private collection

three of the vignettes, those of peasants in their traditional costumes, were done for him by Penry Williams. The book, which was widely praised, was again published by subscription.

One of those who had subscribed was Queen Victoria. As an enthusiastic amateur painter, she much admired Lear's drawing, and she invited him to give her a series of twelve lessons, four at her

Lago di Fucino. Lithograph. Plate 4 of *Illustrated Excursions in Italy, 1846.* 10½in x 14¾in.

visited this idyllic mountain retreat a few miles out-side Rome, in the summer of 1839. He returned there many times, and it came to represent for Lear an ideal of lost paradise to which he would return in memories tinged with melancholy for the rest of his life. Described by Lear in 1861 as 'the old brown picture', it is painted in the convention of rather sombre colour which he was later to dismiss as 'sloshing and asphaltism'. The foreground com-bination of tree and rock, a form in which he delighted, was one that he knew from 'Landscape – Christ tempted' in Claude's *Liber Veritatis*. The painting was developed from a smaller work of the same scene painted for the Revd J. J. Hornby in 1843, and was the first of several large paintings which Lear did with the purpose of establishing a reputation. It is an indication of the direction in which he now saw his career moving.

Civitella di Subiaco. 1847. Oil on canvas. 50in x 76in. The Clothworkers' Company

newly built house at Osborne on the Isle of Wight and the others at Buckingham Palace. Although he no longer gave lessons in Rome, Lear was an experi-enced teacher and the Queen seems to have enjoyed her time with him. 'Had a drawing lesson from Mr Lear, who sketched before me and teaches remark-ably well, in landscape painting in watercolours', she wrote in her diary on 15 July, 1846. Two of the drawings she did under his guidance are preserved in the Royal Library at Windsor.

Lear returned to Rome at the end of December. '... you have little notion how completely an artist's paradise is Rome, and how destitute all other places would be of capacities to study or prosper', he had written to Ann a year after his arrival, but now he realised that in order to become established as a serious painter he must be in London.

From 1840 until he left Rome in 1848, the em-phasis of Lear's work and the main source of his in-come moved from studio drawings to oil paintings; he had not yet returned to doing studio water-colours. Most of the paintings he did at this time are quite small, measuring typically about 10in by 15in. In 1847, however, he began work on a large and ambitious uncommissioned painting. This picture, which now hangs in the Clothworkers' Hall in the City of London, is of Civitella di Subiaco. He first

Girgenti. 27 May 1847. Oil on board. 12in x 19in.
Private collection

Calabria and Sicily

By the beginning of 1847, Lear no longer felt settled in Italy. His thoughts now were turning towards living permanently in England, but before doing so there were many places he wished to see and draw so that he would have folios of work on which to base later paintings. In these drawings he needed to record as much information as possible, so that he could later recall the scenes accurately.

That summer he went south from Rome to explore Sicily and Calabria, parts of Italy he had earlier visited in 1842. Prompted by the success of *Illustrated Excursions in Italy*, he kept a daily journal for later publication. It was an exciting journey, made particularly so by outbreaks of political disturbance which anticipated the more serious uprisings of 1848. The wild countryside through which they travelled did not, however, need the addition of revolution to make it dramatic. 'Calabria! – No sooner is the word uttered than a new world arises before the mind's eye, – torrents, fastnesses, all the prodigality of mountain scenery, – caves, brigands, and pointed hats, – Mrs. Radcliffe and Salvator Rosa, – costumes and character, – horrors and magnificence without end', he wrote in *Journals of a Landscape Painter in Southern Calabria*, published in 1852.

He spent nearly three months in Sicily. A number of *plein air* oil studies on board, where the oil is laid over an initial pencil drawing, survive from this

tour. Although charming in themselves they did not give him the reference he needed, and he worked in this way only once more, in Eygpt in 1854. Most are inscribed only with the place and date, but on one oil sketch of Catania, dated 16 June 1847, he has written: 'This was done on a thorough Scurrato day. You may therefore make all the colour infinitely brighter. Etna bluer – sky warmer lava distant, pinker – near browner & Asphaltumer.'

The watercolour of Syracuse on the other hand, dated three days earlier, gave him exactly what he needed. In this, he began by doing a detailed pencil drawing to which he then added notes – 'stone, peeping through covering of Ivy', 'brown yellow clumps of grass', 'figs', 'vine', 'light gray', 'purple gray', 'dove gray' – which enabled him to recall both content and colour. He laid in the watercolour wash

and penned out the pencil drawing later. In this method of annotated watercolours, which he was to use for the rest of his life, he returned to a system he had employed with such success in his parrot drawings and in some of his earliest landscape, and which he employed occasionally but not consistently, during the intervening years. He was about to begin on the longest unbroken series of travels of his life, and he had found a method of working which would allow him to exploit the limited time he would be able to spend in each place.

Back in Rome for the winter, Lear had to decide what he should do next. In February 1848 he wrote to Fortescue: 'I am a disturbidous state along of my being undecided as to how I shall go on with art – knowing that figure drawing is that which I know least of & yet is the "crown & roof of things".' He

talked of spending the spring and summer in Rome working at figure drawing, or of returning to Calabria to see those parts of the Kingdom of Naples which he had been unable to visit the previous year. As well as this he had been invited to visit Corfu, and he longed to go to Egypt and Syria and Asia Minor '& all sorts of grisogonous places'. With so many possibilities, he felt himself to be in 'a state of know-nothingatallaboutwhatoneisgoingtodo-ness'.

In the end, the increasingly unsettled political situation in Italy decided the question for him, and in April he left Rome for Corfu.

Syracuse. 12 June 1847. Pencil, sepia ink, watercolour. 13⅞in x 19⅞in. The Walker Art Gallery, Liverpool

Scutari Costume. 8 October 1848. Pencil and sepia ink.
10¹⁵/₁₆in x 7³/₈in. Private collection

Albania

The progress of Lear's journeys over the next fifteen months was dictated as much by chance as by planning. Unexpected meetings took him from Corfu to Athens and Attica, and then on to Constantinople (see p.19), where he lay ill with malaria for some weeks. From there he went back to Greece where he had arranged to meet Charles Church, and to travel with him to Mount Athos. When he landed in Salonika, however, he found the city isolated by an outbreak of cholera. Unable either to make contact with Church or to get to Athos, he could still leave the city by a north-westerly route, and so he decided to set out on his own across northern Greece to Albania.

Although familiar to readers of Byron's *Don Juan*, Albania was a country little visited by Englishmen. For a landscape painter, however, it offered beautiful and dramatic scenery. 'You have the simple and exquisite mountain forms of Greece,' Lear wrote in his published journal of the tour, 'so perfect in outline and proportion – the lake, the river, and the wide plain; and withal you have the charm of architecture, the picturesque mosque, the minaret, the fort, and the serai . . . you have that which is found neither in Greece nor in Italy, a profusion everywhere of the most magnificent foliage recalling the greenness of our own island – clustering plane and chestnut, growth abundant of forest oak and beech, and dark tracts of pine. You have majestic cliff-girt shores; castle-crowned heights, and gloomy forests; palaces glittering with gilding and paint; mountain passes such as you encounter in the snowy regions of Switzerland; deep bays, and blue seas with bright, calm isles resting on the horizon; meadows and grassy knolls; convents and villages; olive-clothed slopes, and snow-capped mountain peaks; – and with all this a crowded variety of costume and pictorial incident such as bewilders and delights an artist at each step he takes.'

In his oil paintings, Lear would paint peasants in their traditional dress, and throughout his journey he was fascinated by the ornate and picturesque local costume, which was partly Christian and partly Muslim in its origin. That of Scutari, the most northerly point of his Albanian travels, was the finest of all. Many of the men were traders, making fortunes in business with Italy. '. . . it is in Venice or Cáttaro that the Skodra merchant unfolds himself, as it were, for at home his fear of exciting the cupidity of the Turks prevents any such display. Abroad

Berat. 15 October 1848. Pencil, sepia ink, watercolour. 8¼in x 11½in. The Houghton Library, Harvard University

he exhibits all the blazing richness of full Gheghe costume; while it is at home that the Skodra lady indulges in a magnificence of costume almost beyond belief.' In the home of the British Consul he made drawings of a Gheghe chief in his traditional costume, and the daughter of the Consul modelled a Scutarine bridal dress for him.

On 14 October he reached the fortress town of Berat, 'the capital of Central Albania – a place I had so long desired to see'. The next morning he made a social call on the local Bey in his magnificent Turkish-style residence, and he then settled down to work, watched at a discreet distance by an in-

terested and peaceful crowd. But then, suddenly, the local police chief 'casually passing, and being seized with an extemporaneous conviction of some impropriety requiring castigation . . . rushed wildly into the midst of the spectators, with the energy of a Sampson, dashing his stick at their legs, heads, and backs, and finally dispersed the unresisting crowd'. Distressed by the unnecessary violence, Lear gathered up his things and moved to another part of the town.

The watercolour of Berat recedes, as does so much of Lear's work before the 1850s, through brown to grey. It is drawn on grey paper and light-

ened with white bodycolour. The way in which he has composed the group and their carts, echoes the line of the distant hills. He has used empty space as part of the composition, resting the eye and concentrating the interest on the jagged, diagonal activity of the peasants and buffalo, something which he was not prepared to do in his oils.

Outside the walls of Suez. 17 January 1849. Pencil, sepia ink, watercolour. 7⅞in x 5⅛in. Private collection

Wady Feiran, Sinai. 24 January 1849. Pencil, sepia ink, watercolour, heightened with white. 7in x 11⅝in. Private collection

Travels in the desert

Lear finished his Albanian tour on 12 November 1848, and after nine days' quarantine on the island of Santa Maura he sailed to Malta en route for Egypt, the land of 'Memphis & On & Isis & crocodiles & ophthalmia & nubians – & simooms & sorcerers, & sphingidæ'. Here he had arranged to meet a friend, John Cross, whom he had known at Knowsley. From Cairo he wrote to Lord Derby, 'This strange place is so remarkable that I cannot describe it, – & Lane's works [*An Account of the Manners and Customs of the Modern Egyptians*, by Edward Lane, 1836] give a better account of it than I can. The camels amuse & amaze me: I rode on one – a rehearsal ride – yesterday – & was not uncomfortable: only I wish they would not roar & snarl so.' Despite this, they provide Lear the natural history illustrator with willing subjects which he handles with greater aplomb than he does the human figures.

In contrast to Albania, he had come to a country which had been well documented by contemporary artists. Since the time of Napoleon's invasion in 1798, and the subsequent publication of the monumental *Description de l'Egypt* (1808–25) which re-established the importance of an ancient civilisation which had been largely forgotten, artists from all over Europe had been drawn to Egypt. The best-known English artist to have travelled and worked there was David Roberts, who had arrived in Cairo ten years before Lear and who, between 1842 and 1849, published *The Holy Land, Syria, Idumea, Arabia, Egypt & Nubia*.

Although there was so much to see and draw in Egypt, Cross was anxious to go to Mount Sinai and they spent only a few days exploring Cairo before setting out across the desert. The biblical lands in which he now travelled excited Lear with their strange and empty beauty.

He fitted his time for drawing into long days of travel. 'Cross & I rise about 6, & having made our "room" ready – we have breakfast a little after 7 – coffee, bread & butter, eggs & meat', he told Ann. 'After this, the luggage is prepared for the camels – 8 of which are for carrying it. The tent is struck – also the little white tent where our Dragoman lives – & in an hour or so – between 8 or 9 – we are all away from our last night's abode.'

'. . . towards 11 – we stop our camels who make a horrible fuss while kneeling – but soon go on quietly, as we walk ahead of our Caravan. Sometimes we try – when mounted – to pat or scratch them – but they invariably turn round their heads & roar & growl as if we were sticking pins into them: – odious beasts: – so we let them have their own sulky way. – Then we go on – sometimes on camels – (& bye the bye we always lunch on bread & cold meat – oranges & brandy & water, on our moving vehicles: – we get them close together, & so pass plates or

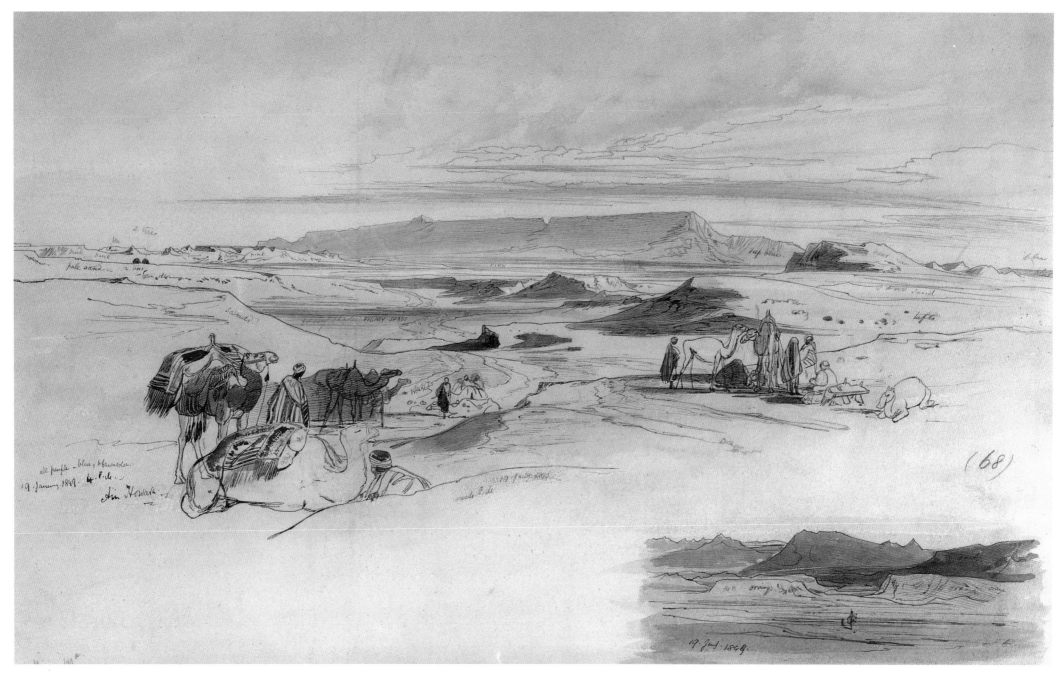

bread &c – from one to the other, – you couldn't fall off if you tried) – and sometimes on foot – till about 4 or ½ past, when Ibrahim goes on to look for a smooth place for the tent, & one that is not exposed to the wind – & then all the camels kneel to unload – the house is made up for the night – & we have dinner at 7 or ½ past 6, after which we seldom sit up long as the day has enough work in it, tho' not very fatiguing.'

On 19 January they passed the Well of Bitter Water called Howara. 'The scenery became beautiful as we went on', he told Ann, 'i.e. – the form &· colors of the mountains on our left – all the rest is sand & rock, but of every variety of shape & tint.' When laying in the watercolour washes in his drawing of Ain Howara he ignored the variety of tint on the distant hills. Instead of laying in the small areas of pink and purple which he observed, he followed another note which suggests that the overall feeling of the scene is one of purple, blue and fawn. Lear often made thumb-nail sketches in the corner of drawings. Generally these give an epitome of the overall outline (see p.11), but here the second, small sketch is of a different scene.

Ain Howara. 19 January 1849. Pencil, sepia ink, watercolour. 12¼in x 20in. The Fine Art Society

Wady Feiran, which they reached on 23 January, was 'the most wonderful & beautiful place I ever saw . . . the great beauty of the place is that it is filled up with a forest of palmtrees, & that there is a running stream in the centre . . . certainly the world contains not such another for loveliness'.

There was no time for Lear to linger in Cairo at the end of his Sinai tour, for he had planned to return and spend the spring in Greece.

Greece

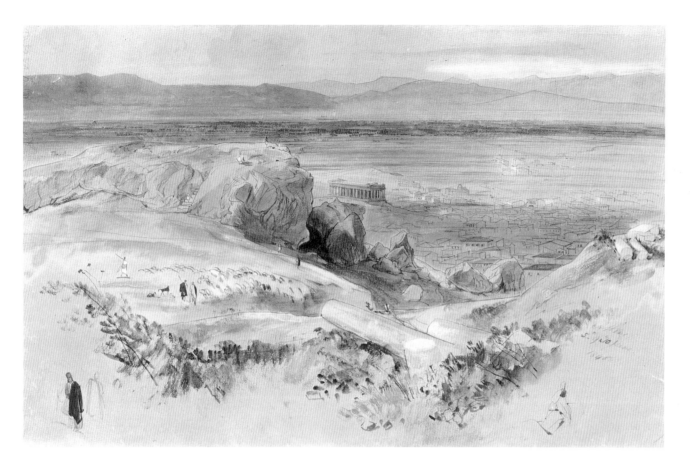

No country so excited Lear's imagination as Greece. The quality of the light with its sunlit clarity, the spacious landscape of wide valleys reaching away to distant hills, combined with associations of ancient history to create an ideal landscape.

Many painters had employed Greek landscape as a backdrop to imagined pictures of the Golden Age of classical antiquity, creating idealised, unreal images. Lear neither romanticised nor intellectualised the landscape, but responded quite simply to what he saw. Looking on the Greek countryside with a clear, visual excitement, he made drawings which are timeless. In his later creations of the Great Gromboolian Plain and the Hills of the Chankly Bore he might weave a web of Utopian fantasy, but here he allowed himself 'no recourse to imagination'. Uncluttered, unaltered, the landscape of Greece was drawn by Lear with more simplicity than by any other painter of his generation.

His first visit to Athens was in June 1848, when he was on his way from Corfu to Constantinople. The days of its glory were long past; for centuries it had been little more than a village of about five thousand people. Chosen as the capital of Greece in 1834, it had not yet sprawled out across the plain. '... surely never was anything so magnificent as Athens!', he wrote to Ann; '... The beauty of the temples I well knew from endless drawings – but the immense

(Above)
Athens. 5, 9 and 10 June 1848. Pencil, sepia ink, watercolour, bodycolour. 11⅜ x 17¾in. The Houghton Library, Harvard University

(Below)
Athens. 23 July 1848. Pencil, sepia ink, watercolour. 4½in x 14¼in. The Houghton Library, Harvard University

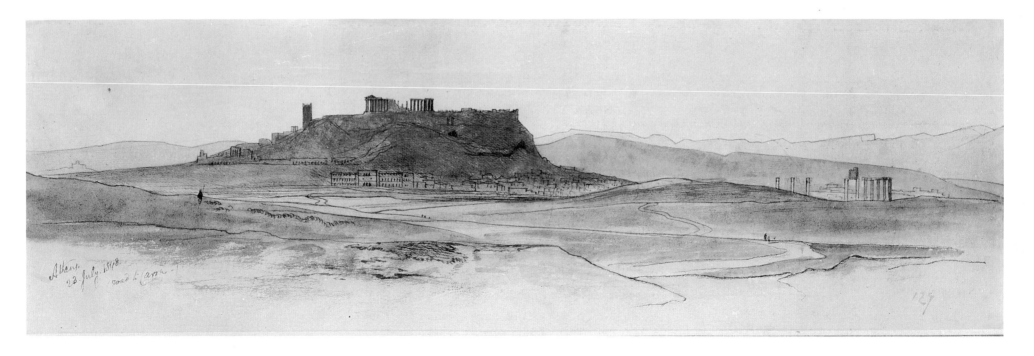

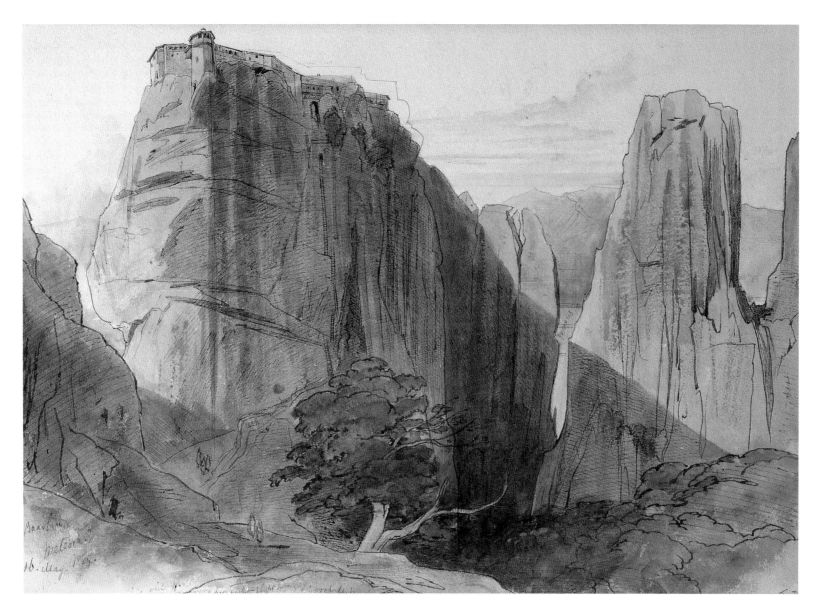

sweep of plain with exquisitely formed mountains down to the sea – & the manner in which that huge mass of rock – the Acropolis – stands above the modern town with its glittering white marble ruins against the deep blue sky is quite beyond my expectations.'

In these two drawings of Athens it seems that Lear worked in watercolour on the spot, although the penning out was probably done later. This was obviously a method which he preferred at this stage, but which he was prevented from using when he was travelling, both by shortage of time and by the problems of packing and carrying sheets of watercolours which were easily damaged when the paper had not had time to dry out.

He returned to Greece with Franklin Lushington at the beginning of March 1849, and they spent six

weeks touring the south of the country. After they parted Lear travelled north on his own, reaching the rocky Meteora on 15 May. Early the next morning he was out drawing the monastery of Baarlam. 'The detached and massive pillars of stone, crowned with the retreats of the monks, rise perpendicularly from the sea of foliage, which at this early hour, 6 a.m., is wrapped in the deepest shade, while the bright eastern light strikes the upper part of the magic heights with brilliant force and breadth', he wrote. 'To make any real use of the most exquisite landscape abounding throughout this marvellous spot, an artist should stay here for a month.'

Throughout the tour his journals and letters are filled with excitement at what he saw. He praises the 'quiet "Arcadian" softness', the 'broad plains, the lines drawn with inconceivable fineness', and 'the

The Monastery of Baarlem, Meteora. 16 May 1849. Pencil, sepia ink, watercolour. 10in x 14in. Private collection

vast yet beautifully simple sweeping lines of the hills'. 'What scenery is this Greece!', he wrote. Yet he knew it would not be easy to re-create what he had seen. 'Shall I remember these lovelinesses, these pure grey-blue seas, these clear skies, cut chiselled hills, and bright white sails, and glittering costumes, and deep shadows, when I am far away from them?' he wrote in his journal. 'It will be difficult at a future period to recall, even to memory, the indescribable clearness and precision of this Greek landscape, far more to place it on paper or canvas.'

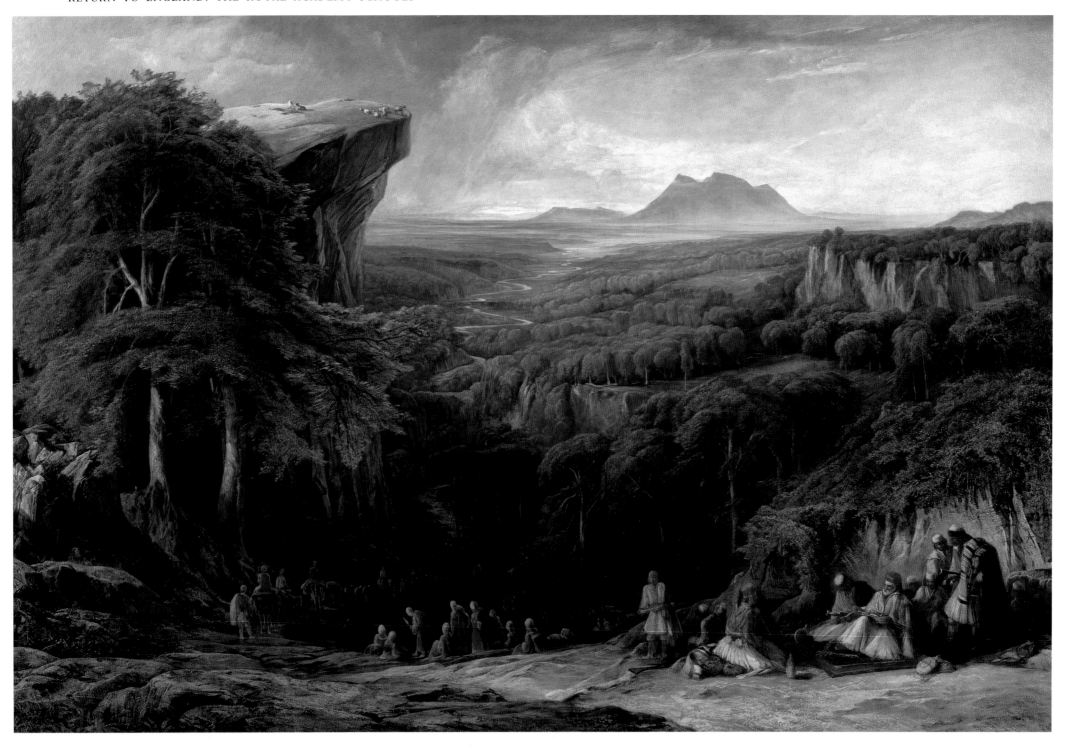

Mount Tomohrit. 1849–52, 1872. Oil on canvas.
48in x 73¼in. Private collection

Return to England: The Royal Academy Schools

Lear returned to England in July 1849, bringing with him folios of drawings from his travels. He had now to decide what he should do next. In Rome he had become a sought-after painter, and through his published work he had also begun to establish a reputation in England. For some time, however, he had felt that he would never be able to develop fully as a painter unless he went back to the beginning, to 'the root of the matter – the human figure – which to master alone would enable me to carry out the views & feelings of Landscape I know to exist within me'. To do this he must go to an art school, something which, despite his age, he was prepared to do. Shortly after his return to England it seemed that this might be possible, for an old family friend left him £500.

The diaries for this period of his life have not survived, and as there are few letters written during his time in England it is difficult for us to know exactly how his plans evolved. Fifteen months of constant travel had left him short of funds, and he told Church that he had come back 'in a good deal of debt and botheration'. Some of this inheritance went immediately in paying off his debts, but enough remained for him to consider fulfilling a long-standing ambition of going as a student to the Royal Academy Schools.

In the autumn of 1849 he enrolled at Sass's School of Art, just as he had done in 1834. During the months before Christmas, he prepared a folio of drawings from the antique which he would submit to the Academy. His sponsor was Thomas Uwins, who was now the Academy Librarian. Meanwhile, he carried on with other work, drawing on the extensive collection of studies he had done on his travels.

The painting of Mount Tomohrit in Albania, with its swirling clouds, its huge rocky crag and its cascading waterfall, has a dramatic power reminiscent of the work of John Martin and is the most sublimely picturesque of all Lear's oils. It shows his continued use of a rather sombre palette. He began work on it in 1849, with the beech trees at Uppark as his models. He then put it on one side, and it was not completed until 1877. He had made the preliminary drawings on 27 September, 1848, and in the published journal of his Albanian travels he described the scene. 'How glorious, in spite of the dimming sirocco haze, was the view from the summit, as my eyes wandered over the perspective of winding valley and stream to the farthest edge of the horizon – a scene realising the fondest fancies of artist imagination! The wide branching oak, firmly rivetted in crevices, all tangled over with fern and creepers, hung half-way down the precipices of the giant crag, while silver-white goats (which chime so picturesquely in with such landscapes as this) stood motionless as statues on the highest pinnacle, sharply defined against the clear blue sky. Here and there the broken foreground of rocks piled on rocks, was enlivened by some Albanians who toiled upwards, now shadowed by spreading beeches, now glittering in the bright sun on slopes of the greenest lawn, studded over with tufted trees, which recalled Stothard's graceful forms, so knit with my earliest ideas of landscape . . . It was difficult to turn away from this magnificent mountain view – from these chosen nooks and corners of a beautiful world – from sights of which no painter-soul can ever weary; even now, that fold beyond fold of wood, swelling far as the eye can reach – that vale ever parted by its serpentine river – that calm blue plain, with Tomóhr in the midst, like an azure island in a boundless sea, haunt my mind's eye and vary the present with visions of the past.'

On 16 January 1850 Lear heard that his application for the Academy had been approved, and he was admitted as a probationer until April, when his work would again be assessed.

The Royal Academy, founded on the pattern of the French Academy in Rome, had been established in 1768 by Sir Joshua Reynolds. Despite its unrivalled prestige, it was the subject of frequent controversy. It was thought by many to emphasise technique and the pursuit of outmoded ideas at the expense of individual talent, encouraging young painters in its schools to see with the eyes of their forerunners rather than developing their own vision.

The Keeper in Lear's time, the man with overall responsibility for teaching, was George Jones. A friend of Turner, his own studies at the Academy had been interrupted by service in the Peninsular War, for his interest in painting was matched by a passion for the army. He had been part of the army of occupation in Paris in 1815, and after his return to England had become known as a painter of battlepieces and military subjects.

Fourteen other students started with Lear, eight of whom – including James Campbell and Robert Harwood – studied painting. The Schools were open daily from ten until three, with the instruction that 'When the Student hath done drawing or modelling, he shall put out his candle'. The first part of the course was spent entirely in the Antique School, where one or more plaster figures of classical sculptures were set out each week for the students to draw. In order to pass on to the next stage, the Preliminary School of Painting, the student had to submit finished drawings of at least three sculptures or groups, as well as those of a head, hand and foot. He also had to do a timed drawing, in twelve hours, of one of the sculptures in the Antique School.

The course in the Preliminary School of Painting was more varied, with painting from casts in monochrome, painting still-life and drapery, copying portions of paintings, and drawing heads, hands and feet from the living model. In the Upper School of Painting there was an opportunity to work more extensively from the living model, both nude and draped, but only after this course was completed could the student move into the Life School. The full training extended over ten years.

Lear completed his three months' probationary period and was accepted as a full student on 26 April 1850. Nothing, however, has survived from this time; there are no known drawings done by Lear at the Academy. It is a period of his life about which he is curiously silent. The only reference he makes to it is in a diary entry in 1860 where 'he rejoiced at my slavy labours at anatomy in 1849–50 – for small progress as I made – I can make somewhat like figures now – & never could before'.

Self-portrait at the Royal Academy Schools. 1850. Sepia ink. Present whereabouts unknown.

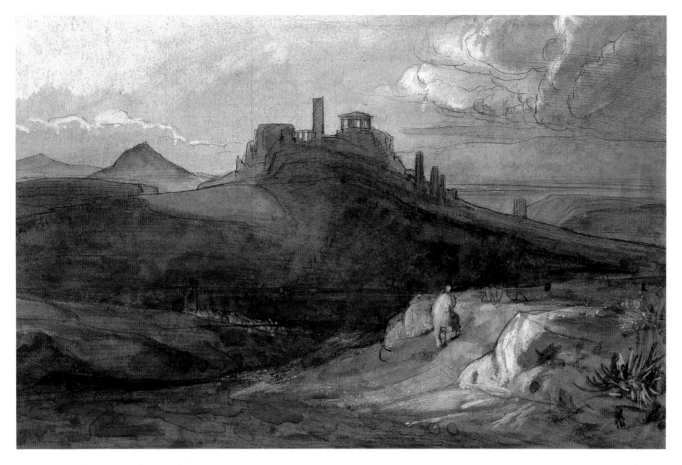

Athens; Study for Oil. 1851. Pencil, sepia ink, watercolour, bodycolour. 5 ¼in x 8in. Private collection

Working alone

It seems unlikely that Lear stayed at the Academy beyond the summer of 1850. Whether shortage of money played any part in his decision to leave, or whether it grew simply from dissatisfaction with the course, is not known. He calculated that it cost him £300 a year to live in London at that time, and it was more than a year since he had sold work of any substance. It appears that the inheritance had all gone.

That year he exhibited for the first time in the Academy Summer Exhibition: his painting *Claude Lorraine's House, on the Tiber*. In the late autumn he was at Knowsley, and after his return to London in mid-November he wrote to Lord Stanley, the son of the 13th Earl, to discuss the subject for an oil painting which Lord Derby had commissioned. Whether the idea for the picture came from Lear or Lord Derby is not known, but it seems likely that the suggestion was Lear's. 'I have often wished to be able to do somewhat to ornament Knowsley', he told Lord Stanley, 'a place, to the owner of which & his family I have so much reason to be grateful.'

Lord Derby had agreed a price of £100 which he paid in two instalments; an initial payment of fifty guineas arrived at the end of November.

The subject for the painting had been left to Lear, and he found it difficult to choose between Athens and Joannina, the ancient city of Dodona in Epirus. He wrote to Lord Stanley asking for his guidance, apologising that 'it is the nature of even the smallest & most wretched of painters to suppose their works may "go down to posterity" – which weakness will excuse my making so much fuss about what is not yet commenced'. In the end Lear decided to paint 'Athens – during the time of Harvest', and he wrote to Lord Derby, 'my idea of taking to Harvest time, is I believe a good one: because, as all the threshing is done on the plain – under the Acropolis – the groups of figures are as *natural*, as they are picturesque in themselves & indispensable to a good foreground in a large subject'.

He proposed to do a preliminary sketch of the scene which he would send to Lord Derby for his approval, although he warned him that 'a small design can only give a *general* idea of a large picture: many of the smaller details are always necessarily modified & arranged during the progress of the work –

else – painting would be easy work'. In March 1851 the sketch was sent with an explanation that it gave 'simply the general effect of light & shade – & the form of the whole. The view is taken from the S. West side of the Acropolis – & commands more features than any other I have – namely – the Acropolis, – & to the right the pillars of the Olympæium with Hymettus beyond: – while to the left are the rocks of the Acropagus, & above them the pointed hill of Lycabettus – with Pentetieus in the extreme distance.'

He had now changed his mind about including figures, and went on to explain, 'The time is to be sunrise or a little after, & I have avoided many figures as solitude & quiet are the prevaling [sic] feelings on that side of Athens . . . The subject is exactly what I wish to do, & I hope your Lordship will write me word if you like it.'

Lord Derby, however, was not entirely happy with the new proposal, and ten days later Lear was writing to him, 'the remark as to the small quantity of detail is true – & that I shall have a good deal of trouble to represent on a large scale the simplicity of the subject; – nevertheless *that* ought to not to prevent my undertaking it. With regard to the great mass of shade – such an extent of quiet unbroken shadow without detail would not be *tolerable* in 999 subjects out of 1000: – but in the present case there are certain qualities, which as far as I can judge, will prevent the effect being liable to objection when finished – these are, the PERFECTLY fine forms – namely the Acropolis & its buildings, Lycabettus, & Hymettus: – these are all excellent, & if one can by

The Akropolis of Athens, sunrise; Peasants assembling on the road to Piraeus. 1852. Oil on canvas. 47 ¼in x 72 ½in. Museum of the City of Athens

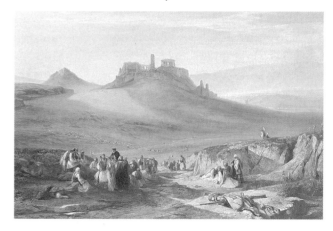

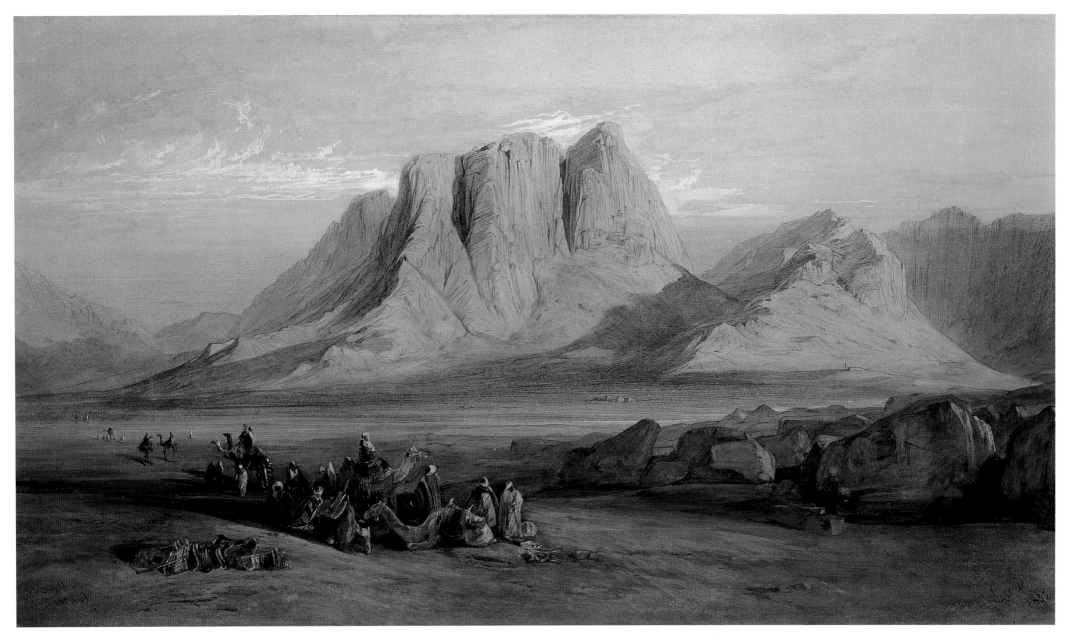

skill fasten the eye & mind on them I do not fear the result. The white marks on the left *do* represent a shepherd & goats, & the light on the right among the rocks is either 1 2 or more figures, according as I may eventually find it necessary to make use of them. In a scene, the chief characteristic of which is excessive solemnity & quiet, it appears to me that all bustle should be sedulously avoided, although one *may* if necessary add what one pleases.'

Apparently it pleased Lord Derby to add figures, and the final painting, which hangs now in the Museum of the City of Athens, is busy with groups of peasants in their traditional costume, the most

peopled of all Lear's oil paintings. The picture, finally entitled *The Akropolis of Athens, sunrise; Peasants assembling on the road to Piraeus*, was exhibited in the British Institution of 1852, and then returned to Knowsley where it remained until 1954 when it was sold at auction for £15.

Other commisions for oil paintings began to come in, including a series of three Grecian pictures for Lord Wenlock. As well as these, Lear was turning increasingly to the preparation of studio watercolours as a means of earning money. These highly finished works, which at this time he did on halftone paper, had now replaced studio drawings as a

Mount Sinai. 1852. Pencil, watercolour, bodycolour. 11½in x 19¼in. Private collection

reliable way of supplementing his income. Based on his travel watercolours, they were designed to be framed and hung rather than kept in portfolios, and they make more use of opaque bodycolour and occasionally gum arabic. As with many of these works, the watercolour of Mount Sinai has two dates, that of his visit there and that on which the watercolour was done.

Working with William Holman Hunt

During the 1840s, the outmoded conventions encouraged by the Academy came under increasing attack. Turgid academic studies of noble deeds from classical antiquity which had for so long filled the walls of the Summer Exhibition, now belonged to an age that was past. The swirling, light-filled brilliance of Turner's work and the value of working direct from nature, were championed by Ruskin in 1843 when he published the first volume of *Modern Painters*.

In the summer of 1849, the year in which Lear returned to England, three paintings, medieval in concept and brilliant in colour, were exhibited at the Academy. Each was inscribed with the initials PRB; the Pre-Raphaelite Brotherhood had arrived as an exciting and controversial challenge to the established art scene.

The Brotherhood was the creation of three young painters: John Millais, Dante Gabriel Rossetti and William Holman Hunt. Their subject matter, based on biblical and medieval themes, was not of particular appeal to Lear, but their aims, of studying nature and employing this study in the expression of genuine ideas, were ones which he had long endorsed. Returning to the work of early Italian painters, they painted into a wet white ground which reflected the light back through the paint surface, giving the colour a rich and gem-like quality.

In the summer of 1852 Robert Martineau, a painter in the Pre-Raphaelite circle, brought Hunt to meet Lear in his studio. In his autobiography, Hunt recalled that Lear was anxious and nervous, as he described to Hunt his method of working from watercolour studies and showed him the painting that he was then doing. This large oil of the Quarries of Syracuse, was based on a drawing which Lear had done in 1847 (see p.51). Hunt believed the reference to be woefully inadequate, but he had a solution. In the foreground of the scene there were chalk cliffs and fig trees; both of these could be found in England. He was about to go down to Fairlight, near Hastings, to work on his painting *Our English Coasts,* a work of which Ruskin later said: 'It showed to us, for the first time in the history of art, the absolutely faithful balances of colour and shade by which actual sunshine might be transposed into a key in which the harmonies possible with material pigments should yet produce the same impressions upon the mind which were caused by the light itself.' He suggested that Lear might like to go with him, so that he could see how he worked. It was a plan to which Lear happily agreed.

Hunt's literal method of working direct from nature meant that he took the canvas itself out of doors, rather than making studies which he then developed in his studio. Lear followed Hunt's teaching in this. 'For the first week or ten days he accompanied me to the cliffs', Hunt later recalled, 'painting the same landscape which I was using for my background. Thus he obtained acquaintance with my manner of work.' In the evenings, as they sat together after dinner, Lear would write into *Ye Booke of Hunte* 'answers to inquiries as to the pigments and system I should use in the different features of a landscape. I hazarded my replies with many protests against their standing as more than the formula of a system, to be modified in every case by conditions and circumstances.' The most immediate result of Hunt's teaching was in Lear's use of colour, an increase in the range of his palette with a move away from browns and ochres. A more subtle effect was the growth of confidence which came from his contact with the most significant art movement of his day. Not himself one of the Pre-Raphaelite Brotherhood, Lear nevertheless considered himself to be a member of its second generation, and he nicknamed Holman Hunt 'Daddy'.

After a few weeks Hunt returned to London, while Lear stayed on at Hastings to finish the Syracuse. Working alone he soon realised how little he still understood, and he wrote despairingly to Hunt, '. . . if you cannot tell me how the shadows of the blessed jackdaws will fall I don't know what I shall do, also the shadows of the 3 blox of stone are too similar in colour, – but I don't know how to change them. Altogether I foresee the possibility of this picture being a failure & remaining unfinished, unless you can help me out of the mess. – It has been so completely impossible even to *see* nature lately – much more to paint from it, that the poor beast of painting has not had fair play. This however by no means weakens my faith as to the proper way of painting – had I been really able to follow it out.'

During that summer and autumn, Lear worked on a series of paintings under Hunt's guidance. As well as the Syracuse, which is still in the family who bought it from Lear, he painted oils of Thermopylae (now in the Bristol City Art Gallery), Reggio (now in the Tate) and Venosa (now at the University of Ohio). 'I really cannot help again expressing my thanks to you for the progress I have made this autumn', he wrote to Hunt in December. 'The Reggio, and the Venosa are both done and in frames, (except that the latter will have to benefit by some of your remarx when we meet –) and I hardly believe I did them. I am now beginning to have perfect faith in the means employed, and if the Thermopylae turns out right I am a P.R.B. for ever. Indeed, in no case, shall I ever return to the old style.' In the spring of 1853, the Thermopylae was exhibited in the British Institution, and a few weeks later the Syracuse was accepted by the Academy from where it was bought by Lord Lygon as an Art Union Prize for £250.

The problems he found in painting out of doors returned in the summer of 1853 when he was working on a picture of Windsor Castle for Lord Stanley, who had now become the 14th Earl of Derby. The weather was constantly changing, and he told Hunt: 'The sky is always beastly blueblack, & I have sent for no end of tubes of that ingredient: – & during this week the sun has shone twice. It is therefore utterly impossible to do this view on a strictly P.R.B. principle, – for supposing a tree is black one minute – the next it's yellow, & the 3d green: so that were I to finish any one part, the whole 8 feet would be all spots – a sort of Leopard Landscape.'

His problems reached a climax when he began work on a large oil of the Temple of Apollo at Bassae. In order to find the right kind of stone for the rocky escarpment in the foreground, he travelled to Leicestershire from where he wrote to Hunt, 'in 15 days there have been only 3 fine & one of those Sunday. I began the subject small, (& it really would be wonderfully fine) – but I found my sight quite unequal to the small near foliage. So, when on Sunday week the "*moon changed*" & it seemed "*set in fine for October*", I fetched the big canvas, (from Leicester, where it had been lying,) & set to work with outline at once as I did at the Syracuse last year. Of course the next day, the 4th, – it poured torrents & did so on the 5th, 6 – 7th – & 8th – all day long each day. I got oak boughs indoors, but did no good by so doing. On Monday, it was clearer, – i.e. not raining – so I had the canvass carried up & worked some hours. Yesterday I did so again, but instantly it came down in waterspouts, & nobody coming to me, I absolutely took the 7 foot canvas on my shoulders – & walked off to the inn – a good half mile & more. – Today it rains al solito. I hate giving anything up – it demoralizes one so. If I could only get the *leaves* done, & a little bit of fern, I could get the branches

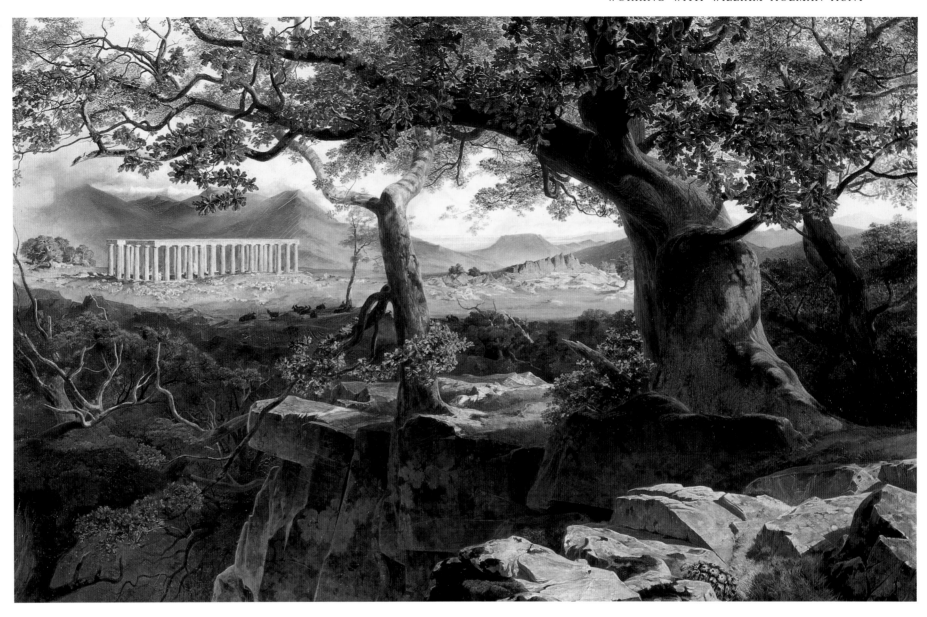

The Temple of Apollo at Bassae. 1854. Oil on canvas. 56in x 91in. Fitzwilliam Museum, Cambridge

& rocks easily. But the leaves are falling fast.' To William Rossetti he wrote with amused resignation: 'I intend to remain until I have finished some rox & oax for a Greek picture – begun last year – à la clair-voyant system'.

In this painting we can see the obvious pleasure which he took in the painting of trees, a subject for which he felt an increasing fascination. The control and understanding which came from his new method of working direct from nature can be seen when this work is compared with his less imagined, more stylised handling of trees in his 1849 painting, of Mount Tomohrit (see p.58). It can also be seen in his painting of the rocks in the foreground. The nineteenth-century geologist, Sir Roderick Murchi-

son, found that Lear's drawings told him the geology of the country, even though Lear had no geological knowledge; the early training in accurate observation was never far away. In this painting, he also allowed himself the amusement of demonstrating an area in which he surpassed even his loftiest peers; in the bottom right-hand corner of the Bassae the natural history illustrator who had once prepared drawings for a volume of Testudinata has painted a clambering tortoise.

On the other hand, although Lear spoke frequently about the strict topographical accuracy of his paintings, in this picture he moved mountains. The shape of the distant line of hills has been altered to create a more balanced design, and the various

elements which make up the picture, all of which exist at Bassae, have been assembled from different viewpoints. Lear took such artistic licence on at least one other occasion, when he was painting Pentedatelo in Calabria. Although contrary to his proclaimed practice, these improvements to the natural composition play their part in making this one of the most exciting and successful of Lear's oils.

The painting, which remained unsold for some years, was bought in 1859 by a group of friends who donated it to the Fitzwilliam Museum in Cambridge, 'being desirous that Mr. Lear's Picture of the "Temple of Bassae", should find an appropriate and permanent place in the Museum of a Classical University'.

Egypt and the Nile

A succession of English winters had taken its toll on Lear's health. Days of confinement indoors in 'those dark smoky rooms' where the light was 'so narrow & contracted & small' depressed his spirits. His asthma and bronchitis returned, and he knew that he must abandon his idea of settling in London. With another winter coming on, he made plans to leave England.

During their time at Clive Vale Farm, Lear and Hunt had discussed the possibility of travelling together to Egypt and Palestine. But Hunt was working to complete his painting, *The Light of the World*, and could not leave at once. By the end of November Lear could delay no longer. Thomas Seddon, one of the Pre-Raphaelite circle, was already on his way out to Cairo; Lear would join him there, and together they would await Hunt's arrival.

He left England at the beginning of December, 1853, reaching Cairo on the 18th. A few days later he did two watercolour portraits of Richard Burton the explorer. Strangely, Lear does not mention this meeting in his diary, although there is no doubt that the watercolours were done from life.

Apart from a few early drawings (see p.21), Lear attempted few portraits. His lack of understanding of the human form was something which troubled him all his life, and we have seen that his attempts to master this had come to nothing. In this portrait, which was probably done directly in watercolour, the hands and feet are unfinished, but whether this is because he could not resolve the drawing or because he ran out of time, we do not know. Certainly, they display a weakness of draughtsmanship which is often found in his figures. On the other hand, there is a brooding presence which suggests that, had he had the opportunity to master human anatomy as he did that of birds and animals, his figures would have enhanced his paintings instead, as so often happens, of detracting from them.

He had planned to stay in Cairo until Hunt arrived, but he suddenly changed his plans. He had developed a fever, possibly a return of malaria, and as Cairo was damp he decided that he would leave at once for Upper Egypt and the Nile. He was travelling on his own, and wrote anxiously to Charles Church, 'Do not say a word of my fever, or of my

Richard Burton. 23 December 1853. Pencil and watercolour. 9in x 6⅛in. The Houghton Library, Harvard University

Cairo Dec. 23. 1853

being alone, if you please, as I do not wish my sister to hear of those facts.' Indeed, his letters to Ann are full of delight about the party of agreeable English people with whom he was travelling, and the beauties of everything he saw. '. . . it is a magnificent river', he told her, 'with endless villages – *hundreds & hundreds* on its banks, all fringed with palms, & reflected in the water; – the usual accompaniments of buffaloes, camels, etc. abound, but the multitude of birds it is utterly impossible to describe, – geese, pelicans, plovers, eagles, hawkes, cranes, herons, hoopoes, doves, pigeons, king fishers & many others. The most beautiful feature is the number of boats, which look like gigantic moths.'

When he reached Philae he decided to go no further south, but to stay and explore the island. He was there for ten days, and having more time than was usual on his travels he decided to use oil paint and watercolour as well as making drawings. 'It is impossible to describe the place to you,' he wrote to Ann, 'any further than by saying it is more like a real *fairy island* than anything else I can compare it to. It is very small, & was formerly all covered with temples, of which the ruins of 5 or 6 now only remain . . . The Nile is divided here into several channels, by other rocky islands, & beyond you see the desert & the great granite hills of Assouan. At morning & evening the scene is lovely beyond imagination. – I have done very little in oils, as the colours dry fast, & the sand injures them; water colours also are very difficult to use. But I have made a great many outlines.' In his watercolour *Philae,* he has again used empty space as a compositional foil to the busyness of the middle distance.

After his initial excitement, he felt that Egypt lacked 'the romance or the variety and interest of Greece, but *what there is* is so perfect in its own peculiar beauty. Some scenes are wonderfully lovely, though many are too monotonous and without any recommendation, but the unconsciously exquisite colour of sky and earth.'

When he revisited Egypt in 1867, he realised that in his studio work he had failed to recreate accurately what he had seen. 'I have never made enough of the *dark gray* & *black*=rooted granite rox in the water – always too red & yellow in my drawings,' he wrote. 'It seems to me, my former drawings were not *severe* enough: & certainly, I never made enough of the grayness of local colour, nor of atmosphere – nor of contrast of almost black & green with the oker &c. The rox – so I think now – are not dark enough in my former drawings . . . the sky not tawny browny purple enough, it seems to me today – cindery'.

He arrived back in Cairo to find that Hunt had arrived and was about to leave for Palestine with Seddon. Lear wanted to go with them, but as the Nile journey had been expensive and he could not afford to extend his travels further, he left once more for England.

Philae. 31 January and 4 February 1854.
Pencil, sepia ink, watercolour.
12¼in x 19¼. Private collection

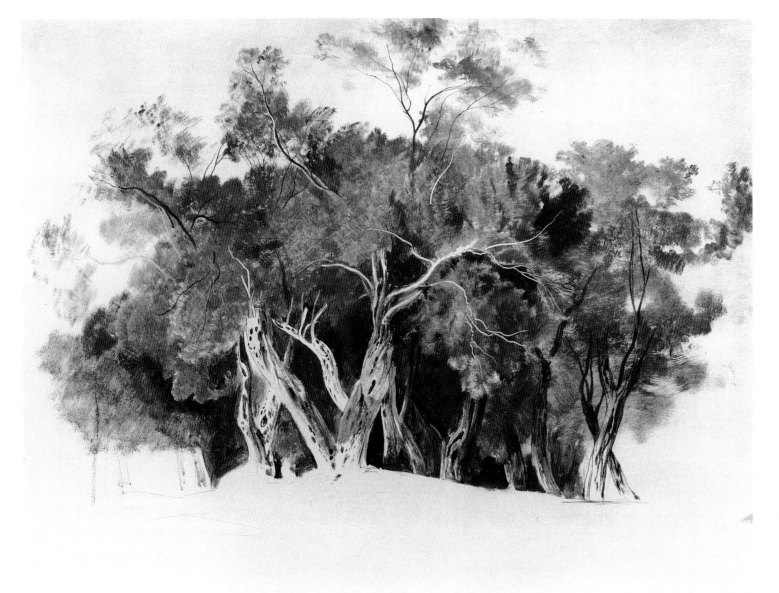

Olive Trees. 1858. Oil on paper. 18in x 23in. The Houghton Library, Harvard University

immense grove of olive trees – so that you see over a carpet of wood wherever you look; & the higher you go, the more you see, & always the Citadel & the Lake, & then the Straits, with the great Albanian mountains beyond.' It was a view he was to paint many times, and was the subject of his next large, uncommissioned oil. He ordered a canvas measuring 9ft 4in by 6ft, to be sent out from London, and while waiting for it to arrive he explored the island.

In June he was at the village of Horoepískopi, fourteen miles from Corfu, 'on a double rocky hill in the midst of a valley entirely full of splendid oranges – & cypresses; just as if it were in a basin; – on the other side of the basin are several other villages – & to the north all the hills slope away to the sea, beyond which, my old friends the Khimariote mountains are seen.' Living on the island, he had time to experiment in other ways of working; there was no need to hurry from one place to the next gathering as much reference as he could. At Horoepískopi he did a number of dramatic and interesting drawings which display a new and technically experimental ingenuity and boldness in his use of watercolour. This was the beginning of a decade which produced Lear's most accomplished watercolours, an improvement which he himself attributed to the confidence which had grown from his recent experience in the use and handling of oil paint.

In preparation for his large oil, he also made a number of powerful *plein air* oil studies of olive trees: 'The trees go on bit by bit very decently', he told Hunt, 'I go up to Ascension . . . & make the studies: – & then reproduce them.' Of all trees, the olive, with its shimmering green and silver leaves and its gnarled and twisted trunks which read grey in the light and black against it, most fascinated Lear. Ten years later, revisiting the island and climbing the hill above the village of Ascension, he wrote: '. . . Over head ever the loved olive: far below "bowery hollows" of green – ever & ever retreating: spotless blue above: glimpses of darker blue sea, & pearly radiant mountain through the transparent foliage. No wonder the Olive is undrawn – unknown: so inaccessible=poetical=difficult are its belongings.'

After the constraints of London life, he found Corfu a perfect place in which to live. 'There is so much chance of constant improvement here, that I should find great difficulty in giving the place up wholly,' he told Ann, 'for I can run out for fore-

Corfu

In that summer of 1854 Lear spent two months touring Switzerland, from where he wrote to Ann, 'I am . . . greatly delighted with what I have seen of Switzerland, though I do not think I can ever paint it; to represent it well, it requires more hard labour than the landscape of any country I am acquainted with, – because, though there are not great distances, yet all around one is as it were on perpendicular & in & out surfaces, – filled up with innumerable details, to draw which, requires immense study.' Close, overpowering mountains never appealed to Lear as subjects for pictures, nor was he at ease in enclosed valleys. In a country which had inspired

the imagination of so many painters, he produced little work of interest.

The following winter was a difficult one for him. It was wet and cold and dark, and he realised that he could not stay in England for another winter. In the summer of 1855, Lushington was appointed a judge in the British protectorate of Corfu, and he suggested that Lear might go with him. It was an invitation which Lear accepted happily.

On his last, brief visit to Corfu in 1848 he had been overwhelmed by the beauty of the island, and on his return now he was not disappointed: '. . . no place in all the world is so lovely I think', he wrote to Ann, describing the view from above the village of Ascension. 'The whole island is in undulations from the plain where the city is, to the higher hills on the west side; & all the space is covered with one

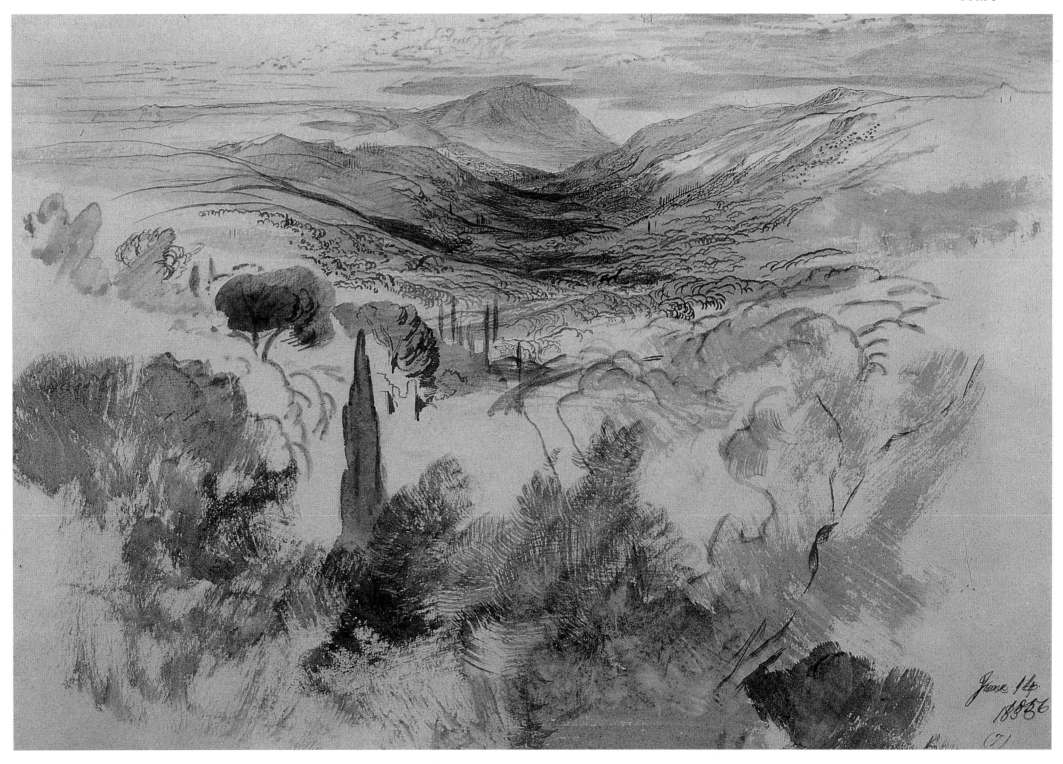

Horoepískopi. 14 June 1856. Pencil and watercolour. 9in x 13³/₁₆in. The British Council, Athens

grounds close by – cliffs, olives, myrtles etc. etc. – at any time, & as it appears to me more & more that my painter's reputation will be that of a painter of Greek scenery principally, so this place presents on that account many advantages nowhere else to be found.' One of these advantages was a return of the *petit maître* patronage which had served him so well in Rome. In an expatriate community he became known as the resident artist, and many of the British were happy to buy and commission works.

Mount Athos

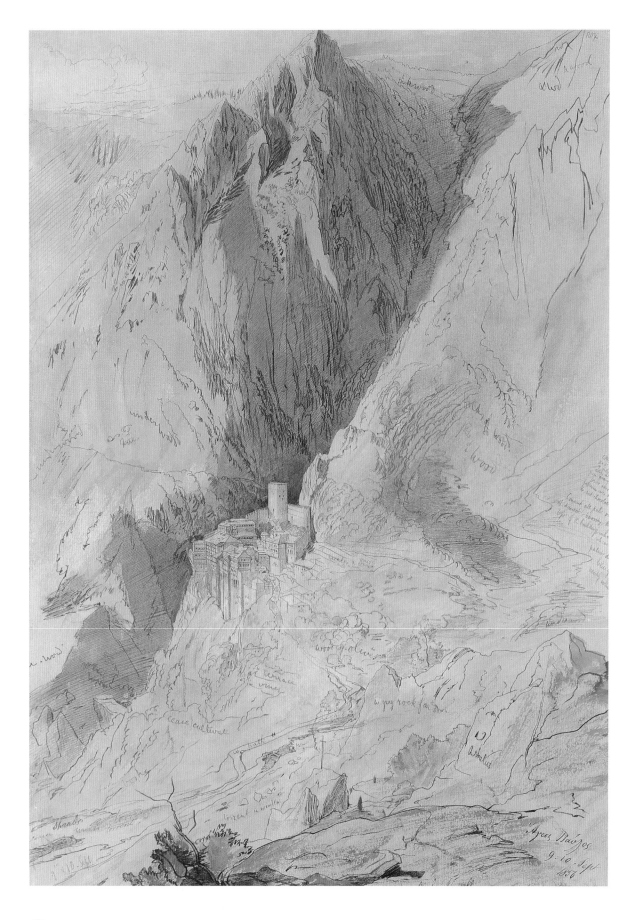

It was Lear's plan, while in Corfu, to revisit mainland Greece and see those parts of it which he had earlier missed. During a pause in his work on the large picture of Corfu, he decided that he would try once more to get to Mount Athos. 'There are 20 principle monastries . . . up & down – besides 50 or 60 little ones!' he told Ann. 'I mean to go to all, & draw all, & most probably publish all.'

He left Corfu with his new servant, Giorgio Kokali, in the middle of August 1856 for a fascinating, but not entirely enjoyable, three weeks. With its banishment of all female creatures, and what he later described as its 'muttering, miserable, muttonhating, manavoiding, misogynic, morose, & merriment=marring, monotoning, many-Mulemaking, mocking, mornful, mincedfish & marmalade masticating Monx', Mount Athos was not a place in which he felt at ease.

'Do you know the history of Athos – the ancient Acte? –' he asked Emily Tennyson, 'a long mountain narrow peninsular ridge standing up in the sea – joined at one end to the main land by a very narrow isthmus wh: once Xerxes chopped through, & its southern end rising into a pyramid 6700 feet high, strictly the Mount Athos of geography. This peak alone is bare – all the rest of the ridge is a dense world of Ilex, beech, oak, & pine. From Constantine & Justinian, who gave up the whole of Acte to Christian hermits, – to the Byzantine Emperors who added to convents already built, & founded others, and down to Sultans as far as our own day – every ruling power in the East has confirmed this territory to the monks as theirs, on proviso of paying £1500 per ann. to the Porte. So the whole strange place has gradually grown into one large nest of monkery.'

At dusk on his first day he reached the capital, Karyes, where he presented his letters of introduction and was given a circular note to all the monasteries on the peninsula.

Ten days later he approached the monastery of St Paul '. . . through beech & pine woods – very like the Swiss alpine scenes. And on coming to the west side you descend a frightful staircase to St. Anna, a little monastery I greatly regret not having drawn; but I knew there was short time to get to St Paul's – & those cliffs are not places for after dusk . . . St Paul's

The Monastery of St Paul. 9 and 10 September 1856. Pencil, sepia ink, watercolour. 15¼in x 9¾in. Private collection

Karyes. 12 September
1856. Pencil, sepia ink,
watercolour.
14¼in x 20½in.
Private collection

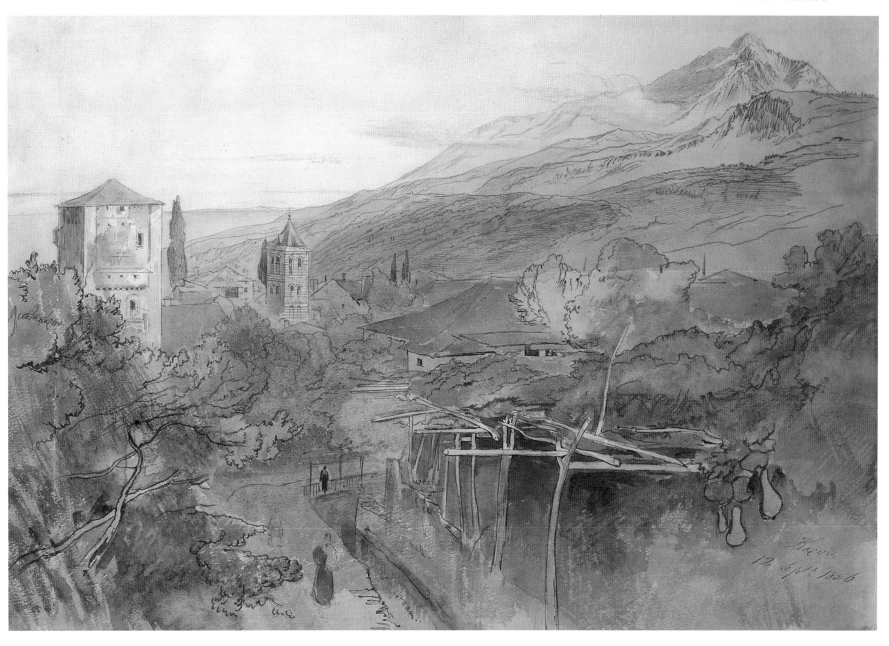

monastery is wholly different to those I had previously seen; piled up on vast rocks over a torrent, just below the highest point of the mountain; I have 2 very accurate drawings of it – but they appear, though exact – almost too wonderful.' The bold vertical composition, in which he excelled, combines with a dramatic landscape to create one of the most brooding and powerful of all Lear's watercolours.

On 12 September he again approached Karyes, this time in the pouring rain. 'I forgot my own rules & maxims' he told Ann, 'for I had got wet in that rain, & yet seeing the finest view of Kariess as I entered the town, I did not go on to change my dress – but stopped to draw over a damp ravine. I had

hardly got into the house when my dearly beloved friend Mr. Fever – gripped me – & in the most decided manner!!' He was ill for three days, an illness which added to the already considerable discomfort of his tour of Mount Athos. But it was a journey that had been worthwhile.

'I never saw any more striking scenes than those forest screens & terrible crags, all lonely lonely lonely', he told Emily Tennyson, 'paths thro' them leading to hermitages where these dead men abide, – or to the immense monasteries where many hundred of these living corpses chant prayers nightly & daily: the blue sea dash dash against the hard iron rocks below – & the oak fringed or chestnut covered

height above, with always the great peak of Athos towering over all things, & beyond all the island edged horizon of wide ocean.'

'. . . oh my! I am so sick of convents!' he confessed to Ann. 'However, anxious as I was to get out of them I could not but feel a great pleasure in having done all I had appointed to do – & in possessing some 50 *most valuable drawings*, for I believe no such collection of illustrations has as yet been known in England'.

He talked of publishing an account of his tour, for he had kept 'a most elaborate journal', but he did not do so, and the journal has since disappeared.

69

Petra

In the spring of 1858 Lear left Corfu to visit the Holy Land, a journey he had long wished to make. He landed at Jaffa on 27 March, and on Palm Sunday he had his first view of Jerusalem. His excitement soon disappeared, however, when he reached the city and found it crowded with Easter pilgrims, and he decided to travel on at once to Petra, returning to Jerusalem when it was quieter.

Petra, the ancient 'rose-red city', once capital of the Nabataean tribe and centre of the Arab world, had been lost for twelve centuries until its rediscovery in 1812. The journey across the Jordanian desert took them over the land of more than one Bedouin tribe, rivals for the rich pickings to be had from travellers. Before leaving Jerusalem, Lear took on a dragoman to act as guide and to negotiate with the tribesman whose land they must cross. At Hebron they picked up an escort of fifteen men.

They left Hebron on camels on 8 April, and passed through 'a pale, strange world of sand and rock', with distant views of the Moab mountains. When they came out from the narrow gorge of the Sufa pass, there suddenly opened before them a scene of 'astonishing beauty of colour and its infinite details of forms and masses of rock and sand'. His painting things, however, were on the back of a camel which had taken another, easier route across the mountain. 'I resolved to remember this lesson of the inconvenience of parting with my tools', he wrote in his Petra journal. Unable to draw, he nevertheless lingered there for a long time, for 'it seemed impossible that one could ever weary of contemplating so strange a glory and beauty as that outspread desert and mountain horizon presented'.

As they went on the scenery grew even more splendid, but nothing had prepared him for the scenes which greeted them as they approached Petra. '. . . after passing the solitary column which stands sentinel-like over the heaps of ruin around, and reaching the open space whence the whole area of the old city and the vast eastern cliff are fully seen, I own to having been more delighted and astonished than I had ever been by any spectacle. Not that at the first glance the extent and magnificence of this en-chanted valley can be appreciated: this its surprising brilliance and variety of colour, and its incredible amount of detail, forbid. But after a while, when the eyes have taken in the undulating slopes terraced and cut and covered with immense foundations and innumerable stones, ruined temples, broken pillars and capitals, and the lengthened masses of masonry on each side of the river that runs from east to west through the whole wady, down to the very edge of the water, – and when the sight has rested on the towering western cliffs below Mount Hor, crowded with perforated tombs, and on the astonishing array of wonders carved in the opposite face of the great eastern cliff, – then the impression that both pen and pencil in travellers' hands have fallen infinitely short of a true portrait of Petra deepens into certainty. Nor is this the fault of either artist or author. The attraction arising from the singular mixture of architectural labour with the wildest extravagances of nature, – the excessive and almost terrible feeling of loneliness in the very midst of scenes so plainly telling of a past glory and a race of days long gone, – the vivid contrast of the countless fragments of ruin, basement, foundation, wall, and scattered stone, with the bright green of the vegetation, and the rainbow hues of rock and cliff, – the dark openings of the hollow tombs on every side, – the white river bed and its clear stream, edged with superb scarlet-tufted blossom oleander alternating with groups of white-flowered bloom, – all these combine to form a magical condensation of beauty and wonder which the ablest pen or pencil has no chance of conveying to the eye or mind. Even if all the myriad details of loveliness in colour, and all the visible witchery of wild nature and human toil could be rendered exactly, who could reproduce the dead silence and strange feeling of solitude which are among the chief characteristics of this enchanted region? What art could give the star-bright flitting of the wild dove and rock-partridge through the oleander-gloom, or the sound of the clear river rushing among the ruins of the fallen city? Petra must remain a wonder which can only be understood by visiting the place itself, and memory is the only mirror in which its whole resemblance can faithfully live. I felt, "I have found a new world – but my art is helpless to recall it to others, or to represent it to those who have never seen it." Yet, as the enthusiastic foreigner said to the angry huntsman who asked if he meant to catch the fox, – I will try.'

At noon he sat down to draw the scene, working until it was too dark for him to see. 'As the sun went down, the great eastern cliff became one solid wall of fiery-red stone, rose-coloured piles of cloud resting on it and on the higher hills beyond like a new poem-world betwixt earth and heaven', he wrote.

It was the last chance he had for undisturbed work. When he returned to the camp, he found angry Bedouin arguing with his men, demanding an extra tax in addition to the one he had already paid. That night they went uneasily to bed, but by four o'clock the next morning a hundred local tribesmen had gathered, demanding tribute-money. Lear packed his things ready to leave, then slipped away to get drawings of the El-Khasnè, the temple of El-Deir, and the theatre.

When he returned, matters had become even worse, with violent quarrelling and shouting. Lear was seized and his pockets emptied. More money was demanded for their safe conduct, and they had no choice but to pay this and leave Petra at once. He had been able to do no more than a handful of drawings.

The painting of the eastern cliff is based on a drawing he had done on his first afternoon, before the arrival of the local Bedouin. He worked on the painting during the winter of 1858–9, and it was subsequently bought for £250 by Sir Thomas Fairbairn, the Victorian connoisseur. In 1872, he borrowed it back so that he might exhibit it in the Academy where it was hung immediately above Whistler's *Arrangement in Grey and Black, No. 1: The Artist's Mother.*

The Times critic lamented its position, 'with all its delicate workmanship of foreground and distance, and its infinitely painstaking elaboration of local colour, utterly invisible where it hangs, beyond critical ken, at the top of Gallery 9. As if in mockery, or by that meeting of two extremes which has grown into a proverb, "Petra" is placed immediately above Mr. Whistler's "arrangement of gray and black", which, thanks to its broad simplicity, would have lost nothing had the two pictures changed places, while, as they hang, Mr. Lear's delicate work is entirely sacrificed.'

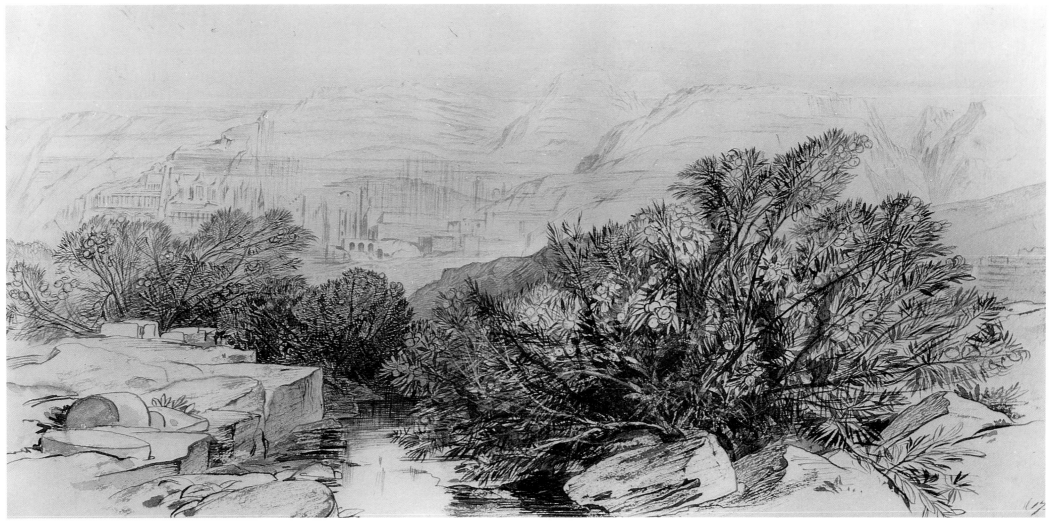

Petra. 1858. Pencil, sepia ink, watercolour, bodycolour.
10in x 20½in. Private collection

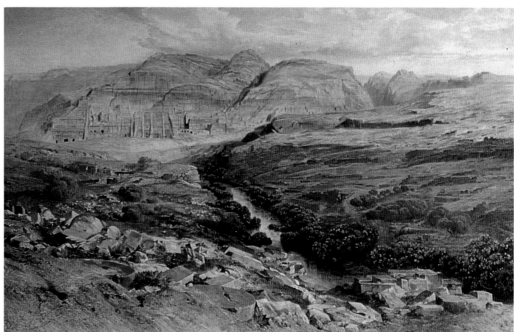

Petra. 1859. Oil on canvas.
36in x 60in. Private collection

Jerusalem. 24 April 1858. Pencil, sepia ink, watercolour. 13in x 19¾in. Private collection

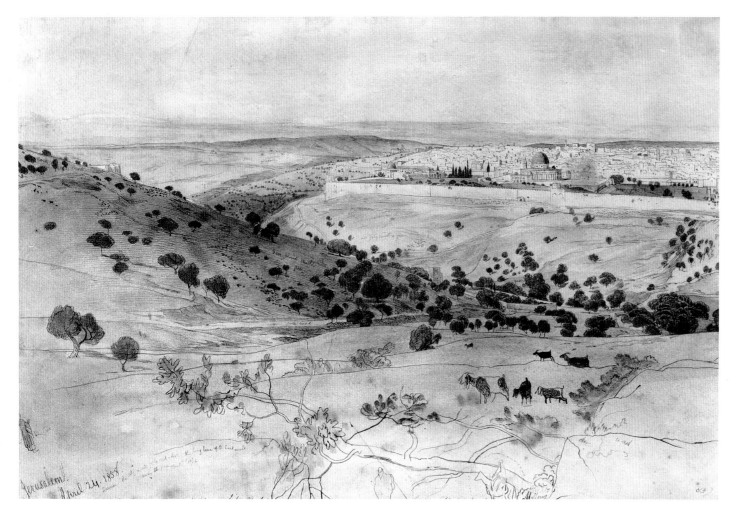

Palestine

From Petra, Lear went to the Dead Sea and Masada, and then returned to Jerusalem. Before leaving for the Holy Land, he had been given two commissions by Frances, Lady Waldegrave. One was to be a view of Jerusalem, and he now set about finding the best position from which to paint the city.

He camped for a week on the Mount of Olives, and went out each morning before dawn making preparatory drawings. '. . . just at sunrise the view of the city is most lovely', he wrote to Ann, 'all gold & white beyond the dark fig & olive trees; but it is very difficult to draw correctly; & unless it is quite so, the drawing is useless.'

For Lady Waldegrave's painting, he chose a north-east view of the city: '. . . the site of the temple & the 2 domes . . . the ravine of the valley of Jehosaphat, on which the city looks: – and Absalom's pillar–(if so be it is his pillar–) the village of Siloan, part of Adeldama, & Gethsemane are all included in the landscape', he wrote to tell her. 'And besides this the sun, at sunset, catches the sides of the larger Eastern buildings, while all the upper part of the city is in shadow; – add to all which there is an unlimited foreground of figs, olives, & pomegranates, not to speak of goats, sheep & huming beings'.

The drawing which he did on 24 April, with its rhythmic, overlapping lines of hills, its sweeping curves of dotted trees and its outsized goats, is one of the studies on which he based the painting. It was a view which he painted several times but of which he wearied, finding the small architectural detail impossibly trying to his eyes.

On 30 April he set out to visit the ancient monastery of Dar Mar Sabbas in the Jordanian desert. It 'stands in the gorge of the Kedron – not far from the Dead Sea', he wrote to Ann. '. . . in about 2½ hours from setting out, [we] came to the spot where the Kedron, (when it has water in it) runs steeply down to the Dead Sea between terrific walls of perpen- dicular rock. Down the sides of this – stuck against it as it were, is the monastery, fortified by immense walls – & oddly differing from my Athos acquaintances in as much as it is all sand colour – all like the desert round it. If it were not for the towers & the white domed church it would hardly seem separate from the rocks.' Despite the terrific heat, he made a number of excellent drawings packed with an inventiveness and flowing rhythm which has become smoothed out and deadened in his later oil painting of the same scene.

The following day he was back in Jerusalem, from where he wrote to Ann on 3 May, 'This morning I was out before sunrise, drawing the west side of the city. Giorgio took out some coffee & sugar, & we built a kind of small oven of stones, where he made a very good cup; it was very acceptable for it is cold here early.' 'G's coffe shop' is written on the drawing.

Within a few days Lear had finished his Jerusalem work, and he left the city going north towards the Sea of Galilee and Nazareth. On the road he was stopped by a group of Arabs demanding money. Exhausted by the heat, he realised that he could not go on and turned back to Jerusalem. He later regretted that he had missed places he so much wished to see, and which would have given him valuable drawings. Three months later, in the peace of Corfu, he began to draw up a new scheme which would allow him to go once more to the Holy Land, this time for a much longer visit. 'I have a wonderful new plan – to go to Jerusalem for 2 months – by way of a novel arrangement,' he wrote to Fortescue, '. . . for 100 friends to have a £10 drawing of any place they will name – in Palestine – the tin to be advanced beforehand – thus enabling me to stay there 2 or 3 years, & to illustrate all the topography.' He spoke of doing a 15ft painting of the city, and of preparing drawings for engraving, but none of these plans came to anything, and although he visited Jerusalem again in 1867 he never succeeded in getting to either Galilee or Nazareth.

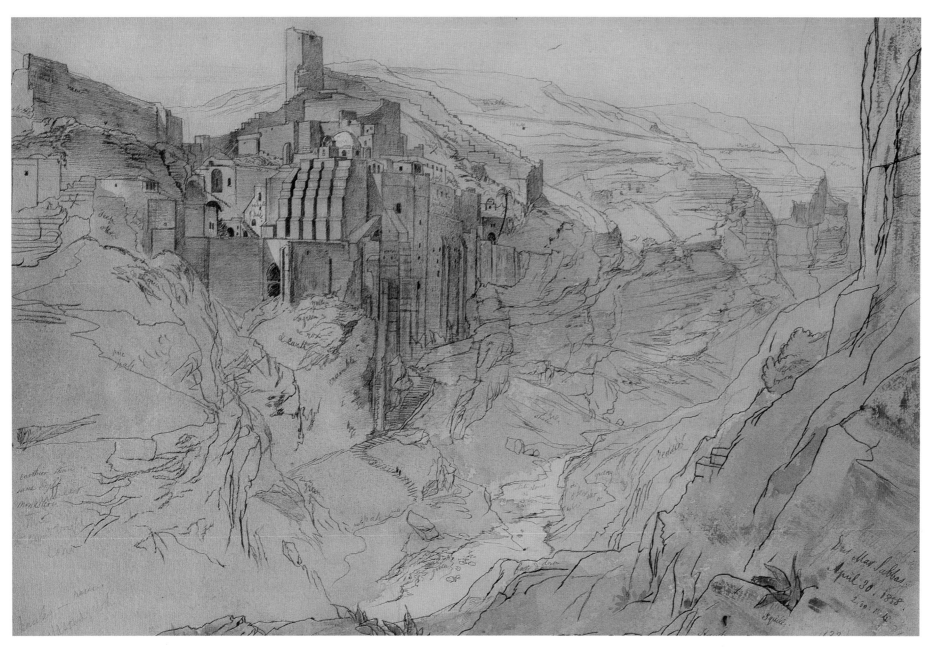

Jerusalem. 3 May 1858. Pencil, sepia ink, watercolour.
6in x 19¾in. The Tate Gallery

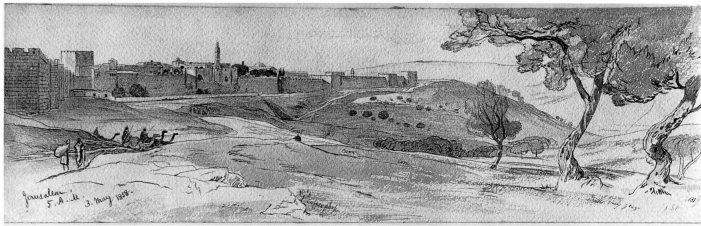

Dar Mar Sabbas. 30 April 1858. Pencil, sepia ink,
watercolour. 14in x 22¾in. Private collection

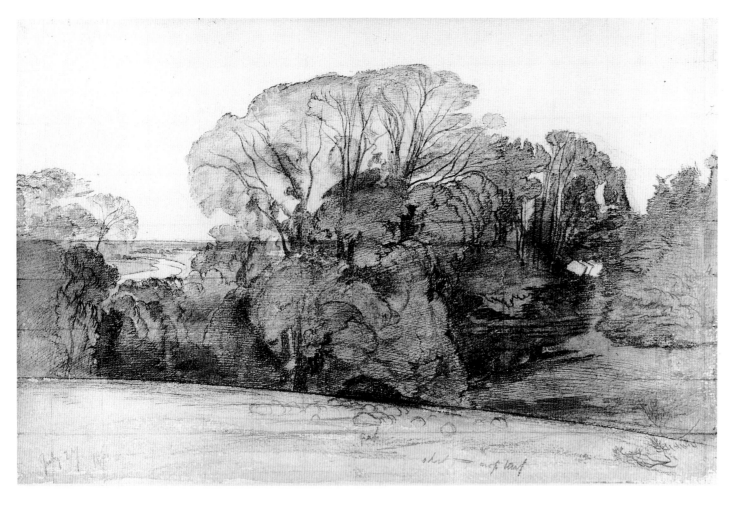

Nuneham, Oxfordshire

In 1858 Lushington resigned from his post in the Corfiote judiciary and returned to England. Lear was undecided about what he should do. 'My plans? – my dear boy', he wrote to Fortescue, 'my plans are frightfully vague & prismatic & shifting.' In the end he decided to return to Rome for the winters of 1858 and 1859. But it was a mistake to have gone back. Since leaving Italy he had not only travelled in some of the most wild and beautiful countryside he was ever to see, but he had also, in his contact with the Pre-Raphaelites, moved into the mainstream of contemporary English painting. The way of life he found in a city which had once offered him so much, now seemed narrow, claustrophobic and artificial. He visited it only once more, in the summer of 1871.

When he returned to London in May 1860, he was commissioned by Lady Waldegrave to do two oil paintings of her house, Nuneham in Oxfordshire. Despite his affection for the English countryside, with its lush green vegetation, Lear produced only six known English oils. Perhaps he felt that there were others who could paint it far better than he would ever be able to do. Certainly, in selecting the subjects for his large, uncommissioned oils – Civitella di Subiaco, Mount Tomohrit, Syracuse, Bassae, Corfu – he had chosen countryside that was more dramatic and visually powerful than anything the softer landscape of England could offer. He had visited places which no other English painter had seen, and he believed that it was in his wide travels and his understanding of the form and atmosphere of Mediterranean scenery that he could make his particular contribution.

His first English oil, of the mill at Arundel, was painted in 1847 for a family whom he had known there as a boy; in 1853 he painted Windsor Castle from St Leonard's Hill for the 14th Earl of Derby, a painting which resembles the Nuneham oil in its sheep-strewn foreground and the line of trees which make up the middle distance, and also in its greenness. '. . . there are many who think that trees should never be painted green (because they *are* so)', he had written. 'To such, strict copies of nature are odious.' The representation of the actual colours which existed in nature had been much criticised by some painters and their theoreticians earlier in the century, when only the sombre palette appropriate for the serious study of Historical painting had been thought acceptable. 'That's a nasty green thing', some Academicians had said of a Constable painting of English landscape, but Ruskin defended this use of colour. 'Such things *are*', he wrote, 'though you mayn't believe it.'

Lady Waldegrave invited Lear to stay at Nuneham while he worked on the pictures. He was never at ease working in other people's houses where he had little control over his timetable or his use of daylight, and before leaving for Nuneham he wrote to her: 'I am going to ask you if I may divest myself of the duty of breakfast in the mornings – (save Sunday,) because, as I begin early, & the effect of light & shade ceases at 11/2 – the interruption of cleaning & feeding at 10 – will just cut up the best part of my morning. Alas, when in a state of application, or incubation as it were, I am more or less necessarily disagreable [sic] & absent, & should certainly answer "Elm trees & bridges", if they asked me whether I would "take tea or coffee".

'Directly after I finish my morning work, I should willingly devour a Sandwich, & go across to the Church view, which I shall be able now to see very well, as I can place my canvass on a lofty easel, I myself standing on the green seat, thus:'

The squared-up preliminary watercolour above is one of very few such watercolours to have survived; the watercolour of Athens (see p.60) represents a later stage in the gestation of the picture.

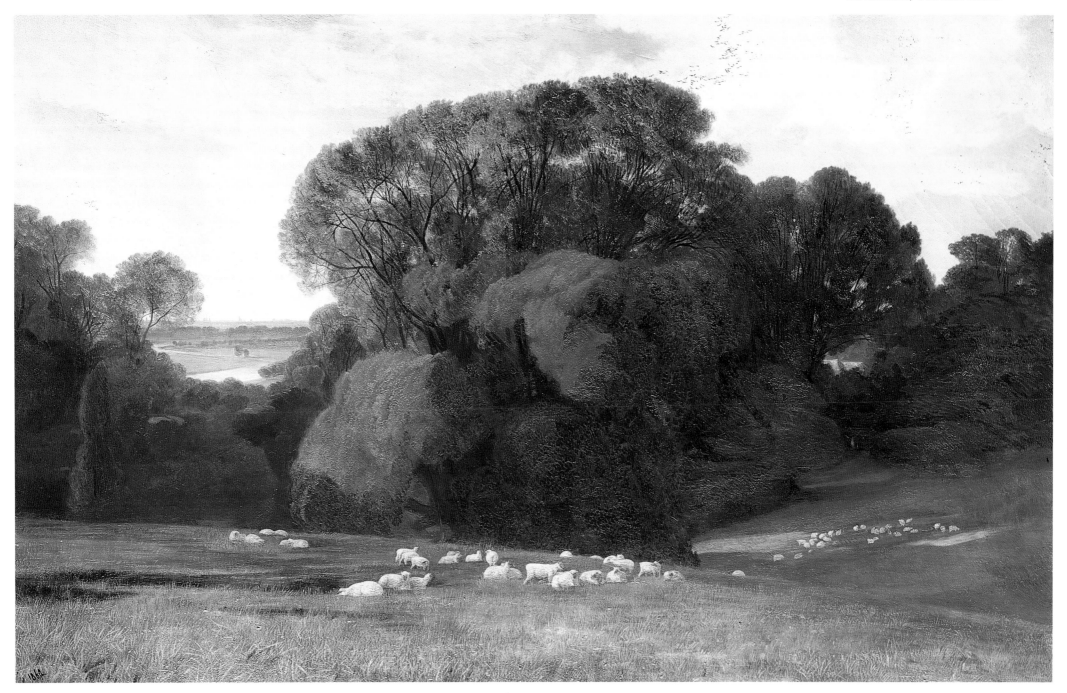

Nuneham. 1860. Oil on canvas. 18in x 29 ¼in. Private collection

(Left)
Self-portrait Painting on Bench. 26 July 1860. Ink on paper. 2 ¼in x 2 ¾in. Somerset Record Office, Taunton

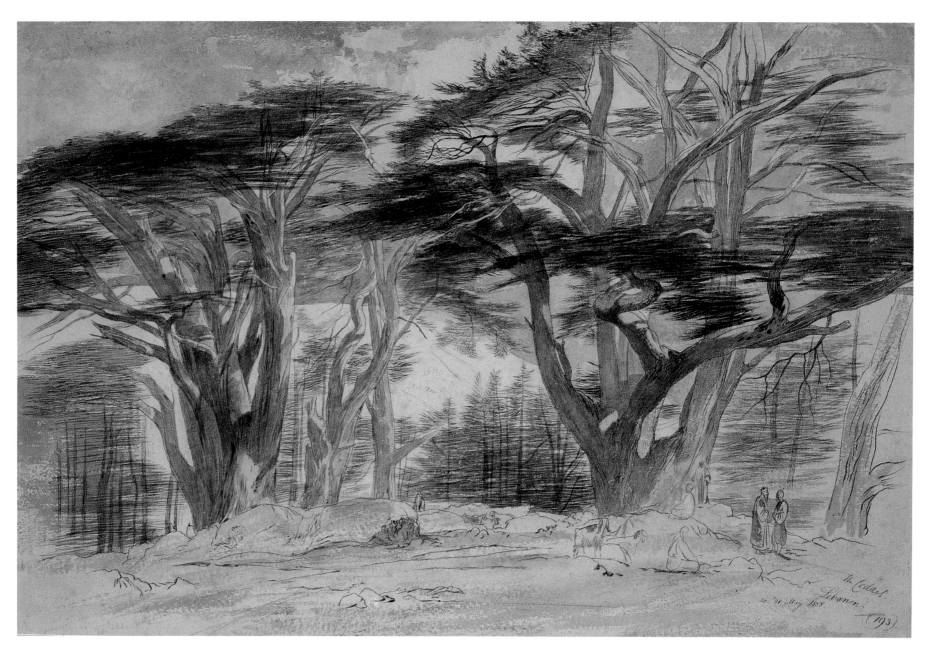

The Cedars of Lebanon

The painting of Bassae had been sold in December 1859, and Lear now turned his thoughts to the subject for his next large, uncommissioned oil. After leaving Jerusalem in the spring of 1858, he had travelled to Lebanon. Here he had visited Baalbec, but classical ruins now excited his imagination much less as his interest turned increasingly from man-made objects to scenes of untouched natural beauty. More exciting were the ancient cedars in which the birds of the air had built their nests. 'So fine a view I suppose can hardly be imagined – more perhaps like one of Martin's ideal pictures', he had written to Ann, describing his climb towards the trees: 'the whole upper part of the mountain is bare & snowy, & forms an amphitheatre of heights, round a multitude of ravines & vallies – full of foliage & villages most glorious to see: – and all that descends step by step to the sea beyond! – Far below your feet, quite alone on one side of the amphitheatre is a single dark spot – a cluster of trees: these are the famous Cedars of Lebanon.'

The Cedars of Lebanon. 20 and 21 May 1858. Pencil, sepia ink, watercolour. 14in x 21¼in. Private collection

In the summer of 1860 he decided that the cedars would be the subject of his next important uncommissioned painting. The *Syracuse* and *Corfu* had sold quickly and at good prices; the *Bassae* had found a slower market, and although it now hung in the Fitzwilliam Museum the lack of interest shown in it for some years marked a pause in the growth of his reputation. It was therefore essential that the next picture be a critical and popular success. *The Cedars of Lebanon* seemed to offer the possibility

for this. It had a fashionable oriental theme, and as a study of trees it was a subject in which he could excel.

After Lear's return to England, he found suitable cedar trees from which to work at Oatlands Park Hotel, near Weybridge in Surrey. We do not know whether he painted directly on the canvas out of doors, or if he prepared studies from which he worked in his room. The picture progressed well, and by March he was able to write: 'The cedars are so far advanced, that millions of sparrows are said to sit – (I never saw them myself,) on the window ledges, pining with hopeless despair at not being able to get inside.'

By May the 9ft picture was completed. He had then to decide what price he should ask for it. Both the *Corfu* and the *Bassae* had sold for 500 guineas; for this new painting Lear decided to ask 700 guineas.

It was exhibited in Liverpool in the late summer of 1861. Here it was warmly received, one critic writing that "Mr Lear has in this great picture not only achieved a professional success – but he has also conferred an obligation of the highest order on the whole Christian world". '(!!!!! – After that, take care how you speak or write to me)', he warned Fortescue, delightedly.

But despite such praise, the picture did not sell, and when the exhibition closed it was taken back to Lear's studio in London. Before leaving to spend the winter again in Corfu, he arranged for it to be sent in to the Great International Exhibition which opened in South Kensington on 1 May 1862.

The hanging of the exhibition was the responsibility of two Royal Academicians. They disliked the work, and hung it so high that it could scarcely be seen. Tom Taylor, one of the most influential critics of the day, reviewing the exhibition for *The Times* on 11 June, 1860, warned against the painter allowing himself to be merely a mirror of the scene he was painting, rather than recreating it and setting upon it the seal of his own mind. He added that the height at which *The Cedars of Lebanon* was hung made it impossible to say if these remarks, which he had made initially about the work of another painter, were also relevant to Lear. However, the link between his painting and lack of poetic feeling had been made.

Lear believed that in his work he combined the truth of nature with the poetry of art, and he was devastated by criticism which seemed to dismiss his painting as mere topography with neither soul nor intellectual content. In 1870, Holman Hunt, speaking of criticism of his own work, complained to Lear

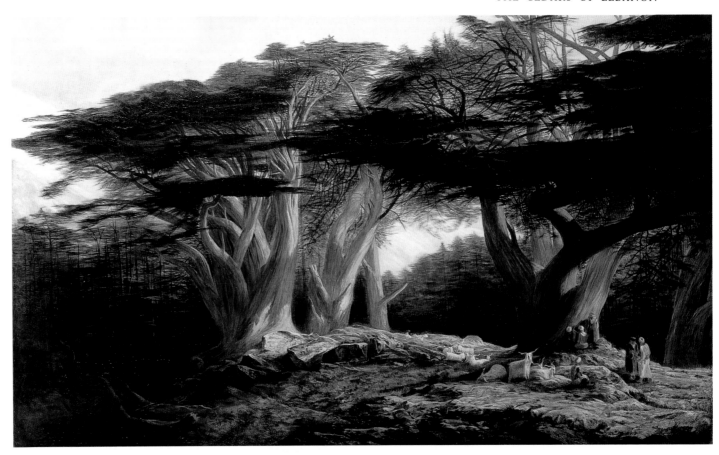

The Cedars of Lebanon. 1877. Oil on canvas. 26¾in x 44⅝in. Private collection

that his critic 'could not have said the picture was badly drawn or painted inferiorly but the charge of want of poetic feeling and proper sentiment of beauty is that few people feel strong enough to gainsay a man who speaks overpoweringly'.

Certainly no one was prepared to gainsay Tom Taylor, and *The Cedars of Lebanon* was dismissed by the public. In October Lear wrote despairingly to Fortescue, 'What I do with the Cedars I do not know: – probably made a great coat of them. To a philosopher, the fate of a picture so well thought of & containing such high qualities, is funny enough: – for the act of two Royal Academicians in hanging it high, condemn it first, – & 2dly the cold blooded criticism of Tom Taylor in the Times, quasi= approving of its position, stamps the poor canvass into oblivion still more & I fear, without remedy.'

It was five years before the picture sold; it was bought in December 1867 by Louisa, Lady Ashburton who paid 200 guineas, less than a third of its original price. She had the words, 'The Lord Breaketh the Cedars of Lebanon' inscribed on the frame, but Lear asked that the inscription be removed as it was 'so injudiciously divided as to be a mistake'. It would be interesting to know if this was

the real reason, or whether he felt that the words were out of keeping with the spirit of the painting.

The failure of *The Cedars of Lebanon* marked the turning point in Lear's professional life. He was fifty, and he realised that he would never now become established as one of the accepted painters of his day. Although friends might continue to buy and commission his work, from this time he was largely ignored by the general public. It was several years before he painted another large, uncommissioned oil.

After Lady Ashburton's death in 1903 the painting was sold for 12 guineas; its present whereabouts is unknown. It was a subject which Lear painted twice more; this smaller version was painted in 1868. It is impossible from this to know anything about the quality of the original painting, but certainly the excitement of the original watercolour has been dissipated in the formality of this later oil.

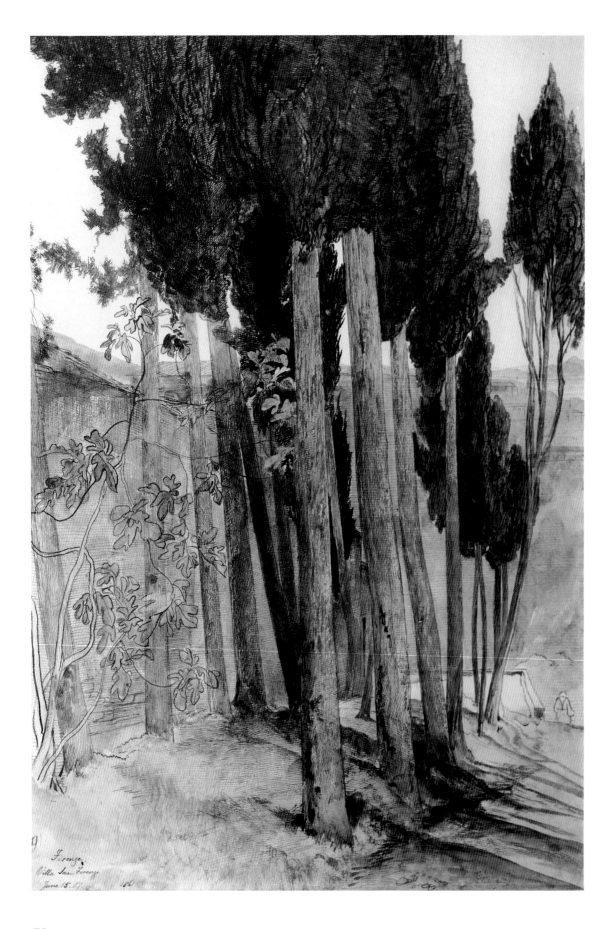

Florence and Beachy Head

In March, 1861 Lear's sister Ann died. His response to grief was always a wish to be on the move, to lose his thoughts in travel, and when Lady Waldegrave commissioned him to do a painting of Florence, he left London for Italy. In preparation for his *View of Florence from Villa San Firenze* he made careful and detailed drawings of cypresses. On the basis of these, he painted the Claudian foreground of trees in the large oil. By now he had abandoned the practice of working on the canvas in the open air.

In the summer of 1862 he began work on two oil paintings which were the first to be linked directly to the poems of Alfred Tennyson. From the publication of the *Poems* in 1842, Lear had seen links between the poet's descriptions of landscape and his own painting. On some of the drawings of 1848 and 1849 he has written lines of Tennyson verse which the scene had suggested to him (see p.12). The use of poetry as the inspiration for paintings was generally acknowledged, and it was accepted practice for painters either to inscribe the words on the frame or to print them in the catalogue when exhibiting the work. In Lear's case, those of his pictures which were linked to Tennyson's work were conceived not as direct illustrations of any poem but rather as existing in parallel with them, pointing a link between the two forms of artistic expression. What he admired in Tennyson's works were their musical charm, the vivid imagination they displayed, and their terse, descriptive power.

We do not know if it was Lear, or Henry Grenfell who commissioned the pictures, who suggested the subjects and their link with the poem, 'You ask me why'. This praises the Englishman's birthright of freedom of speech. The painting of Beachy Head illustrates the opening lines:

> You ask me, why, tho' ill at ease,
> Within this region I subsist,
> Whose spirits falter in the mist,
> And languish for the purple seas?

Cypress Trees at Villa San Firenze. 15 and 17 June 1861. Pencil, sepia ink, watercolour. 21½in x 14½in. Private collection

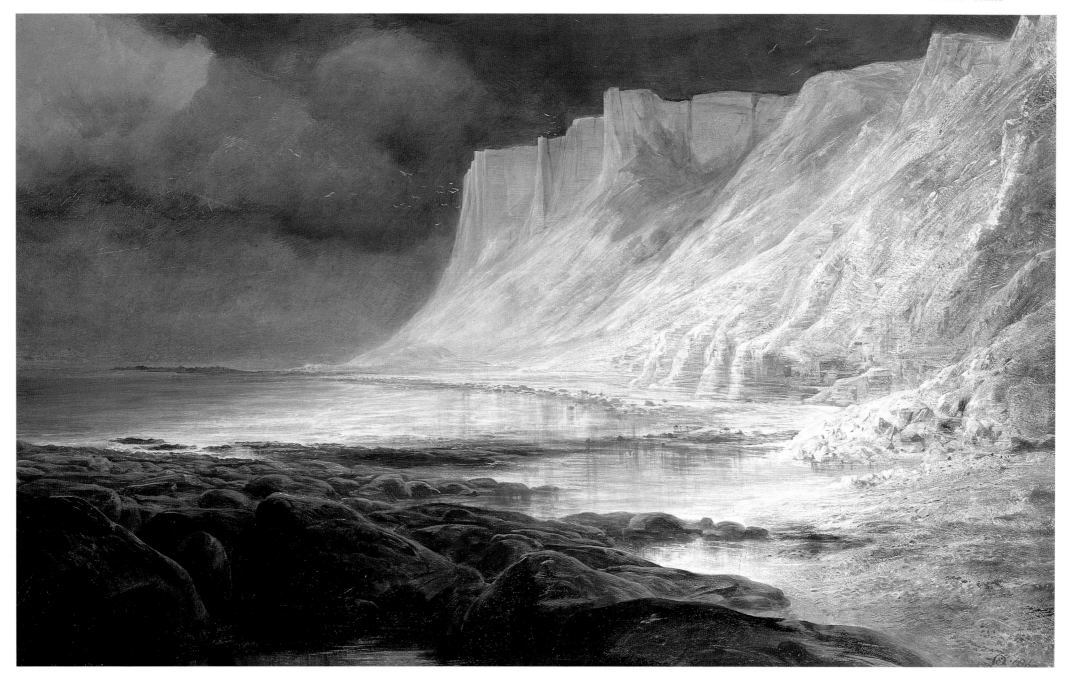

It is the land that freemen till,
 That sober-suited Freedom chose,
 The land, where girt with friends or foes
A man may speak the thing he will.

The second painting, of Philae on the Nile, is linked to the last verse, where the poet proclaims that if this freedom should be destroyed, he would no longer stay in England's chill dampness:

Yet waft me from the harbour-mouth,
Wild wind! I seek a warmer sky,
And I will see before I die
The palms and temples of the south.

Despite its link with the poem, *Beachy Head* remains a straightforward topographical picture. However, by relating it to a high-minded theme, Lear was able to give it both a cerebral and an overtly

Beachy Head. 1862. Oil on canvas. 29in x 40in. Private collection

poetic dimension, confounding critics who saw in his work nothing but a topographical record.
 It was his last English oil, and in its delicate, unlaboured form and simple, monochromatic power suggested by Tennyson's purple seas, it is not typical of his usual work.

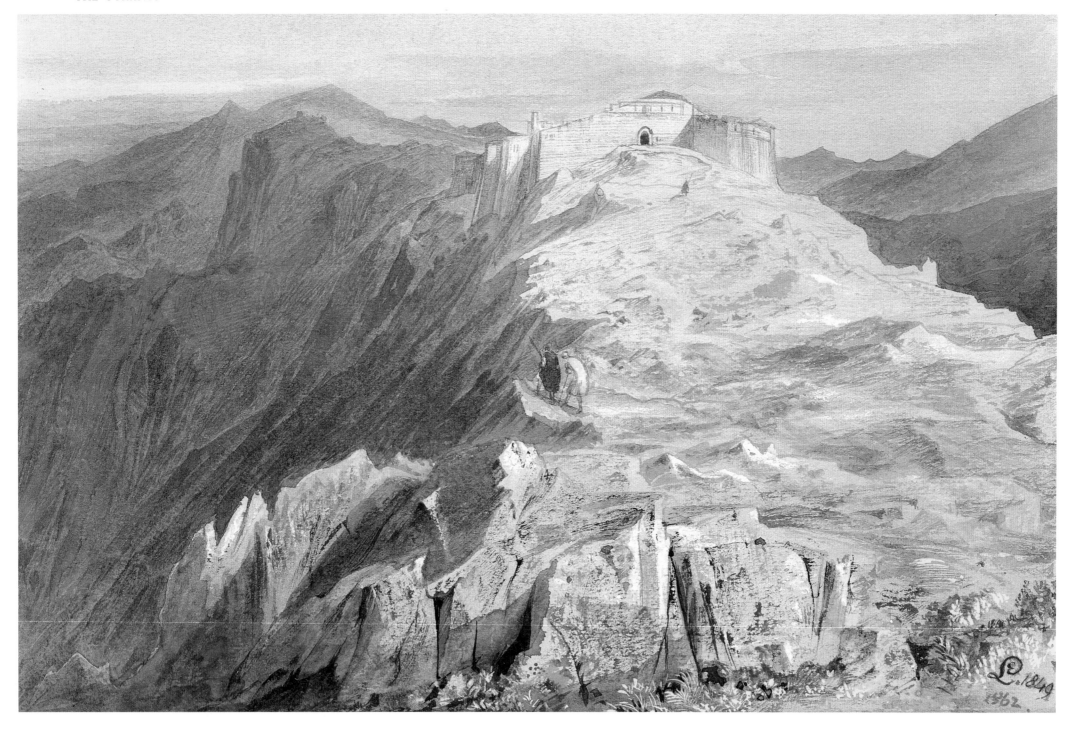

Suli. 1862. Watercolour and bodycolour.
7¹⁵/₁₆in x 14¹⁵/₁₆in. Private collection

The Tyrants

In November 1862, Lear left England to winter once more in Corfu. There he took an extraordinary step. Within days of his arrival he began sorting through his travel watercolours, choosing from them a collection of sixty views which he believed would sell. He prepared sixty sheets of paper and then, working on the first thirty, he drew pencil outlines of the views. After this, he went over the pencil outlines in grey watercolour, and when this had dried he rubbed out the pencil drawing.

Then, working across the pictures one by one, he laid in first a pale blue wash, then a red, and a yellow. He next painted in what he called 'gray details' and 'gray outlining & shadow', before beginning to build up the picture, using ochre and opaque paint, and concentrating on 'general effect & applications of Indigo & stronger colours'. He worked more into the 'nearly finished distance' and then completed the 'white paint foreground'. That done, he took the next thirty sheets of paper, and began the process again. The entire set was completed in sixty days.

Meanwhile, he ordered frames, and 'after 2 days' insertion of the drawings – measuring & nail knocking – I have made a really remarkable gallery of Water Colr. works'. These, hung on the walls of his show room, were priced at ten and twelve guineas. When everything was ready, he invited the people of Corfu to come and see his exhibition. 'I doubt my success in selling the drawings', he told Fortescue, sending him an illustration of how the exhibition looked and a list of the subjects he had painted. 'Cheap photographs are the order of the day now.'

'I have done with oil-painting & have collapsed into degradation & small 10 & 12 Guinea drawings calculated to attract the attention of small Capitalists', he wrote, and the small capitalists responded. The low-priced works sold quickly. Sir Henry Storks, the Corfu High Commissioner, immediately bought a view of Jerusalem and another of Corfu, and others quickly followed his lead.

Some of those who came, however, were less responsive to the works on show, 'Sir C. Sargent to wit – who saw all 60 drawings in 19 minutes, calling over the names of each saying "£700! why you must give a ball!" Fool! As yet I have sold £120 worth – but have not received one farthing – for great people generally suppose that artists gnaw their colours and brushes for food.'

This group was the first of what Lear called his Tyrants; they were his response to the public's dismissal of his large oils. He returned to this way of working, a method he had seen used by the colourists in Hullmandel's studio, on many occasions, sometimes preparing as many as one hundred and twenty Tyrants at a time. Between 1862 and 1884 he produced nearly a thousand of these works. Their quality varies considerably. They are worked according to a formula, and reveal a lack of the imaginative searching which must exist in any satisfying work of art. The best are indistinguishable from some of his finished watercolours, but the worst are very bad, and although they fulfilled their function of bringing in money, their production and exhibition did lasting damage to Lear's reputation.

Letter to Fortescue. 22 February 1863. Ink on paper. 7¹⁵⁄₁₆in x 9⁷⁄₈in. Somerset Record Office, Taunton

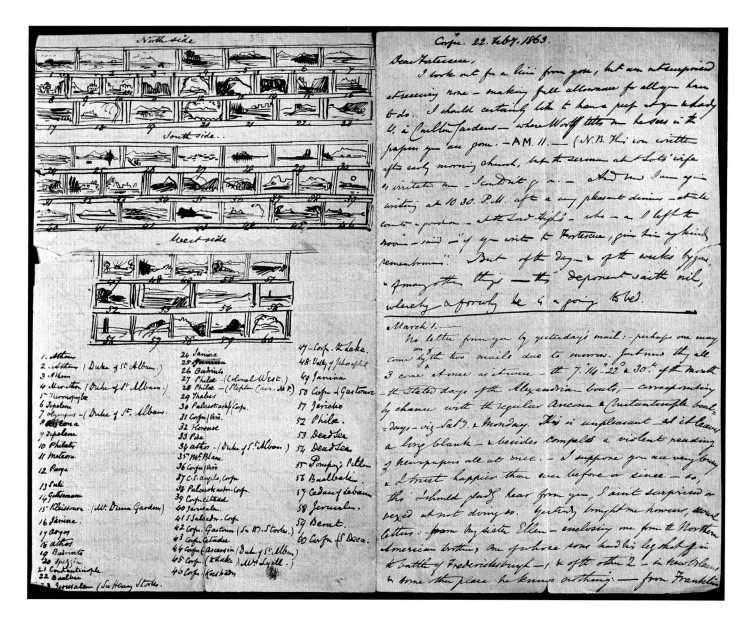

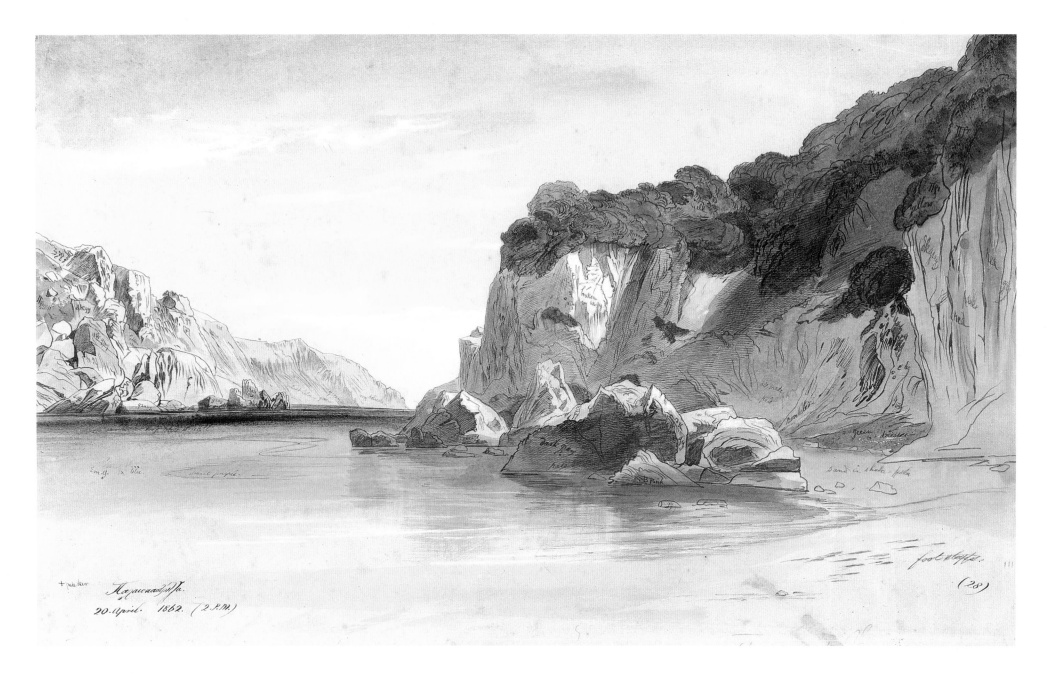

Return to Corfu

The saving feature of that winter, as he worked to produce his Tyrants, was the loveliness of the island. The scenery of Corfu combined all that he found most sympathetic in landscape. '. . . the more I see of this place, so the more I feel that no other spot on earth can be fuller of beauty & of variety of beauty', he wrote in his diary on 30 March 1863. The gentle, luxuriant beauty and freedom of sunlit space were set against the etched form, the precise delineation

of distant hills which he drew so well. The clarity of light and the way in which it worked upon the landscape, was perfectly expressed in his limpid use of watercolour wash. And then, unlike when he was travelling and always on the move, he need be in no hurry as he worked.

The previous spring he had spent a week in the picturesque small village of Palaeokastritza, and from there he wrote to Fortescue: 'I have been wondering if on the whole the being influenced to an extreme by everything in natural or physical life, – i.e., atmosphere, light, – shadow, & all the varieties of day & night, – is a blessing or the contrary . . . I

Palaeokastritza. 17, 18, 19 and 20 April 1862. Pencil, sepia ink, watercolour. 12⅞in x 21⅜in. The Houghton Library, Harvard University

should have added "quiet & repose", to my list of influences, for at this beautiful place there is just now perfect quiet, excepting only a dim hum of myriad ripples 500 feet below me, all round the giant rocks which rise perpendicular from the sea: – which sea, perfectly calm and blue stretches right out westward unbrokenly to the sky, cloudless that, – save a streak of lilac cloud on the horizon.' The watercolour of Palaeokastritza was done on Easter

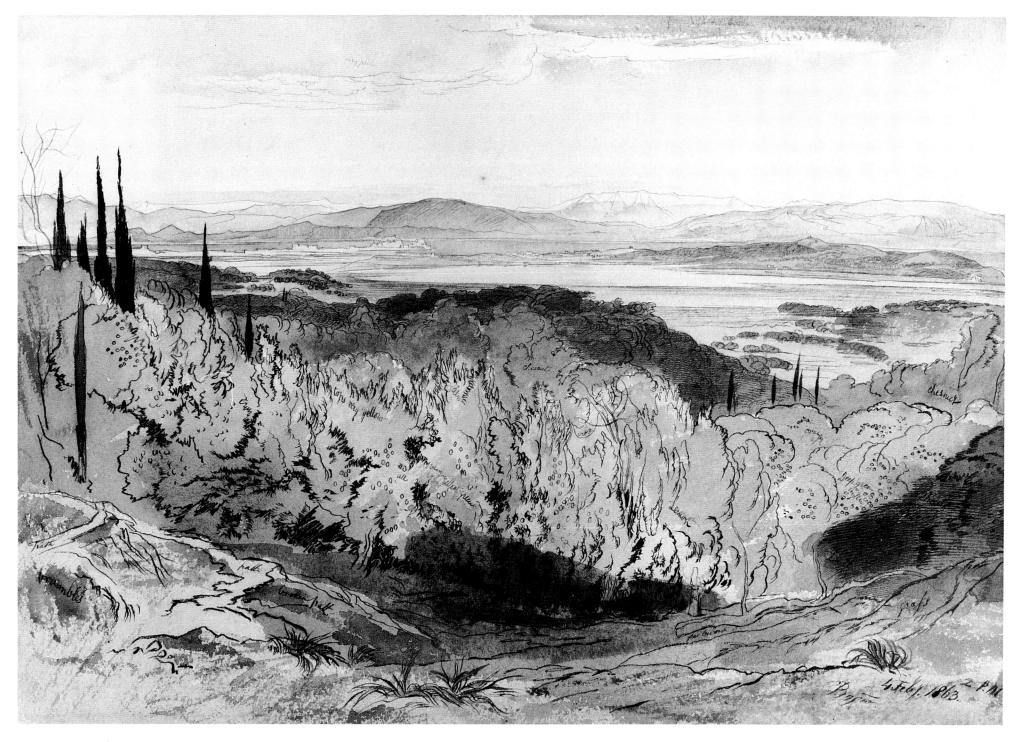

Sunday, 1862. 'How still! how silent!', he wrote, 'even the bubble surf so far below is scarcely heard! Palaiocastritza memories if I live, will live with me.'

During the early months of 1863, he allowed himself occasional days away from his work on the Tyrants. At the beginning of February he spent a day drawing above the orange gardens of Viro. In this picture, the swirling, tufted, vertical chunkiness of the shadowy orange grove and dark cypress trees works in satisfying contrast with the delicate, horizontal lines of the distant hills.

But his time in Corfu was coming to an end; the British Government was negotiating the return of the Ionian islands to Greek rule. By the end of February his Tyrants were completed, and they were exhibited in his studio throughout March. When the

Orange Gardens of Viro. 4 February 1863. Pencil, sepia ink, watercolour. 14⅝in x 21¼in. The Gennadius Library, Athens

exhibition came down, he decided to spend two months exploring the other islands in the group. Freed from the tyranny of his winter's task, he produced some of his finest drawings.

83

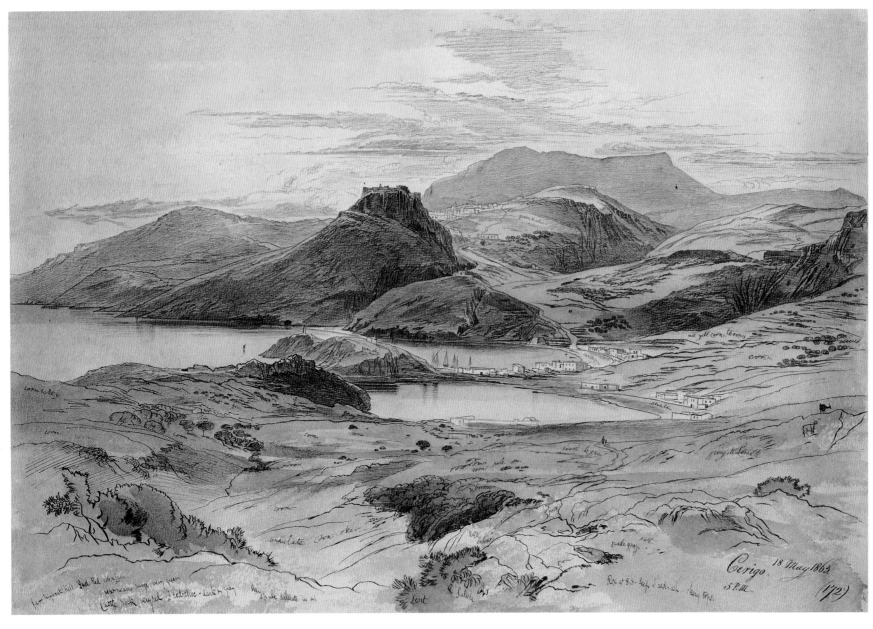

Cerigo. 18 May 1863. Pencil, sepia ink, watercolour. 14⅝in x 21⅝in. *Drawing for Plate 20 of Views in the Seven Ionian Islands*, 1863. The Houghton Library, Harvard University

The Seven Ionian Islands

With the Tyrants finished, Lear turned his mind to how he would next earn his living. No one was more qualified than he to prepare a work illustrating the scenery of the seven Ionian islands, and with the British about to leave this seemed a perfect time for such a book.

As he toured the islands, the countryside was bathed in the beauty of spring. On 18 May, he was in the village of Kapsáli on the southernmost island of Cerigo, the ancient Cythera, where 'stern mountains, rich in colour but bare in foliage, stretch into sea'. The power of his rhythmic, swirling draughtsmanship in creating sculpted form can be seen in his drawing of Cerigo. Nine days later he was on the island of Zante, drawing the more delicate and distant scene looking over the olive groves on the side of Mount Skopo towards the town of Zante and beyond to 'the Castle Hill (whose sides are curiously cut into lines & chasms), and the long, elevated ridge called Akroteria'.

Back in England in June, the prison walls closed around him as he began work on the lithographs for the book, the last lithographs he was to do. 'I go on grinding on most sadly & painfully,' he wrote to Fortescue, 'for it is not altogether the physical annoyances of banishment from fresh air & nature combined with many hours daily work of a constrained kind that bothers & depresses me, – but beyond these – the impossibility of getting any compensation=spiritual from the Views I am drawing, since their being all executed reversed causes them to seem unreal, & without any interest.

'You may ask – then why undertake a task so odious? – The reply to which would be, what else could I do? – The remains of my Watercolour gains could not carry me through the winter, & therefore, as ever the case with Artists who have no settled income – something else was necessary. And as it

would be folly to commence more oil works – those I have done being still unsold, – or to begin more Watercolours when there are none to see them, – the Ionian Book was my only apparent open=door of progress.'

Views in the Seven Ionian Islands was published by subscription at a cost of three guineas on 1 December 1863. It contained twenty plates, each accompanied by a short descriptive text.

Zante. 27 May 1863. Pencil, sepia ink, watercolour. 14⅛in x 21in. Private collection

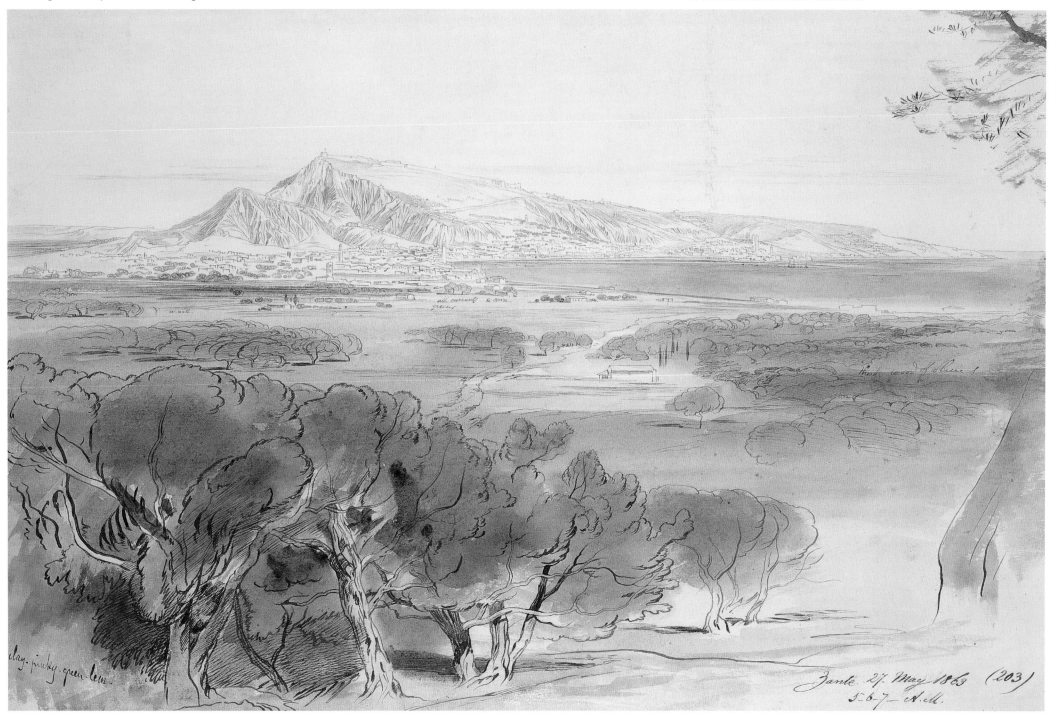

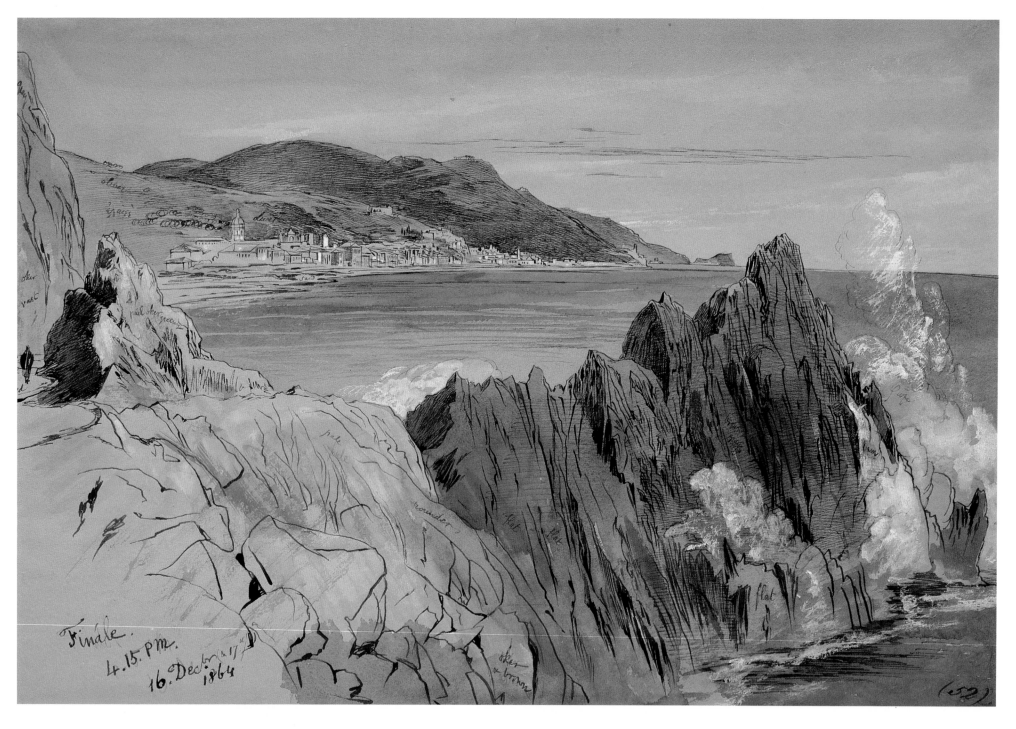

Finale.
4.15.P.M.
16.Dec.17"
1864

The Corniche
and Venice

In December 1863 Lear returned to Corfu, but with the break-up of the English community in the spring of that year he had now to find another winter base. He considered Athens, but a short stay there on his way to visit Crete in the spring of 1864 made him realise that, apart from a good climate and the nearness of the Greek countryside, it had little to offer. In the end, he chose the South of France.

In November 1864 he found rooms in Nice, and

Finale. 16 December 1864. Pencil, sepia ink, watercolour. 14½in x 21¼in. The Houghton Library, Harvard University

there he began work on a group of 240 Tyrants. After a month of this soulless occupation, he and Giorgio set out for a cold but exhilarating walking tour along the Corniche. He was away for a month, drawing the 'strangely wild & magnificent' coastal

scenery. The excitement he found in this rocky coastline can be seen in his drawing, *Finale*, where the rugged, jagged form of the vertical rocks which reach out into the sea is made more powerful both by the rounded form and lack of resolution in those that are nearer, and by the understated, horizontal lines of the more distant hills.

Nice was not a success, and the following year he decided to try Malta, travelling overland to Italy where he picked up a boat in Venice. Lady Waldegrave, one of his most loyal patrons, had commissioned a painting of the city, and as with the picture of Jerusalem she left the choice of viewpoint to Lear.

For the first few days of his stay he wandered up and down the canals, hunting for a suitable scene. On 13 November, he 'got a gondola for the day. First drew S[anta] M[aria] de S[alute] by the Doge's Palace – then from the Iron Bridge . . . but it was very cold.' In fact, conditions made it impossible for him to go on with the drawing, and he did not return to finish it until the 16th, when he wrote: 'The same bright gorgeous – but cold weather. Anything so indescribably beautiful as the color of the place I never saw.'

The detailed drawing of Santa Maria de Salute is balanced by the freely handled use of watercolour in the sails and water. In much of the work he did in

Venice, Lear worked directly in often quite wet watercolour, laying in flowing washes which most accurately captured the shifting colour and light of the canal scenery. He did some fine work in Venice, but towards the end of his visit there he wrote in his diary: 'These Venetian scenes are no delight to me, as repeating a life of at best curiosity & interest, – but seldom great pleasure: – never – the poetry of plain or mountains – or woods – or rocks, Manwork – not God work'.

Venice. 13 and 16 November 1865. Pencil, sepia ink, watercolour. 12¾in x 19¾in. Private collection

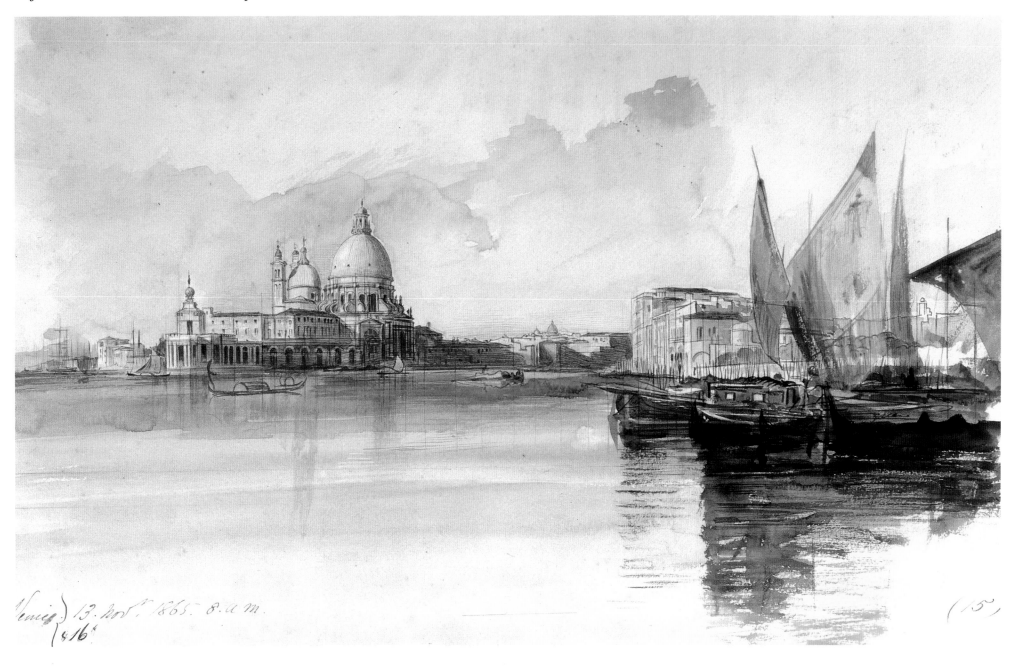

87

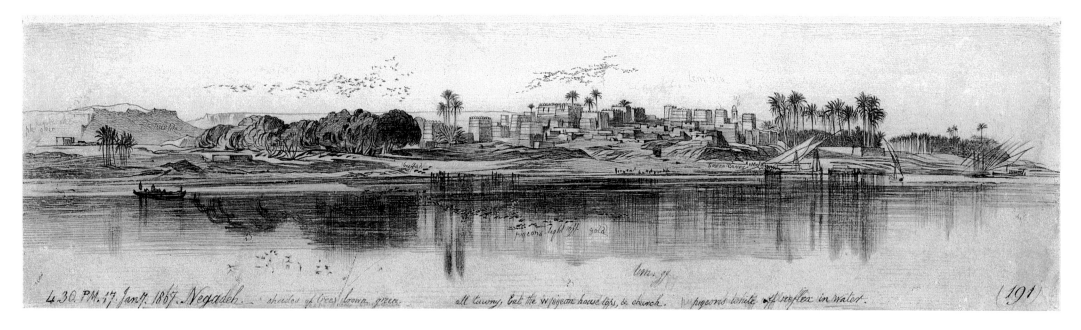

4.30 P.M. 17 Jan.y 1867. Negadeh. *shades of trees brown, green*, *all tawny, but the w/pigeon house tops, & church.* *pigeons white off w/reflex in water.* (191)

The Nile and Corsica

In the following winter, Lear decided to return to Egypt to complete his travels down the Nile to the second cataract. He left Cairo on 31 December, 1866 for a ten-week river journey.

It was not easy countryside to paint. 'It will be difficult to work out anything like the sentiment – of the infinite detail of rocks!' he wrote, 'the upper side light, the lower so dark. In the foreground – the pale rock & gritty sand is blazing bright – while all below is a dark depth. The farthest range of hills is sandy pale, with grey from crowds of rocks.'

Despite the problems, however, he found it fascinating. 'In no place – it seems to me, can the variety & simplicity of colors be so well studied as in Egypt; in no place are the various beauties of shadow more observable, or more interminably numerous. Every mud bank is a picture, every palm – every incident of peasant life.'

'Most lonely lonely river!', he wrote. 'The intense loneliness of this river! How could it ever have been what, when these temples were built, it needs must have been – a populous country?' 'The intense deadness of old Egypt is felt as a weight of knowledge in all that world of utter silence.'

Lear kept a detailed diary during his journey. In 1885 he corresponded with Amelia Edwards, asking her help in arranging its publication, together with that of his earlier Egyptian voyage. Nothing came of the idea, and the manuscript, like that of so many of Lear's travel journals, has disappeared.

He spent the following winter in Cannes, and from there he set out in May to visit the island of Corsica. He found it an island pervaded by a strange melancholy, yet he produced some fine, sensitive watercolours which reflected the 'beauties of light and shade in mountain and valley, the contrast of snowy heights and dark forests, the thick covering of herb and flower, shrub and tree'. 'Since I made drawings at Mount Athos, in 1856', he wrote at Sartène, 'I have seen no heights so poetically wild, so good in form.'

In the last week of April, 1868, he arrived at the pine forest of Bavella which he thought 'one of the most wonderfully beautiful sights nature can produce'. During a sudden thunderstorm there, he sheltered in a forester's cottage. '...when the storm ceases for a time, and the sun gleams out through cloud, the whole scene is lighted up in a thousand splendid ways, and becomes more than ever astonishing, a changeful golden haze illumes the tops of the mighty peaks, a vast gloom below, resulting from the masses of black solemn pines standing out in deepest shadow from pale granite cliffs dazzling in the sunlight, torrents of water streaming down between walls and gates of granite.' His water-

Negadeh. 17 January 1867. Pencil, sepia ink, watercolour. 3½in x 13¼in. Michael Appleby

colour of this scene is one of only a very few where Lear has recreated an atmosphere of mist and water-laden sunlight. He rarely attempted the subtle handling of the effects of diffused light, yet he accomplished it with such success that one must wonder why he did not paint in this way more often.

Indeed, throughout his tour he was fascinated by the effects of light, so much more muted than those created by the bleaching sun in Egypt. '...the great heights opposite are, at this hour, covered with the loveliest velvety grey-green, furrowed and fretted with infinite lines, and beautifully mysterious with floating clouds and misty "scumblings"', he wrote at the village of La Piana.

He used this tour as the basis for his last travel book, *Journal of a Landcape Painter in Corsica*, published in 1870. The combination of powerfully flowing line and tonal delicacy characteristic of his best watercolours was well served by lithography, but he was unwilling again to face what had by now become the disagreeable chore of preparing lithographic plates. Instead he chose wood engraving. Some of the plates were prepared for him by others, and in his preface he acknowledges 'the care and accuracy with which they engraved the drawings', but these stylised, romanticised reproductions lack both the conviction and the verisimilitude of his other published topographical work.

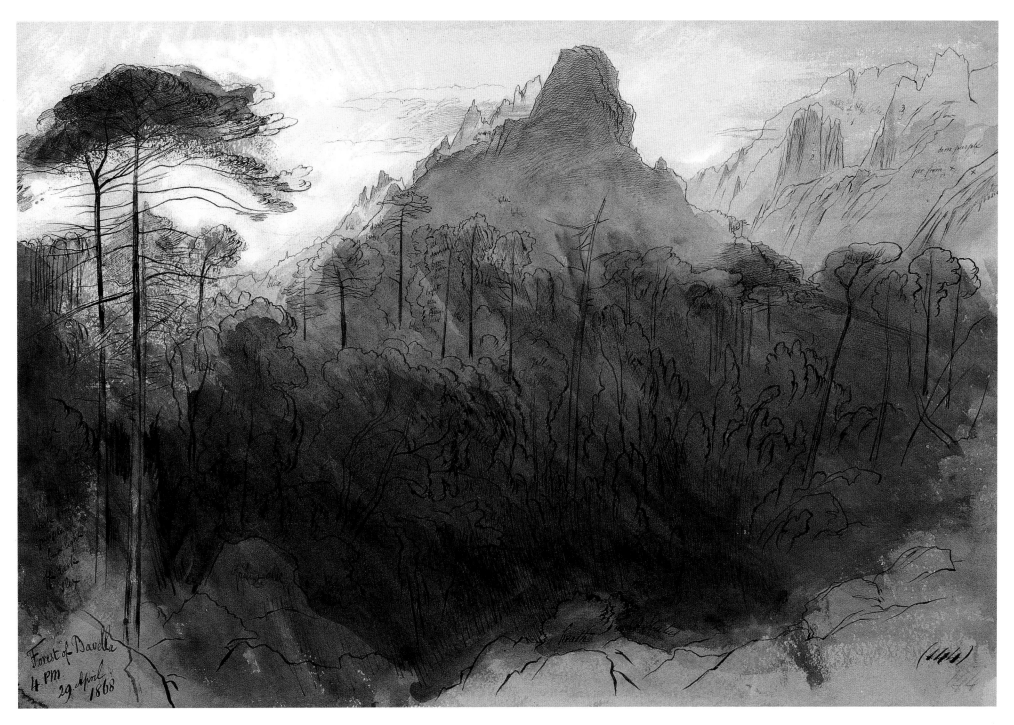

Bavella. 29 April 1868. Pencil, sepia ink, watercolour.
14³⁄₈in x 21¹⁄₈in. The Houghton Library, Harvard
University

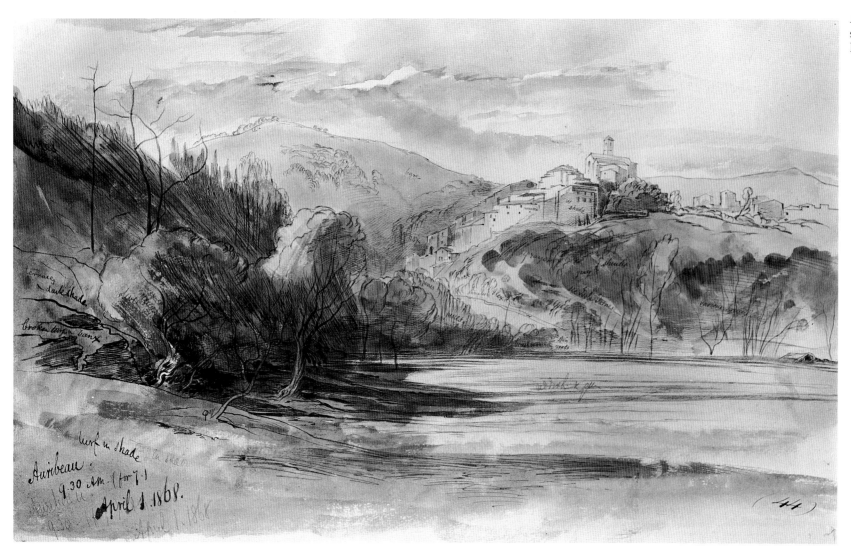

Auribeau. 1 April 1868. Pencil, sepia ink, watercolour. 12in x 20in. Private collection

Villa Emily, San Remo

He returned to Cannes the following winter. From there he could make expeditions into the hills, as he had also done the previous winter. He and Giorgio would leave Cannes early in the morning, and he would spend the day drawing. Auribeau is a village between Cannes and Grasse.

His European travels were now over. Apart from a few drawings done in the Italian Alps during the summer months of the 1880s, these were the last of his European drawings. Those of India have a different feeling and character. He had come to the end of this work whilst still at the height of his powers as a draughtsman and watercolourist.

In the winter of 1868–9, he settled down to paint two large oils of Corsica. 'I can't help laughing at my "position" at fifty-seven!' he wrote to Fortescue in August 1869. 'And considering how the Corfu, Florence, Petra, &c, &c, &c, are seen by thousands, & not one commission coming from that fact, how plainly is it visible that the wise public only give commissions for pictures through the press that tell the sheep to leap where others leap!'

That winter he finally decided that he would settle permanently abroad. He had talked of spending his old age in England, foreseeing the loneliness of exile, but the climate made that impossible. Instead, he now decided to settle in San Remo on the Italian Riviera, a place 'Neither too much *in*, nor altogether *out* of the world'.

He instructed the architect on the accommodation he needed in what was to be his first proper studio, and wrote to Holman Hunt: 'You remember how I have always been wanting a real settled paint-

ing place – I having always been more or less convinced that I have talent enough to do some good Topographical painting yet, what though I am 58 – if only I could attain "North light" & "quiet".' Now he would have both, and he could look forward to spending the rest of his life in uninterrupted painting.

The house stood in an olive grove, and from his first floor studio window he looked across to the sea. 'I never before had such a painting room', he wrote to tell Fortescue. '32 feet by 20 – & with a light I can work by at all hours, & a clear view S. over the sea. Below it is a room of the same size, which I now use as a Gallery, & am "at home" in once a week.' His plan, in addition to his weekly open day, was to prepare work which he could send home 'to every kind of exhibition in England'. Meanwhile, the picture handlers Foord and Dickenson, of Wardour Street, agreed to exhibit his work on a regular basis.

Then, in 1872, he was invited by an old friend,

George Baring, who was now the Earl of Northbrook, to travel out to India where Northbrook had been appointed Viceroy. Lear was uncertain what he should do. He had just settled down for the first time in his life, and it seemed perverse to leave his home for a year or more.

That summer he went on his annual visit to England, and was given a number of important commissions for Indian landscape. It was clear that he should accept the invitation, and at the end of 1872 he and Giorgio shut up Villa Emily, and set out for Suez where they would pick up the boat for Bombay.

He had not been in Egypt since before the opening of the Suez Canal in 1869. To commemorate the occasion, an avenue of acacia trees had been planted. 'Nothing in all life is so amazingly interesting as this new road & avenue – literally all the way to the Pyramids!!!', he wrote in his diary on 13 October 1872. The following day he made drawings of the Pyramids Road as a possible subject for one of the paintings which Northbrook had asked him to do. 'The effect of this causeway in the middle of wide waters in singular . . . there is much of poetry in the scene, but it wants thought and arrangement.'

Shortly before leaving England, he had had a bad fall and damaged his right eye. As he waited for the boat, the discomfort of this, and the fuss and bother of the arrangements, began to distress him. In a moment of sudden anger he decided he would not go to India after all, and he and Giorgio set out at once for San Remo.

Within days he realised the folly of what he had done. He had lost not only valuable commissions, which he could ill afford to do, but also the opportunity of seeing a country he had long wished to visit. He decided that he would go the following year, and meanwhile he settled down to paint Northbrook's picture. Again, as in so many of Lear's later paintings, it is his interest in trees which had dictated his choice of subject. His 'thought and arrangement' resulted in an asymmetrical composition of receding rhythmic diagonals, and produced one of his most unusual paintings.

Pyramids Road, Ghizeh. 1873. Oil on canvas. 20½in x 40⅝in. Private collection

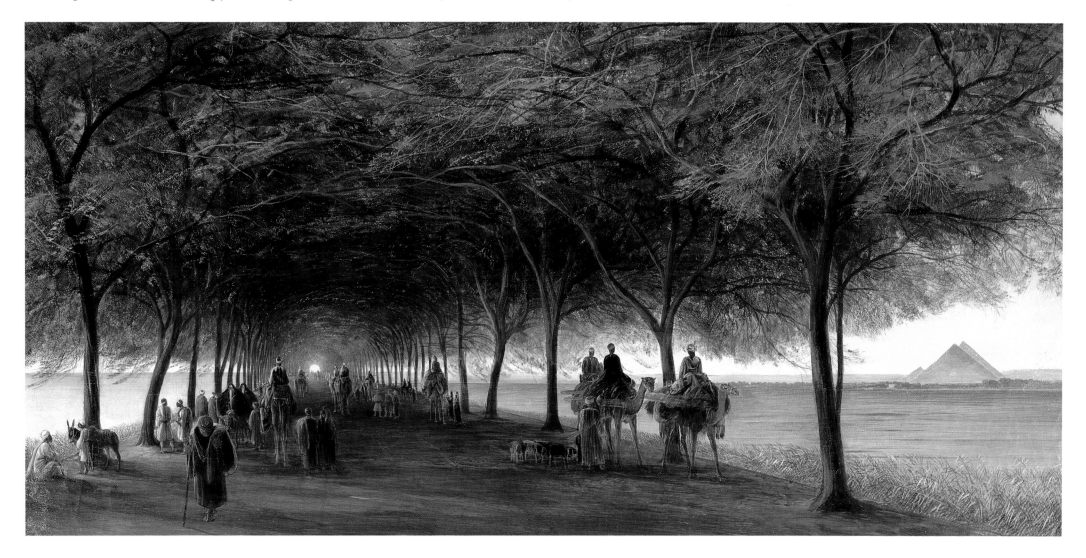

Teog. 2 May 1874. Pencil, sepia ink, watercolour. 12^7/$_8$in x 21^7/$_{16}$in. The Houghton Library, Harvard University

Benares. 1875. Pencil and watercolour, heightened with white. 9^5/$_8$in x 15in. Private collection

India and Ceylon

Lear was overwhelmed with what he found when he arrived in India in November 1873. 'Violent and amazing delight of the wonderful variety of life and dress here', he wrote. 'The way . . . drove me nearly mad from sheer beauty & wonder of foliage. O new Palms!!! O flowers!! O creatures!! O beasts!! . . . anything more overpoweringly amazing cannot be conceived!!! Colours, & costumes, & myriadism of impossible picturesqueness!!! These hours are worth what you will.' He had expected to find the Indian scenery he had known from the Daniells' sombre engravings, and he was unprepared for the brilliance of colour which surrounded him. Throughout his tour it was the effects of light and colour, often Turneresque in their beauty, and the sumptuousness of the tropical foliage, rather than the sculptural quality of delineated form, which thrilled him most.

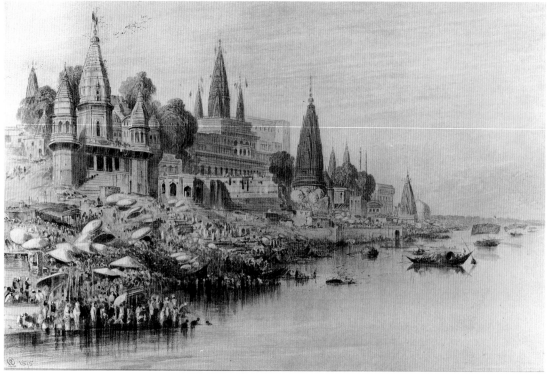

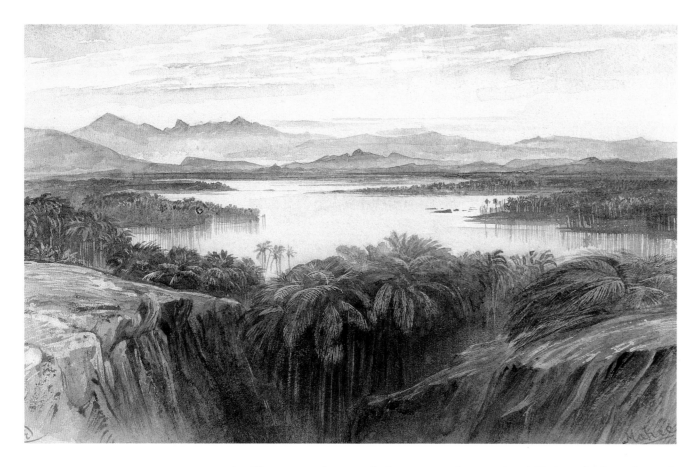

Mahee. n.d. Pencil and watercolour. 6³⁄₈in x 10¹⁄₈in. Private collection

Lear was now over sixty, yet in the fifteen months he was in India and Ceylon he covered thousands of miles, making drawings as he went. Sometimes there were endless journeys with little to see; at others, one visual excitement followed another. He had grown to dislike painting architecture, but now found himself fascinated by the ancient Indian temples. The Taj Mahal overwhelmed him with its beauty. 'Henceforth let the inhabitants of this world be divided into two classes – them as has seen the Taj, – & them as hasn't', he exclaimed in delight. His drawings of street scenes bustle with life. There was almost too much to take in. '. . . such scenery may be compared to eating rich Plum pudding continually', he wrote at Tellicherry. India was the epitome of picturesqueness.

He reached the holy city of Benares, now Vārānasi, on 12 December. 'Utterly so wonderful is the rainbow=like edging of the water with thousands of bathers, – (all) reflected in the river. Then, the color of the Temples! & the strangeness of the huge umbrellas!! & the expressibly multitudinous detail of Architecture, Costume &c. &c. &c. &c.!!!! . . . How well I remember the views of Benares by Daniell, R.A. – pallid, – gray – sad, – solemn, – I had always supposed this place a melan-

choly, – or at least a "staid" & soberly coloured spot, – a gray record of bygone days! – Instead, I find it one of the most abundantly bruyant, and startlingly radiant of places of infinite bustle & movement!!!' He hired a boat, and made a number of drawings of the ghats. This was one of the places where he believed that photographs would help with his later work. It was a bravura scene which he would once have made the subject of a large oil painting, but with its minute architectural detail such a view was now too trying on his eyes.

In January he had reached the Himalayas. 'Kinchinjunga at sunrise is a glory not to be forgotten', he wrote. 'Kinchinjunga PM is apt to become a wonderful hash of Turneresque colour and mist and space.' He was out before dawn, making studies for the paintings which had been commissioned, working in a wind which was so cold that he could scarcely hold a pencil while Giorgio held down the paper to steady it. But he found the mountains daunting in their vastness and difficult to draw well. More sympathetic in scale were the mountain flowers, like the 'Exquisite white sort of Creeper, brightening the trees' which he found at Teog. The compositional device of a straddling horizontal foreground is one which he had used before (see for

example p.72). Here the contrast in scale emphasises the pale delicacy of the mountain flowers.

He was at Mahee on the Malabar coast at the beginning of November 1874, after nearly a year of travel. '. . . the view there *is* a stunner!!!! As a river scene *can* any other equal it?' he wrote in his Indian journal. He thought it 'wondrous & wholly unlike other landscapes if only from the inconceivably curious & rich texture of the myriad-multitude of Cocoatrees far & wide. These, – deep gray green with touches of light, – those on the nearer foreground bright green, gold, & orange, – melt away into infinite spaces of lilac green cocoa=forests, beyond which suddenly rise beautiful smooth downs and detailed hills, standing out, though remote, – from the pale mist beyond, and below the farthest range of mountains that stretch along the horizon in pallid clouded pearliness.'

Only Ceylon disappointed him, for although the foliage was more luxuriant than any he had seen, the scenery offered nothing new. By this time he had been travelling for nearly fifteen months, and he was tired. Suddenly he decided to bring the journey to an end, and on 12 January 1875 he sailed from Bombay. But even as he was sitting in the boat taking him back to Europe, he was planning to return to see the places which he had missed.

The watercolours of the temples at Benares and of Mahee are both studio works, painted after his return to San Remo.

Self-portrait with Giorgio on an Elephant. 25 October 1873. Pen and ink. 4¹⁄₂in x 4³⁄₄in. Somerset Record Office, Taunton

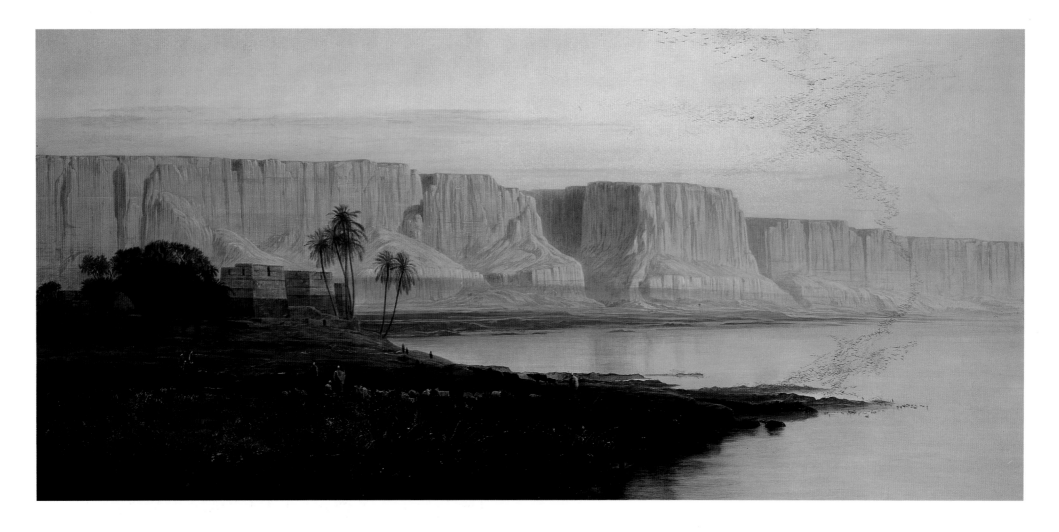

Last years

After Lear's return from India, he settled down to work on his many Indian commissions. As he sent these off and was paid for them, he was able to replace the savings which he had used to build his house. Within months he had more money in his account than ever before. 'Wisdom of preparing for a dignified old age & death long before they may come to pass', he wrote in the front of his diary each year, and it seemed as though, after so many years of uncertainty, he could look to the future with confidence.

His right eye had not recovered from the fall he had had before going to India, and the sight in it slowly deteriorated. Yet he was able to complete a number of magnificent Indian oils, all of which were well received. When these commissions were done, he turned to the unfinished paintings in his studio. '. . ."took up" the Crag that fronts the Evening, which I glazed & bebothered all over', he had

written in 1872, '& as Giorgio says – "Sir, if you leave him alone now, he will be best" – But unfortunately I shan't leave him alone'. This fine painting of Kasr-es-Saad, based on drawings he had made on his first journey down the Nile in 1854, was bought in 1877 by Louisa, Lady Ashburton, who ten years earlier had bought his painting, *The Cedars of Lebanon*. It was installed in her house in Knightsbridge, where it was 'let into the wall in a vast black frame all the room being gilt leather! Never saw anything so fine of my own doing before – & walked afterwards with a Nelevated & superb deportment & a sweet smile on everybody I met.' After Lady Ashburton's death in 1903, the painting was sold for £5.

Lear's loneliness was at times overwhelming, but there was a balance in the pleasure he found in peaceful 'poetical=artistic application'. Then suddenly, this all changed. The olive groves over which he looked towards the sea were sold without his knowledge, and there was a bustle of activity on the land. Within weeks, foundations had been laid for a huge four-storey hotel which would not only block

Kasr-es-Saad. 1877. Oil on canvas. 22in x 54in. Private collection

his view to the sea but, since it was to be painted white, would reflect brilliant light into his studio making it impossible for him to paint.

'. . . it is a dreadful thing to be obliged to stop all one's poetical life-work', he wrote, but some of Lear's friends found it difficult to understand why he should have reacted with such distress to what was happening. Few realised his need for quiet and an open view, nor understood the struggle which had brought him to the point where he could build his own retreat away from the 'generally vulgar and vicious world'. The deception involved in the sale of the land without his knowledge distressed him deeply, and the quotation in his diary about a dignified old age was replaced by another from *Persuasion:* 'There is always something offensive in the details of cunning. The manoeuvres of selfishness & duplicity must ever be revolting, but I have heard nothing which really surprises me.'

He could not continue to paint in Villa Emily, but with the help of friends, and by using some of the money which he had put aside for his old age, he was able to build another house, identical in its design to the first. The uncertainty, the move, the slow sale of Villa Emily, and the sense of outrage he felt at having been the victim of what he, in his loneliness, saw as deception and malevolence, ate into Lear's soul, and he never really recovered.

Lord Northbrook, whose generosity and support never faltered, advanced him £2,000 which was repaid in pictures. In the early months of 1886 Lear sorted through his travel watercolours of almost fifty years, and packed up nearly a thousand of these which he sent to England. The correspondence between Lear and Northbrook has been destroyed within the last fifty years, and we cannot now know Northbrook's response on receiving these beautiful watercolours. The respect he felt for Lear's work, however, can be seen from the seven magnificent volumes, now in the Liverpool Public Library, in which he mounted the text and illustrations of Lear's Italian journals alongside the original drawings from which the plates had been taken.

During his last years, Lear worked on his final and largest oil which measured 15ft by 9ft. Its subject was suggested by the fictional island of Tennyson's castaway, Enoch Arden. In it, Lear painted all the tropical foliage which had so fascinated him, not only in India and Ceylon but on all his travels. The picture was unfinished at his death and its whereabouts is not known, but its composition can be seen from the drawing which he did for that poem in his project to illustrate Tennyson's work.

This scheme, which occupied most of the last years of his life, had been in his mind ever since he had first read Tennyson's poems in 1842. He summarised his thoughts on it in a letter to Hallam Tennyson. 'I suppose no "dirty Landscape-painter" ever got together so curiously diversified a collection of Topographical illustrations, tho' many have illustrated particular places more betterer, for I don't pretend to be a painter in the ordinary sense of the word', he wrote. 'Very few painting coves, – however superior to this child as artists, could illustrate the Landscape allusions in your Father's poems with such variety & perhaps accuracy. So that, if please God I live to finish all the 200 – the spectacle will be at least remarkable.'

He decided to publish the illustrations as a record of his life's work. The proposed book was modelled both on Claude's *Liber Veritatis*, and on Turner's *Liber Studiorum* which in 1871 was reproduced by the process of autotype in a volume which excited Lear's hopes that he could produce something similar. Over many years he experimented and re-experimented in methods of reproduction. With the help of an assistant who prepared some of the plates, he tried autotype, lithography, chromolithography, photography and platnatype, but all without success. As he worked his eyesight continued to deteriorate, so that by October 1880 he was writing, 'It is plain that owing to my very defective sight wh. cannot work without a distinct outline, – I have to make that outline so dark that it interferes with the light & clearness of the drawing, all through its future progress. It seems nearly impossible that I can *gradually* achieve colour & form together.' In the end, he abandoned the project as a failure.

The last years of Lear's life were ones of increasing loneliness and despair. Far from friends, isolated from the artistic community of his day, he died on 29 January 1888, knowing that his reputation did not reflect the quality of his contribution. He believed that the power of the art establishment and the influence of fashion, rather than the strength of the work itself, determined the success or failure of too many artists, leading to the grinding down of real talent. Although it is true that he had grown to depend upon, and at times to exploit, the kindness of his friends, he believed that in buying his works they were acquiring objects of value which would give pleasure to generations of their families.

But he knew that he could look forward to something better to come. In 1864, he wrote to Holman Hunt, 'When you & I go to heaven we won't paint any more, but will sit in Chestnut trees & smoke & drink champagne continual.'

Enoch Arden's Island. n.d. Pen and ink. 12½in x 20in. No 200 in the series of Tennyson illustrations. Private collection

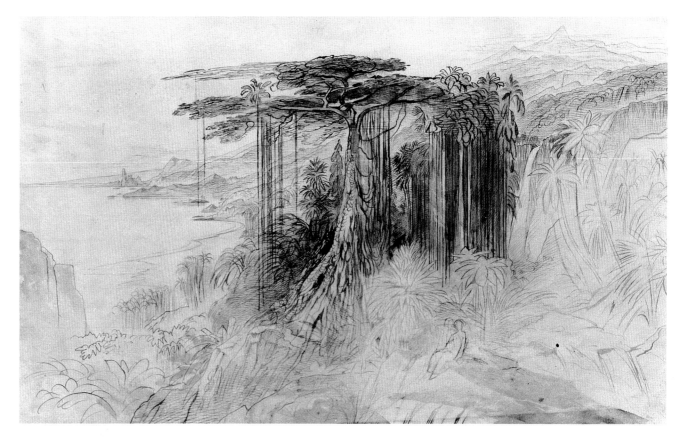

Index